LONDON

TRADITIONS

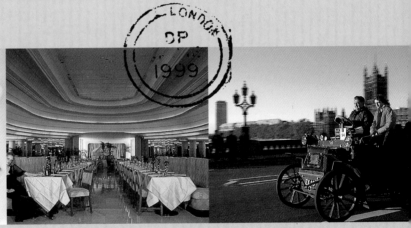

LEFT Miniskirt pioneer Mary Quant.
ABOVE Art deco ballroom of the Biba shop, 1973.
RIGHT The London-to-Brighton veteran car run.

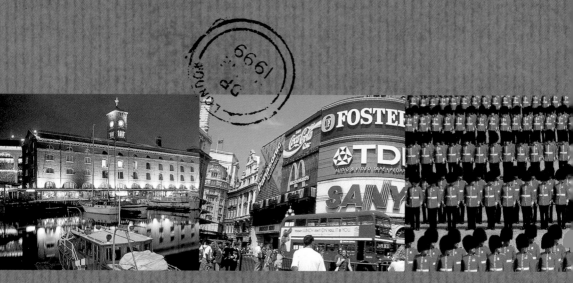

LEFT The redeveloped St Katherine's Dock.
ABOVE Piccadilly Circus in London's West End.
RIGHT Guards at the Trooping of the Colour.

LEFT War and fashion in London, 1940.
BELOW The Royal Academy Summer Exhibition.
RIGHT A scene from *Jesus Christ Superstar*.

LONDON
TRADITIONS

Watson-Guptill Publications
New York

First published in the United States in 1999 by
Watson-Guptill Publications, a division of
BPI Communications, Inc., 1515 Broadway,
New York, NY 10036

Publishing Director: Laura Bamford
Executive Editor: Mike Evans
Editors: Michelle Pickering, Humaira Husain
Production Controller: Joanna Walker
Picture Research: Wendy Gay

Creative Director: Keith Martin
Executive Art Editor: Geoff Borin
Design: The Design Revolution

First published in 1999 by **Hamlyn**, an imprint of Octopus
Publishing Group Limited, 2-4 Heron Quays, London E14 4JP

ISBN 0-8230-5408-X

Printed and bound in China

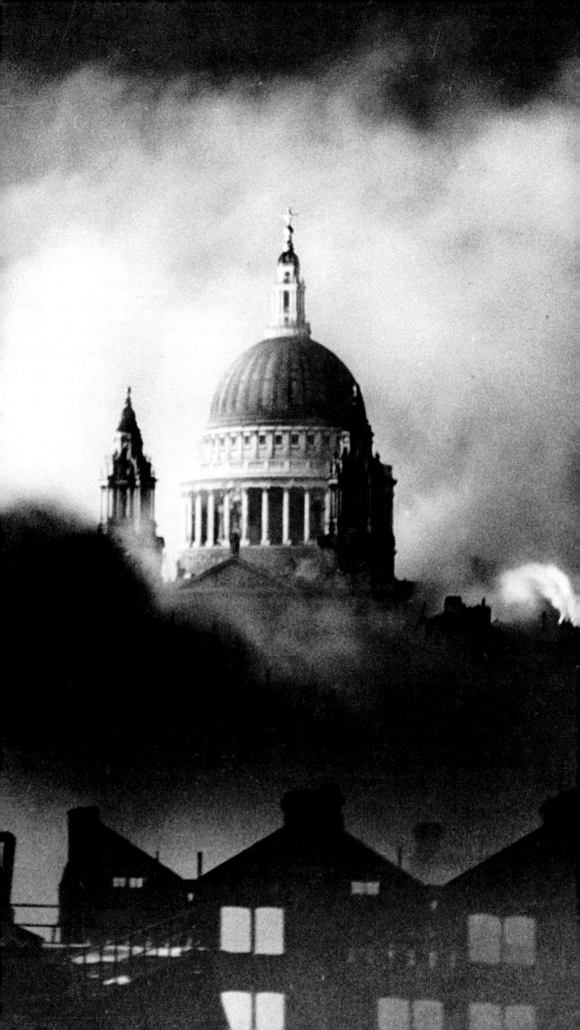

CONTRIBUTORS

1 GRAHAM VICKERS Architectural writer specializing in urban design, contributes to RIBA magazine and various books including *Key Moments in Architecture*.

2 DEBRA SELLMAN Background in arts administration at leading London galleries, writing includes the journal *Issues in Architecture, Art and Design*.

3 JESSICA STEIN Fashion journalist and consultant with editorial and writing experience with Paris *Vogue*, *Elle* and *Harpers Bazaar*.

4 NIGEL CAWTHORNE Many books on art, popular culture and social history include *The Sixties Source Book* and Hamlyn's *New Look*.

5 SUE JAMIESON Regular food and drink writing has included work for *The Restaurant Magazine*, *The Publican* and *Wine & Spirit International*.

6 ROGER MORTON Music editor for the UK men's monthly *GQ*, film reviews for *Esquire*, reviews in *The Observer* and a book on the band Suede.

7 ADAM WARD Writing and editing sports books, including the *Arsenal Official History*, *Football Wizardry* and *Football Fitness and Skills*.

8 IAIN DRIVER In addition to writing about the performing arts, an established actor in his own right on the London stage, and in films and television.

CONTENTS

ARCHITECT

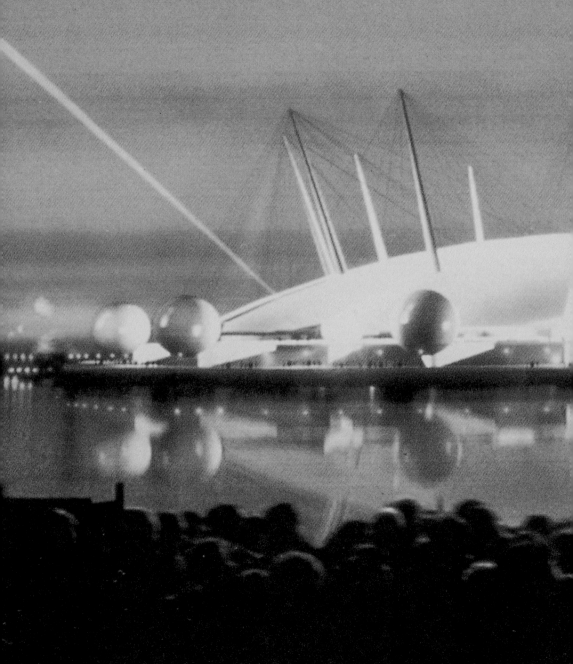

The Millennium Dome, designed by Sir Richard Rogers, will act as the focal point for the nation's celebrations for the year 2000. London's architectural icons are varied – the Tower of London, St Paul's Cathedral, Nelson's Column, Tower Bridge – and it remains to be seen whether the dome will join their elevated ranks.

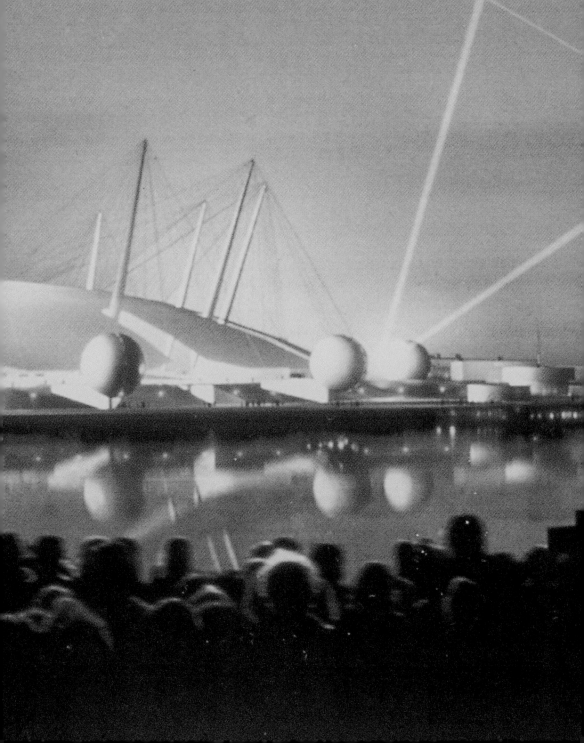

JRE

Text: Graham Vickers

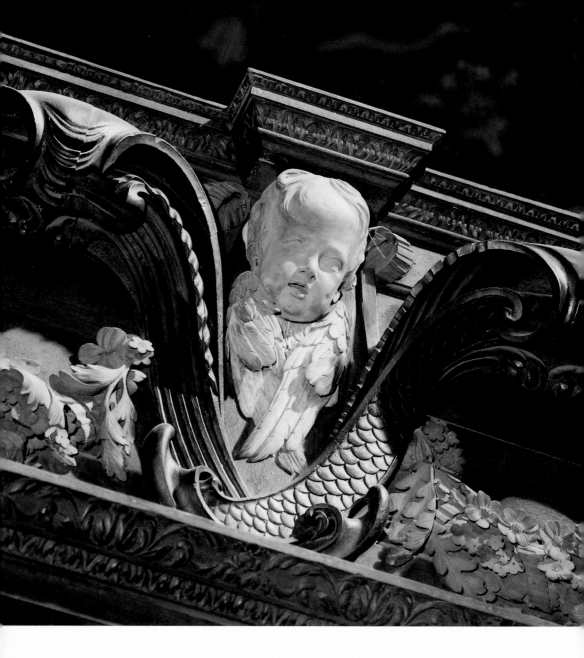

Founded by the Romans in the 1st century AD and boosted by enormous growth in trade and population during the late 16th and early 17th centuries, London is famous for its extraordinarily rich architectural heritage. However, the modern city is not at all the animated building museum so often projected by the tourist industry. If the Statue of Liberty is New York and the Eiffel Tower is Paris, what then is London's natural logo? Significantly, nothing obvious springs to mind. The Tower of London, St Paul's Cathedral, Nelson's Column and Tower Bridge are the structures most usually pressed into service to provide logos for the city. Chosen mainly for their recognisable outlines, these assorted structures illustrate a difficulty: pluralistic London is not easily summarised by a single building. What then should London's icon be?

THE IMPACT OF THE RIVER

In the opening credits of a much-exported BBC TV soap opera, *EastEnders*, the camera pans across a map of the curling horizontal ribbon of the River Thames to identify the locale of the serial; in doing so it also exposes the true spine of London. The River Thames was the most important factor that determined London's primacy, its complex layout and its architectural development.

In many senses the capital effectively exists only north of the river, the south being mainly an unstructured collection of residential districts. The Thames' currents and prevailing winds flow eastward, ensuring the growth of shipping, manufacturing and heavy haulage districts downstream in the East End. The West End meanwhile was taken over by the more affluent classes, who made it predominantly residential and leisure-based. West London also acquired a series of green public spaces spilling out from both banks of the Thames, from Battersea Park and Wimbledon Common in the south, and St James's Park, Hyde Park and Kensington Gardens in the north, all the way to Hampton Court.

LEFT The intricate woodcarving on the choir stalls and organ case in St Paul's Cathedral is the work of the Dutch master craftsman Grinling Gibbons.

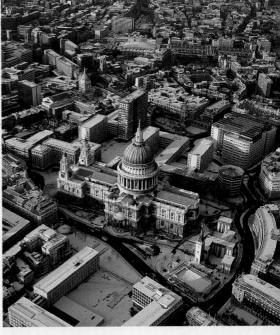

ABOVE Aerial view of St Paul's Cathedral. There has been a church on this site for the past 13 centuries, with the present building being constructed between 1675 and 1710.

BELOW LEFT Early 18th-century print showing the Royal Palace of St James's and the Mall.

BELOW RIGHT This map of London showing the course of the River Thames was printed in 1878.

THE RIVER THAMES

The Tudor palace of Hampton Court on the north bank of the Thames was built by Cardinal Wolsey, who donated it to Henry VIII (reigned 1509–47). Located for the beauty of its surroundings and ease of transport to Westminster by boat, the palace became the favourite home of Henry. For over 200 years it was occupied by reigning monarchs, George II being the last. The gardens, including the famous maze, were laid out in Dutch style for William III (reigned 1689–1702) and numerous additions, both horticultural and architectural, were made by various occupants over five centuries. A major fire in recent years caused much national hand-wringing, although, taking the long view, it may be seen as just another incident in the florid history of a building inured to intrigue, violence and change.

Architecturally, the palace saw an endless process of modification. A moat was dug,

BELOW The world-famous Hampton Court Maze has attracted visitors since its creation in the 17th century. A trick for finding the way out is to walk around the maze always choosing the right-hand turn or always choosing the left-hand turn. This isn't the quickest way out, but it's a sure one.

HAMPTON COURT

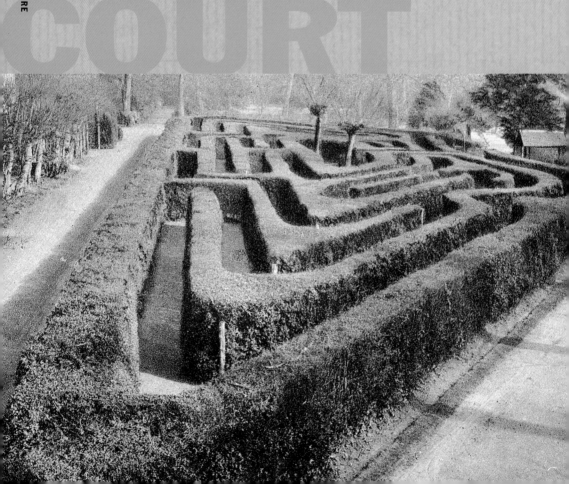

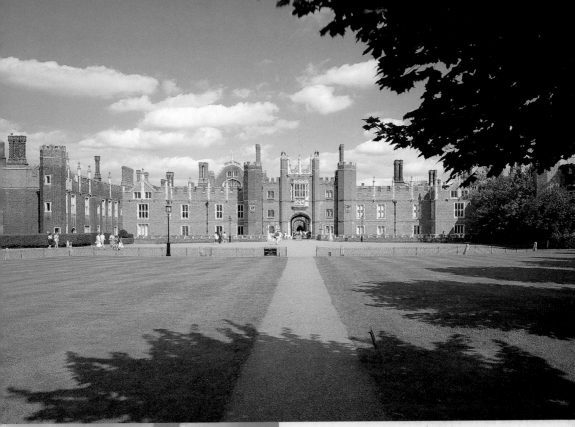

filled in, re-excavated. Dynasties of power came and went. Wren and Vanbrugh added their own touches to the palace – the Fountain Court buildings and some state room decorations, respectively. Yet Hampton Court Palace, however much it is changed, destroyed, refurbished, reinvented, sanitised and relentlessly marketed, is worth keeping at any price. Its scale and its hubris tell the visitor more about Tudor times than any book or photograph can. Grandly conceived 500 years ago, Hampton Court Palace has endured into what must once have seemed an unimaginably democratic and prosperous future but one that, ironically, can no longer afford it, except as public spectacle. It is still within easy reach of central London, but now usually by boat, tour bus or train.

TOP & ABOVE Hampton Court Palace just outside of London is a popular tourist attraction, where costumed guides give visitors a taste of life in Tudor times with tours through its rooms and gardens. The palace was Henry VIII's favourite home and remained a royal residence for 200 years.

CARDINAL WOLSEY

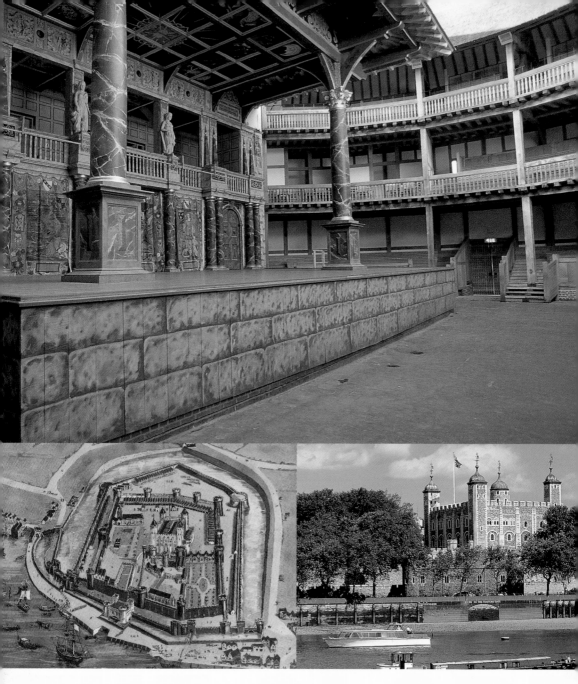

TOP The stage of the reconstructed Globe on the South Bank. The building is an authentic reproduction of the theatre as it was in Shakespeare's day, using traditional materials and building methods.

ABOVE LEFT Engraving of the Tower of London from a survey made in 1597.

ABOVE RIGHT The Tower of London was begun by William the Conqueror in 1066 after his coronation.

OPPOSITE Illustration of Tower Bridge, 1951. The movable bridge was opened in 1894.

THE GLOBE THEATRE

The riverside theatre famous for its contemporary performances of Shakespeare's plays offers a cautionary historical tale about tradition and the fabric of buildings. In 1598 (and in an unexpectedly early example of self-assembly woodwork), brothers Cuthbert and Richard Burbage dismantled an existing London theatre threatened with demolition and took it to a small theatre district in Bankside on the south bank of the Thames. There they put it together again. Shareholders in this venture included the Burbage brothers themselves, the theatre's performers and William Shakespeare. Topped off with what would soon prove to be a combustible thatched roof, this original Globe Theatre succumbed to an incendiary special effect during a 1613 performance of Henry VIII.

It was rebuilt the following year, this time with a fire-proof gallery roof. The reborn Globe was razed to the ground in 1644 to make way for tenement dwellings, an unforeseen threat. Three hundred and fifty years later, largely a result of the efforts of actor Sam Wanamaker, a best-guess reconstruction of the Globe Theatre was created using traditional building methods and materials. There it stands today, on the South Bank, a working anachronism that delights some, infuriates others and represents to all the peculiar potency that buildings possess to enshrine and encourage mystical links with the spirit of the past.

THE TOWER OF LONDON

Immediately after his coronation in 1066, William the Conqueror built a fortified tower on the north bank of the Thames adjacent to the present City of London (an administratively distinct business district one square mile in area). His aim was to contain possible local uprisings in the mercantile district and to secure what was then the major port of the Pool of London. A central keep called the White Tower followed and over the course of two centuries this was to become the pivot of two concentric fortified enclosures, each featuring their own array of towers. Subsequently, the fortress complex served as royal palace, military garrison, place of execution, strongroom (for the Crown Jewels), Royal Mint, menagerie, jail (Sir Walter Raleigh and Rudolf Hess both languished there) and all-purpose symbol of royal might. A moat was added but this was drained in the mid-1800s. The current fussy topography of the surrounding area (busy one-way streets, pedestrian tunnels and walkways) makes the simple architectural logic of the original hard to see. A plan of the tower in the reign of Edward I (1272–1307) shows the original fortifications form.

Today, for a building so replete with rich history, the Tower perpetuates a highly theatrical culture of presentation. It is as though no one would believe in it or visit it without its Gilbert & Sullivan beefeaters, whose security capacity is presumably rather reduced by full Tudor costume. In a minor but telling architectural aside, one of the arguments once put forward in (successful) opposition to the building of a nearby helipad to serve the City of London, was that the noise of the helicopters would prevent tourists from hearing the beefeaters' spiel.

In terms of visual drama, the Tower is overshadowed by the adjacent Tower Bridge. This rather squat but technically impressive movable bridge of the double-bascule type was opened in 1894 to provide a 230-foot-wide opening for tall ships on the Thames to pass through. The original steam-driven hydraulic pumps were replaced by electric motors in the 1970s. Viewed from the south bank of the Thames, Tower Bridge with the Tower of London beyond offers one of London's defining historical setpieces.

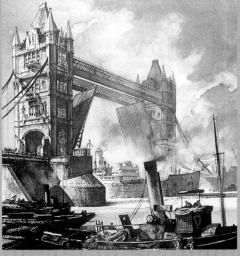

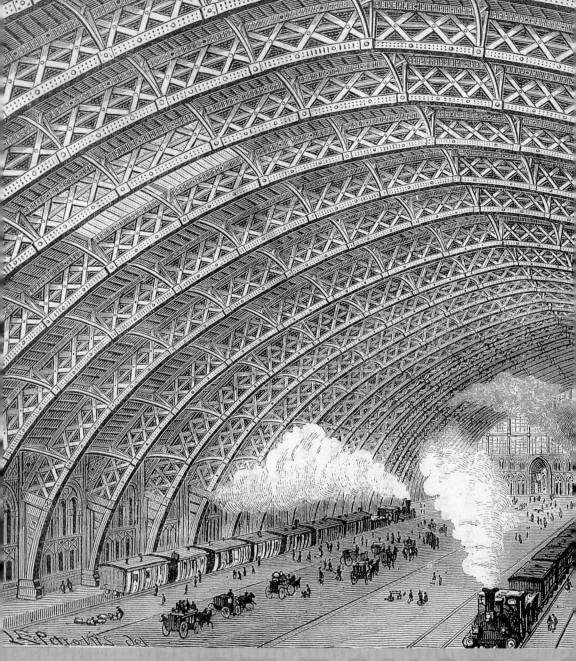

ABOVE The main hall of St Pancras Station with its enormous glass and iron roof, 1883. It was the largest undivided space ever enclosed when it was built a decade earlier.

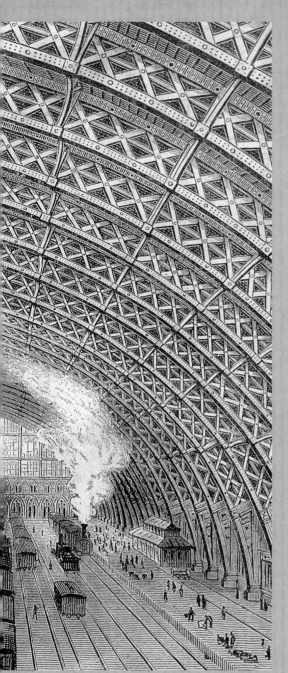

and the site span some 13 centuries. Assisted by architect Nicholas Hawksmoor and the master woodcarver Grinling Gibbons (who was responsible for the choir stalls), Wren produced an iconic building of grace and authority that has so far proved as immune to fire as it was to the bombs of World War II. For a generation of Britons, the famous photograph of St Paul's dome emerging miraculously intact from the fire and smoke of an air raid was one of the most inspiring images of the war.

The celebrated dome is not what it seems and, technically, not a dome at all. The externally visible one is of lead-covered timber. An inner one of brick is low enough and of a scale suitable to show off Sir James Thornhill's eight murals. Sandwiched between the two is a brick conical dome that actually supports the external lantern, ball and cross. An elegant deceit, St Paul's dome tops off a great cathedral boasting galleries, a crypt, a chapel, statuary and even a famous model of itself.

Like the architecturally less interesting Westminster Abbey – another distinguished burial place for the great and the good of several centuries – St Paul's Cathedral is an obvious link with history that still impresses with the immediacy of its design. Issues of space, scale and spectacle have been addressed with a clear mind and a careful appreciation of context and surrounding space. Today St Paul's is surrounded by resonant historical street names still attached to ramshackle developments. Paternoster Square – converted into a windswept shopping precinct of compelling shabbiness – is a notable case in point. However, St Paul's endures, quietly reminding architects and planners that it is both possible and desirable to do so much better.

Both, however, are architectural supporting players to the jewel of London's skyline, Wren's masterpiece and one of London's finest buildings: St Paul's Cathedral.

ST PAUL'S CATHEDRAL

One of more than 50 London churches designed by the prolific architect Sir Christopher Wren, the present cathedral building was constructed between 1675 and 1710 in Latin Cross form. Built of Portland stone, it was commissioned to replace Old St Paul's, which had burned down in 1561. Old St Paul's had itself replaced a 7th-century precursor, also destroyed by fire, so the name

RAIL TRANSPORT

London's architectural character, like that of most other great cities, changed with the arrival of the railroad. Suddenly, a new type of building was required, a new gateway to the city that was in no way related to the traditional points of entry. Railway termini and stations penetrated the very heart of the city. They demanded buildings that were part civic and part industrial. There had never been anything like them before. Engineers

ABOVE The new entrance to Liverpool Street Station, successfully transformed in the 1980s from a complex labyrinth into a shopping mall experience.

OPPOSITE The international terminus at Waterloo Station where trains speed through the Channel tunnel between London and mainland Europe in the space of a few hours.

rose to the challenge of creating ever greater spans for the train sheds, while architects played with traditional and new forms to express what a railway station's frontage might look like.

St Pancras, built in 1873 and serving northern regions, came up with a dramatic High Gothic hotel façade disguising an enormous single-span train shed roof – a glazed hall spanned by 243-foot trussed iron arches. It was the largest undivided space ever enclosed. Its neighbour, King's Cross Station, chose a smaller scale and a frank expression of the internal arches carried through to its façade. Euston, with its famous (and now lost) arch, once reflected something of the ceremonial aspect of travel. Paddington, a creation of Brunel and serving the west, kept a low external profile, again largely hidden by an enclosing hotel building that exposes only a single small train shed arch at the end of a deeply recessed frontal approach. These were the general models, with, to the south, Victoria, Waterloo and Charing Cross arriving at broadly similar solutions.

All became the sudden focus of new activities that rerouted buses, demanded space for taxis, promoted travel-related outlets and necessitated the provision of grand hotels and townhouses adapted to bed-and-breakfast needs. The technology and iconography of train travel – closely allied to that of bridges and heavy industry – also introduced a whole new range of possibilities both for the realisation and decoration of buildings in general.

No station building better illustrates the changing role of the railway in London than Liverpool Street. Once a grimy labyrinthine cavern with odd dislocations and adjunctions brought about by piecemeal development, it was transformed in the 1980s as part of a larger development. Something of the old spirit of patronage was briefly revived in London at that time, and the embracing Broadgate development enabled the virtual reinvention of this major station serving East Anglia. The steel, brick and glass fabric of the building was renovated, but the internal architectural space was transformed into an airport-style shopping mall where you can now buy food, underwear, pharmaceuticals,

LIVERPOOL STREET

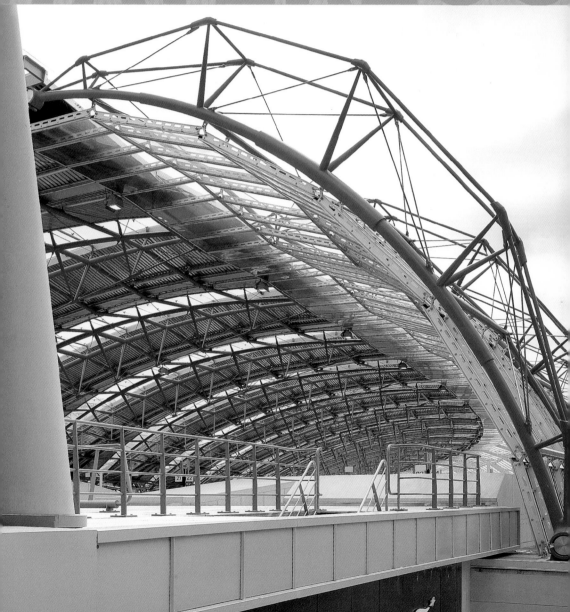

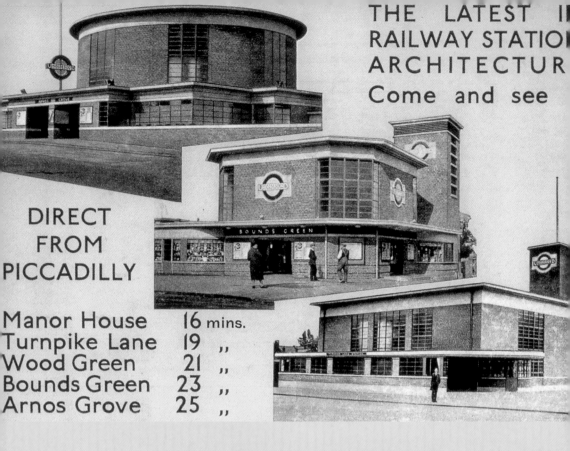

DIRECT
FROM
PICCADILLY

Manor House	16	mins.
Turnpike Lane	19	"
Wood Green	21	"
Bounds Green	23	"
Arnos Grove	25	"

books, cellular telephones, computer software and more. Cafés and restaurants complete the conversion of a train terminal into a retail leisure experience, one of whose services – now largely invisible from the concourse – involves train travel. Is this a legitimate updating of what a London railway station was originally conceived to be? Or is it a dubious deal whereby a buoyant retail sector provides diversionary glitz for the terminal of a long-neglected regional rail network?

A parallel situation can be seen at Waterloo Station's international terminal for Channel tunnel passenger trains. As a terminal building Nicolas Grimshaw's solution is exemplary – a dazzling train shed, elegantly serpentine in its effort to fit into a very tight site, and altogether a fine extension of London's great tradition of station architecture. However, the line itself – underfunded, prone to problems and laughably slow compared with its French equivalent – invites once again the suspicion of an administrative willingness to let building design make grand promises that no one is able to keep.

Rail transport determined London's layout more than any other factor after the Thames. The capital's underground railway was the world's first, a distinction that cuts both ways since adequately funding the maintenance of

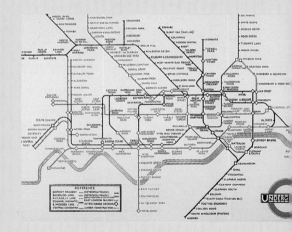

TOP Stations on London Underground's Piccadilly Line. Some station buildings are of significant architectural interest and are now listed buildings.

ABOVE The London Underground map by Harry Becks distorted real distance to represent the Tube lines in a clear, diagramatic form. Each of the lines is colour coded.

such an antique system has proved beyond the will of successive modern governments. However, the celebratory trial runs from Baker Street Station in the 1860s marked the start of a system that would have enormous impact upon the capital. Soon the Tube was to create a whole new suburban ribbon development with a genteel culture to match – Metroland. It would, in the 20s and 30s, give London some architecturally fascinating Underground station buildings: Arnos Grove, Edgware, Mornington Crescent, Sudbury Hill and Osterley being good examples.

It would also give us Harry Becks' legendary Underground map, which compressed and stretched real distance to a purely diagrammatic sequence of stops and connections. (This early notion of virtual mapping today finds an echo in the conceptual London airports, so-called despite the fact that Heathrow, Gatwick and Stansted are all many miles from the capital.) Of these, only Sir Norman Foster's Stansted Airport exists as a piece of architecture at all – and a beautiful one at that. The remainder are pragmatic developments, bristling with internally driven accretions that always seem to be lagging behind demand.

BELOW A map showing the position of Tube stations in the western suburbs of London. London's Underground system was the first in the world and remains one of the largest.

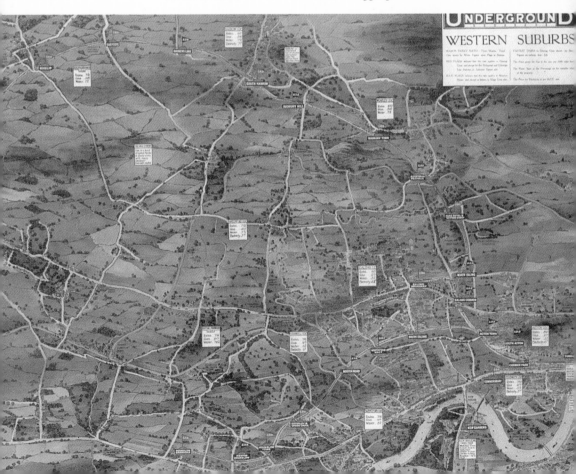

Baker Street's Underground station features some well-restored platforms that give an excellent idea of what the original 1860 station would have looked like. Meanwhile, a continuing extension to the Jubilee Line into Docklands shows what can (and cannot) be achieved with a modern-day underground development.

POST-WAR LONDON

Docklands in many ways exemplifies the post-war London experience. The East/West divide gradually began to blur, with the port economy and manufacturing industry in decline and white-collar workers and new residents moving in. In the early 1980s, a government regeneration project for Docklands' 5,000 derelict acres hastened the process, and the introduction of the

DOCKLANDS LIGHT RAILWA

computer-operated Docklands Light Railway set the seal on a radical change of culture for the area and the end of the old order. London was again reinventing itself.

It was a process started by the aftermath of heavy bombing. Reconstruction and new development had repaired most of the damage, but relocation of manufacturing and shipping outside the city shrank its population and hastened London's move towards becoming a major centre of international trade and finance.

All this was taking place in the 30 years that followed the Festival of Britain, a post-war exercise in national optimism, focused upon an exhibition on London's South Bank.

ABOVE Docklands Light Railway, with computer-operated trains, is the most recent addition to London's transport system.

RIGHT At 800 feet, the pyramid-topped steel tower that dominates Docklands' Canary Wharf is Britain's tallest building.

BELOW Stansted Airport is the most architecturally appealing of London's three main international airports, though it is actually over 35 miles out of central London.

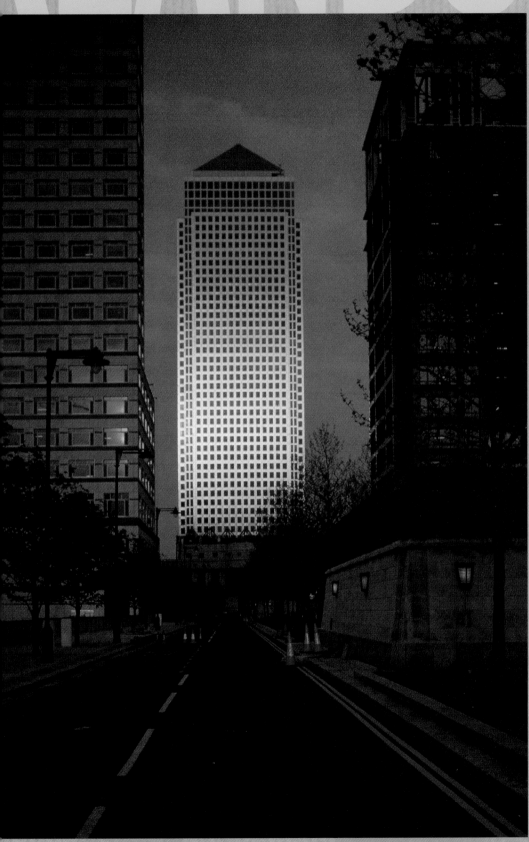

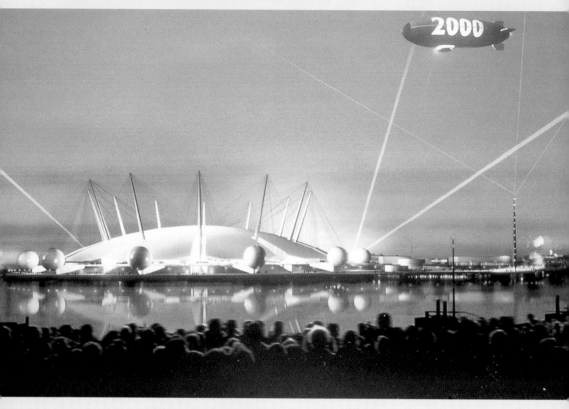

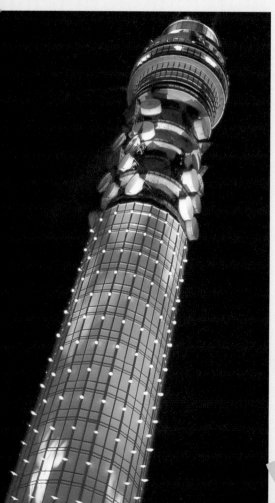

ABOVE The Millennium Dome Experience, planned to celebrate the coming of the year 2000, consists of a vast dome that will house a number of innovative and interactive exhibitions.

LEFT The British Telecom Tower is a central London landmark to the north of Oxford Street. Although there are now many taller buildings, the Telecom Tower remains a potent symbol of Britain's success in the field of telecommunications.

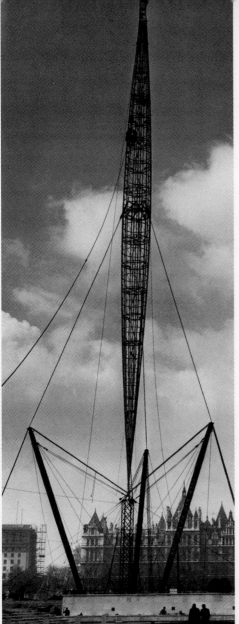

There, temporary structures such as the Skylon (a cigar-shaped pylon) and the Dome of Discovery (a British Commonwealth-flavoured collection of exhibits) suggested a dynamic future with the usual degree of accuracy of all such feel-good ventures. Forty years on and also sited on the South Bank, the Millennium Dome at Greenwich, by Sir Richard Rogers, seeks to reinvent the impact of the Dome of Discovery for a new generation with a very different perspective on the immediate past and future. Whether this proves to be yet another example of legitimate architectural vision harnessed to an underdeveloped message remains to be seen at the time of writing.

Meanwhile, London's sole permanent architectural legacy of the Festival of Britain resides in Sir Leslie Martin's Royal Festival Hall, a building that somehow seems to have improved over the years without ever changing. Perhaps this is because it provides a link with the recent past, about which we are often more fickle than we might be about the comfortably old.

A CITY OF CHANGE

A day spent walking around London will reveal an abundance of random cultural markers from its past and present. The British Telecom Tower stands as a reminder of Britain's contemporary strength in telecommunications and broadcasting. The more traditional beginnings of broadcasting are enshrined in the BBC's Broadcasting House at Langham Place, a 1931 building resembling a great liner about to steam up Regent Street. Over its main entrance is Eric Gill's famous relief *Prospero and Ariel*.

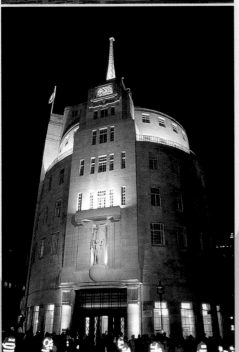

ABOVE LEFT The framework of the 300-foot cigar-shaped Skylon structure, photographed 3 April 1951. It was one of the more memorable architectural features of the Festival of Britain.

LEFT BBC's Broadcasting House at Langham Place during a visit by the Queen to an exhibition celebrating its 50th anniversary.

Next door is John Nash's All Souls Church, a foretaste of his planning work further south in Regent Street where the Quadrant leads into Piccadilly Circus with something of a flourish.

Piccadilly Circus itself has always courted modernity and now owes as much to Times Square as it does to the natural geometry of London. Even the famous Eros statue and fountain were relocated a few years ago to accommodate traffic needs. Nearby Leicester Square also stands as testimony to the increased demands of leisure, consisting almost exclusively of shops, cinemas, street theatre, restaurants and neon signs. The square itself is hardly noticeable. On Piccadilly, Burlington House, now home to the Royal Academy, was built in an almost sylvan setting in 1665, to be cheerfully Palladianised by Lord Burlington in the 1770s and then further developed. A recent gallery addition by Sir Norman Foster offers a fine example of the best of the new being accommodated by a grand old building.

Covent Garden, once a fruit and vegetable market, had its business relocated and its market buildings adapted to the new leisure; it too has joined the international community of work-into-recreation spaces like the Beaubourg in Paris, Fulton Street Market in New York and Faneuil Hall in Boston.

Richard Seifert's Centre Point – the West End's first mini-skyscraper – is now a listed building and stands as testimony to a dubious piece of 1960s real estate dealing which resulted in the block being purposely kept empty while rents rose with inflation.

RIGHT Huge neon advertisements dominate Piccadilly Circus. This crossroads in central London is always bustling with life, day and night.

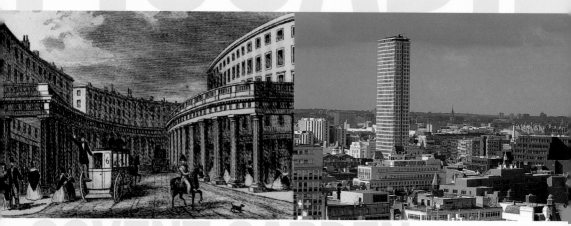

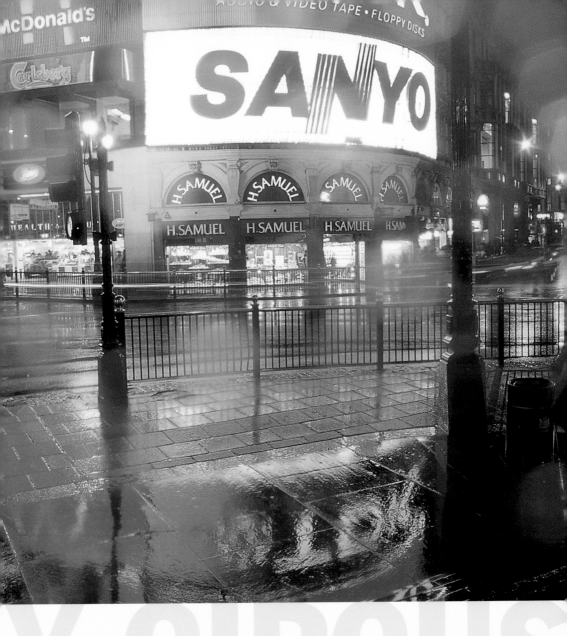

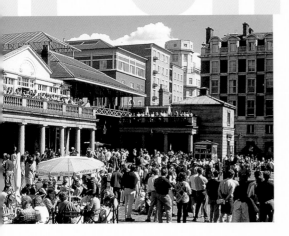

FAR LEFT The Quadrant, where Regent Street leads into Piccadilly Circus, in the 1820s. The street was designed by architect John Nash as a royal route from George IV's residence on Pall Mall to his country estate at Regent's Park.

CENTRE Centre Point, a typical piece of 60s architecture, was the West End's first skyscraper and still towers over surrounding buildings.

LEFT Covent Garden today is as bustling with activity as it was in its days as a flower, fruit and vegetable market. It is now packed with craft, gift and antique stalls as well as numerous places to relax, eat, drink and enjoy life.

Gilbert Scott's Albert Memorial was, to begin with, hilariously intended to sit on top of the Royal Albert Hall. Deemed far too heavy for this purpose, it was placed in the park opposite, where, in recent years, it underwent extensive renovation that kept it completely boxed in, so creating an austere, anonymous, blank-faced memorial that some architectural commentators pretended to prefer to the original.

In the City, Sir Richard Rogers' Lloyds Building still attracts the tourists. With its inside-out logic, it continues to divide the critics but endures as a bold statement of intent, another way in which London might reinvent its office buildings.

Also more interesting as a totem than as a structure is Terry Farrell's building for MI5 near Vauxhall Bridge. The comedy of a secret service building triumphantly advertising its presence with a whole box of post-modern tricks states, as clearly as anything could, that the traditional foreign view of old London and its staid institutions is out of date.

In fact the traditional view of London is always out of date. Constantly reinventing itself to match the passing moment, London is a dynamic metropolis whose long traditions inform its modern infrastructure and reveal its character through buildings both old and new. More than anything else, it is the capital's built environment that provides the genuine London Experience (a phrase otherwise debased by the proprietors of countless sightseeing tours, shops and themed tourist attractions).

Furthermore, it is the capital's architecture that invites London's visitors and residents alike to reconsider tradition as something alive and ongoing – a vital, adjustable process of continuity rather than a closed box containing neatly labelled bits of the past.

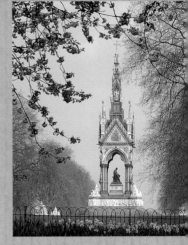

ABOVE The Albert Memorial, in Kensington Gardens, was originally intended to crown the Royal Albert Hall but was deemed too big.

RIGHT The Lloyds Building was designed by Sir Richard Rogers, co-architect of Paris's Pompidou Centre. The impressive glass and steel structure's inside-out theme places normally internal structures on the outside of the building.

BELOW LEFT The 'discreet' MI5 building near Vauxhall Bridge is home to Britain's secret service.

BELOW RIGHT Nelson's Column in Trafalgar Square, viewed from the National Gallery. The Neo-classical building houses the nation's main art collection.

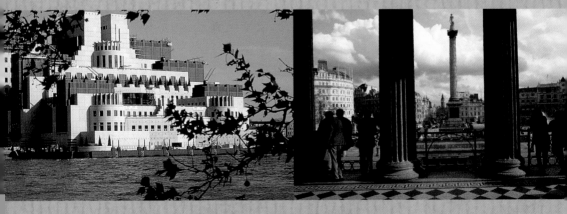

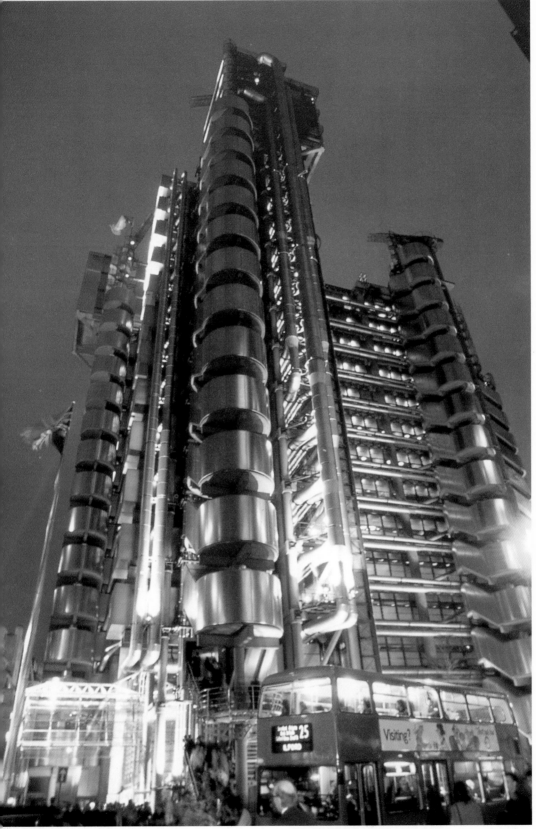

The Tate Gallery is the foremost London gallery for 20th Century art. Here the British sculptor Barbara Hepworth stands with her work 'Four Square Walk Through' during a Tate retrospective exhibition in April 1968.

ART

Text: Debra Sellman

YOUNG BRITISH ARTISTS FROM THE SAATCHI COLLECTION

SENSATION

18 SEPTEMBER –
28 DECEMBER 1997

Since the heady euphoria that accompanied the election of Britain's 'New' Labour Party in 1997, London has had time to take stock and reflect on its new-found image, canonised a year later in *Newsweek*'s headline as 'the coolest city on the planet'. International shows of British artists over the past five years – such as 'Brilliant!' at the Walker Arts Center in Minneapolis, 'Live/Life' at the Museum of Modern Art in Paris and 'Sensations' at the Royal Academy in London – have attracted the interest of the international press and, through the British media, engaged a home audience once scandalised by Carl André's 'Bricks at the Tate'.

PATRONAGE AND PHILANTHROPY

State patronage and private philanthropy have, in fact, existed in London since the 18th century. The British Museum's extensive collections, most noted for the Elgin Marbles, began as a bequest by Sir Hans Sloane in 1749. The Royal Academy, conceived to act as a forum for the 'cultivation of Fine Arts', was established in 1768 with the approval of King George III. For a century its Annual Exhibition, open to artists of 'distinguished merit', encouraged a growth in painters such as Reynolds, Wilson, Turner and Constable.

By 1836 the House of Commons had endorsed not only ancient art but also 'the most approved modern specimens, foreign as well as domestic' and the Victorian era began with a great fanfare of cultural promise. The National Gallery in Trafalgar Square was housed in 1838 in its grandiose edifice designed by William Wilkins; the Wallace Collection, home to the insouciant grin of

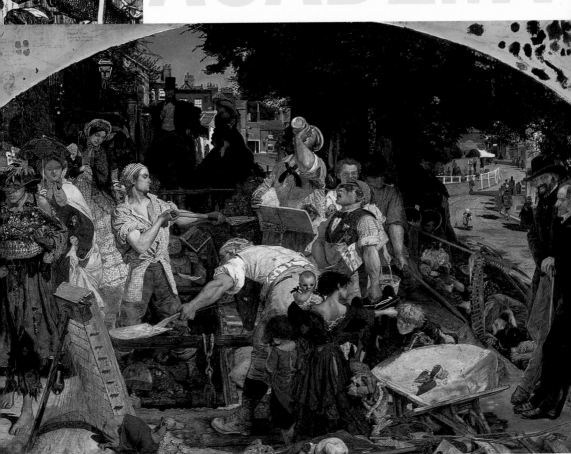

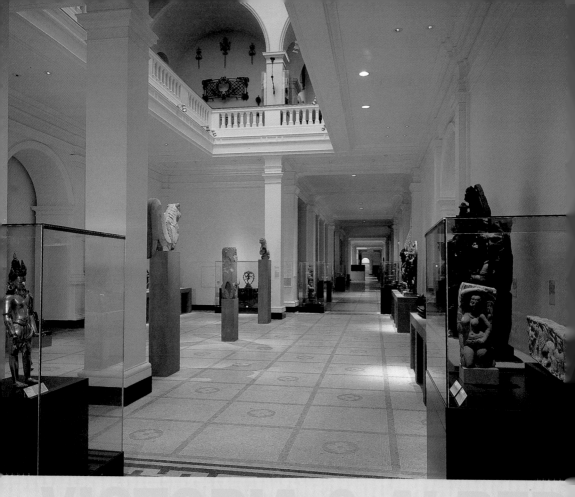

Frans Hals' *Laughing Cavalier*, was passed to the nation in 1897 by the 4th Marquess of Hertford and his son Sir Richard Wallace; the Victoria and Albert Museum, now known as the V&A, opened in 1857; and the Great Exhibition of 1851 left as its legacy the South Bank Centre and eventually, in 1968, the Hayward Gallery. The Victorian era drew to a close at the turn of the century, leaving in its wake an enthusiasm for the arts and an abundance of buildings and institutions that would house many turbulent, creative outpourings in the next century.

Among the many architectural developments in 20th-century London have been the appearance of artist studio spaces, gallery dealerships and the more recent advent of warehouse conversions for exhibitions. The near-legendary exhibition 'Freeze!' was one of the first warehouse shows in London to mark the beginning of 'young British art'. Organised and curated by Damien Hirst, it launched the careers of Turner prize nominee Fiona Rae and Ian Davenport's painterly designer-style abstracts, which attracted an annual retainer of £25,000 from Waddington's.

TOP A view of one of the magnificent galleries in London's Victoria and Albert Museum, one of the great public art and reference places of the city.

ABOVE Plate VIII from 'The Rake's Progress', the series of engravings by William Hogarth chronicling 18th-century London life.

ABOVE The print room at Goldsmith's College of Art in the 1980s, where many names in British art have studied over the years.

RIGHT 'Pandora' (1869) by Dante Gabriel Rossetti, with Millais and Holman Hunt a co-founder of the Pre-Raphaelite Brotherhood.

BELOW From the Hayward Gallery on London's South Bank site, a leaflet for the first major exhibition of the work of the acclaimed British sculptor Anish Kapoor, staged in 1998.

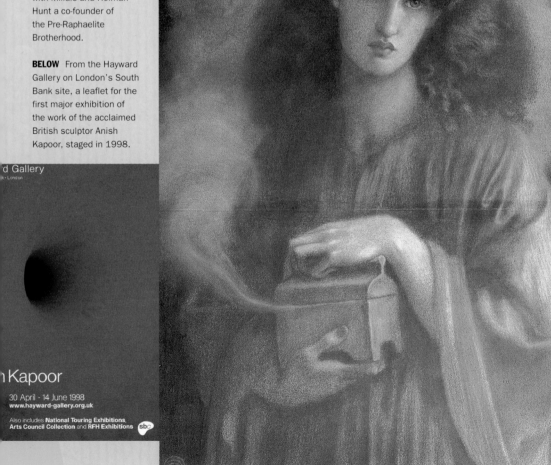

d Gallery
k · London

h Kapoor
30 April - 14 June 1998
www.hayward-gallery.org.uk

Also includes **National Touring Exhibitions**,
Arts Council Collection and **RFH Exhibitions** sbc

CORK STREET AND THE WEST END

Waddington's Gallery in Cork Street was one of the few prestigious art spaces in the West End that managed to survive the financial difficulties of the 1990s. Others, such as the Nicola Jacobs and Nigel Greenwood Galleries, were not as fortunate; even the classic old café Queens, rumoured to be frequented by Sarah Ferguson, Duchess of York, had to go. But today the area is bursting with spaces both for recent art, such as Victoria Miro and Entwistle, and more stately shows, such as Agnews in Old Bond Street and the Marlborough Fine Art Gallery in Albemarle Street.

A short walk from Cork Street is Dering Street, home to the Anthony Reynolds, Anthony d'Offay and Annely Juda Galleries. Reynolds was an early advocate of younger artists, such as Mark Wallinger, whose work critiques the English class system. Annely Juda is famous for her Russian constructivist shows and d'Offay stages spectacular pieces by well-knowns, notably Andy Warhol and Ed Ruscha, with occasional forays into younger unknowns.

As visitors flit around the West End between the various new and Eurocentric galleries to be found there, they might well be forgiven for passing unawares the many public sculptures and monuments, including Elizabeth Frink's *Horse and Rider* in Dover

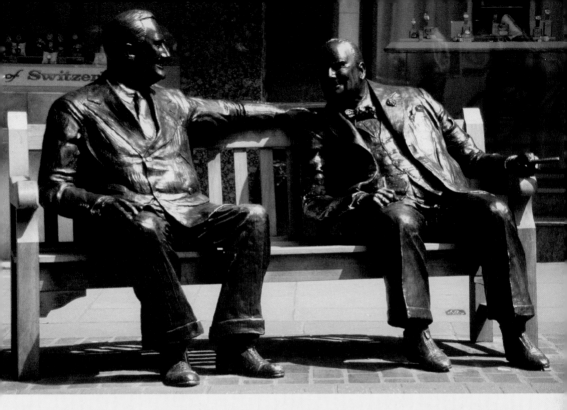

ABOVE A street sculpture in Bond Street, in the heart of the commercial art gallery area, featuring a representation of the World War II leaders Franklin D. Roosevelt and Winston Churchill.

LEFT The effective white space of the Saatchi Gallery during a 1986 show by Richard Bryant.

Street. In their wanderings they will encounter a range of different approaches to space, from the inaccessible London Projects through the characterless Stephen Friedman Gallery to the tranquil Frith Street Gallery.

Jay Joplin, owner of the White Cube Gallery in Duke Street and godfather of the 'yBa's ('young British artists'), picked up sheep-pickling Hirst, who has, without a doubt, been the most commercially successful and famous of his generation. Hirst has relentlessly turned his sensationalist hand to a variety of professions: artist, curator, film and pop video maker, restaurateur and, most recently, record producer. His restaurant, Pharmacy, is a convincing art installation of drug cabinets, waylaying the occasional sufferer so successfully that he has been persuaded to change its name.

Hirst's early minimalist aesthetic appealed to former advertising director Charles Saatchi, perceived alternately as the stalwart of contemporary art and as an overly influential collector-dealer. Renowned for buying in bulk and at a discount, Saatchi switched from an interest in the 60s American 'minimalism' of Judd and André to focus on contemporary British art. His converted paint factory in St John's Wood must still be one of the more impressive spaces in which to see large installations, including the mesmerising '20:50' sump-oil piece by Richard Wilson.

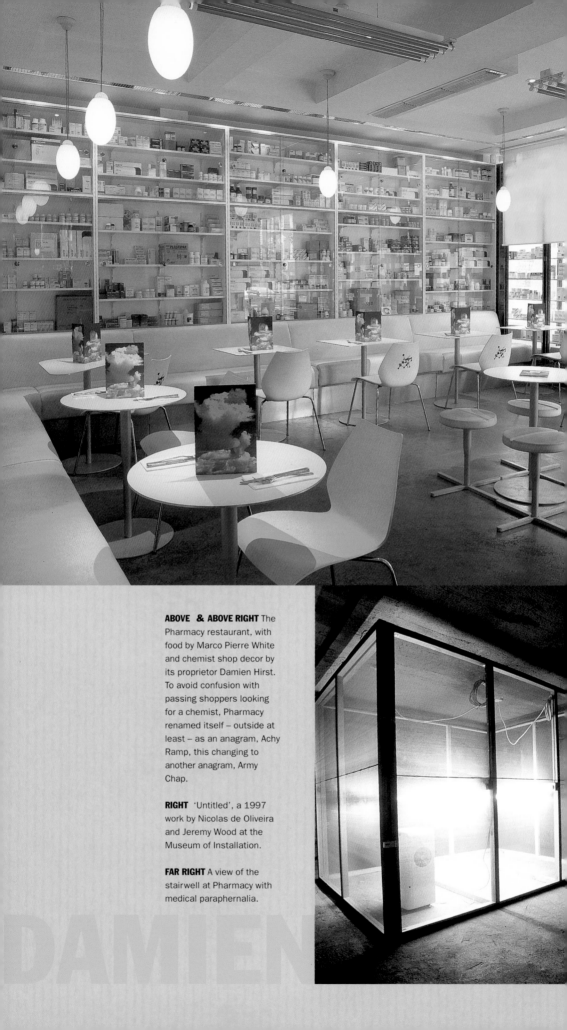

ABOVE & ABOVE RIGHT The Pharmacy restaurant, with food by Marco Pierre White and chemist shop decor by its proprietor Damien Hirst. To avoid confusion with passing shoppers looking for a chemist, Pharmacy renamed itself – outside at least – as an anagram, Achy Ramp, this changing to another anagram, Army Chap.

RIGHT 'Untitled', a 1997 work by Nicolas de Oliveira and Jeremy Wood at the Museum of Installation.

FAR RIGHT A view of the stairwell at Pharmacy with medical paraphernalia.

DAMIEN

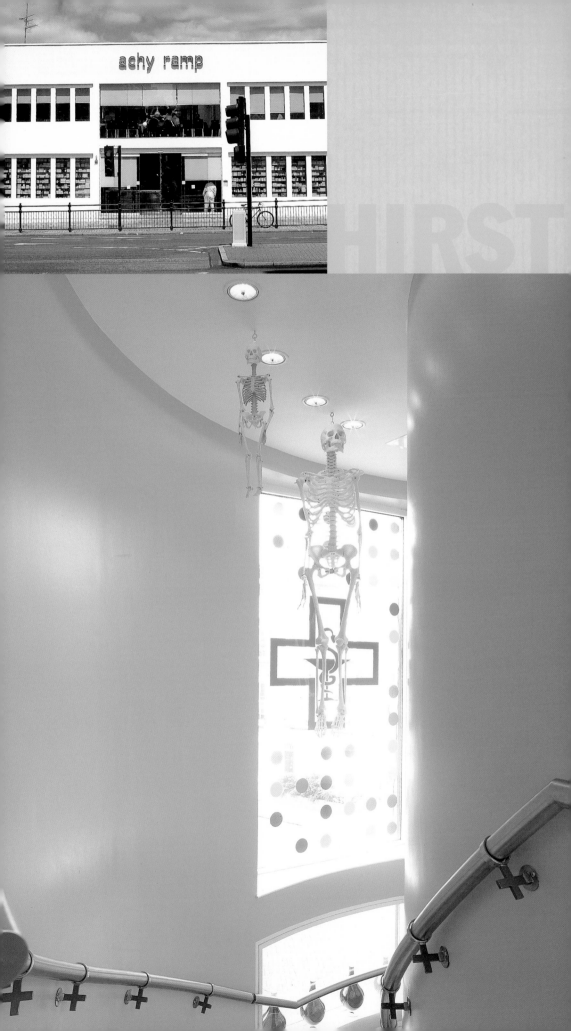

Although commercial success with Saatchi in the 90s has been associated with graduates from Goldsmiths, this is just one of the many heavyweight colleges in London worthy of note. Others include the Slade School, the Royal College, Central St Martin's, and Chelsea and Camberwell School of Art.

The Royal College and St Martin's were centres for avant-garde art in the 60s. At St Martin's, Richard Long, Gilbert & George, Bruce McLean and Barry Flanagan studied under the tutelage of Anthony Caro and Philip King. Both King and Caro had previously been Henry Moore's assistants and made abstract 'heavy metal' sculpture, welding together and then painting free-standing steel shapes.

Under the phenomenological and existential influences of Heidegger, Husserl and Bachelard's topical 'Poétique de l'Espace', 'heavy metal' sculpture attempted to investigate sculptural formalism through abstraction. Sculpture suddenly became a variety of things, no longer requiring a plinth or traditional materials, such as clay or marble, a freedom which inspired the new generation. Gilbert & George thrived in this challenging environment and moved through performance work to their large stained-glass sculptural pieces which continue to challenge sensibilities, most recently with the 'Naked Shit Pictures' shown at the South London Gallery in 1995.

FROM POP ART TO OP ART

The Royal College in the 60s featured tutors such as Richard Hamilton, who was in tune with powerful movements in the American art world and was more interested in translating the quickly changing popular culture into art. In the early years, London was still recovering from the war and the Independent Group, comprising Eduardo Paolozzi, William Turnbull, Theo Crosby and Toni del Renzio, whose meetings of artists, critics, academics and architects took place at the Institute of Contemporary Arts, was driven by a desire to look at contemporary culture and the new technological age.

The highly influential Francis Bacon had begun to use photographic images for his work, which fuelled debates in the use of mass-media techniques and materials. In the 1956 exhibition 'This Is Tomorrow' at the

TOP On display at the Southampton City Art Gallery, 'Wessex Flint Line' sculpture by Richard Long.

ABOVE An impressive piece of steel sculpture by the major British artist Philip King, 'Genghis Khan'.

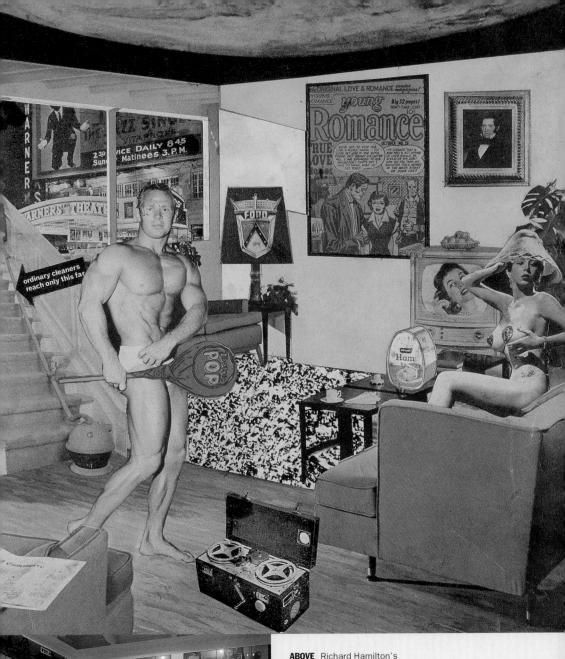

ABOVE Richard Hamilton's ground-breaking piece of pop art from 1959, 'Just what is it that makes today's homes so different, so appealing?'

LEFT The public viewing Gilbert and George's 'Naked Shit Pictures' exhibition when it was staged at the South London Gallery in 1995.

HAMILTON

Whitechapel Art Gallery, which included Richard Hamilton's 'Just what is it that makes today's homes so different, so appealing?', an allegory for the Adam and Eve of a new gadget generation, signaled the advent of Pop Art in London. It combined a serious interest in popular culture with a use of multi-evocative imagery and a sense of interaction between man and machine that had been latent in the minds of many.

The Pop artists – Barrie Bates, Derek Boshier, Patrick Caulfield, Allen Jones, Peter Phillips, Norman Toynton and David Hockney – used media images (cereal packets, pinball machines, weather maps) and graffiti techniques. Hockney was awarded the Gold Medal at the RCA for his paintings and, having dyed his hair buttercup blond, fetched his medal and glory in a gold lamé suit. R B Kitaj toyed briefly with Pop Art but, in a desire to keep figurative painting alive, later formed the School of London, with painters such as Freud, Auerbach, Kossoff and Bacon.

Meanwhile, the Situationist aesthetic desire for 'the reciprocal meeting of the intimate look of the spectator' took hold at the Central School under the tutelage of William Turnbull. The 1960 'Situation' exhibition at the Royal Society of British Artists (abbreviated from 'the situation in London now') changed the direction of many artists. Aware of the epochal Abstract Expressionists and Colour Field painters of the New York School, the exhibition was open both to the action painting of Gillian Ayres and William Green and to artists such as Bernard and Harold Cohen and Robyn Denny, who were less interested in gesture and more in the formalisms of paint and surface, large-scale works that gave a sense of enveloping the spectator and occupying space through simple geometric shapes. Camden Square in North London, where many of them lived and worked, soon became known as 'Situation Square'.

By the mid-60s, Piri Halasz's celebrated article in *Time* magazine on 'The Swinging City' read: 'In a once sedate world of faded splendour, everything new, uninhibited and kinky is blooming at the top of London life.' The scene had moved to the King's Road in Chelsea and parts of Notting Hill and Westbourne Grove where Afro-Caribbean culture was thriving. It was a time for the

ABOVE 'Large Detector – with unravelling evidence' by Jiri Kratochvil was exhibited at the Museum of Installation in 1998; it involved several goldfish swimming through linked glass receptacles, with infra red detectors and computers translating their movements electronically into abstract visual patterns displayed on computer screens.

RIGHT The ICA – Institute of Contemporary Art – in Nash Terrace on The Mall, the scene of many landmark exhibitions in post-war British art.

BELOW The three-dimensional logo for the London Contemporary Art Fair held annually at the Business Design Centre in Islington, showcasing over 100 commercial galleries.

sartorially sensitive Mods, attired in Parka jackets, dark glasses and Fred Perry shirts, and devotees of The Who. The Scene Club, the Marquee, the Lyceum and Carnaby Street were alive with an energetic youth that popped Purple Hearts, Blues and 'dexies'(varieties of amphetamine) and spent their Sundays shopping in Petticoat Lane or Brick Lane markets.

The phenomena that occurred as a visual after-effect of Situationist works led artists such as Bridget Riley, Michael Kidner and Derek Boshier to a direct interest in perceptual effects. Soon this 'optical' art was to find its way into theatre and dance floors through projections. Bill Culbert saw light as a transcendental signifier while Stuart Brisley saw it as raw material, but they worked together in performance projections. The aesthetics of light included Steven Willats' stroboscopic effects. Son et Lumière projections began in various venues, including the Roundhouse in Camden Town, which famously inaugurated the underground magazine *International Times* in 1966 with a crowd of 2,500 people, most of whom were tripping on LSD to the new acid bands Pink Floyd and Soft Machine.

But many artists at the time were also attempting to gain access to a 'real' world beyond the media 'spectacle' of the TV or cinema screen. In Norland Road Study in

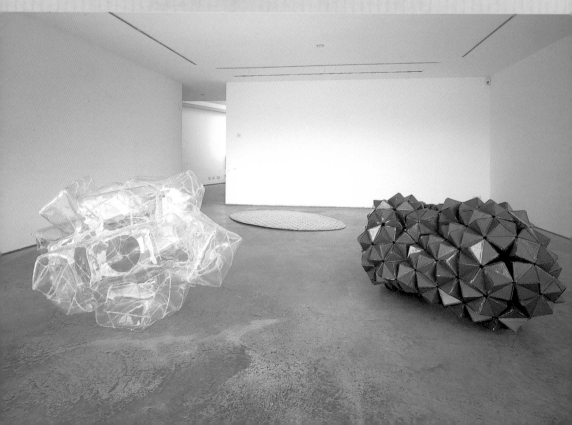

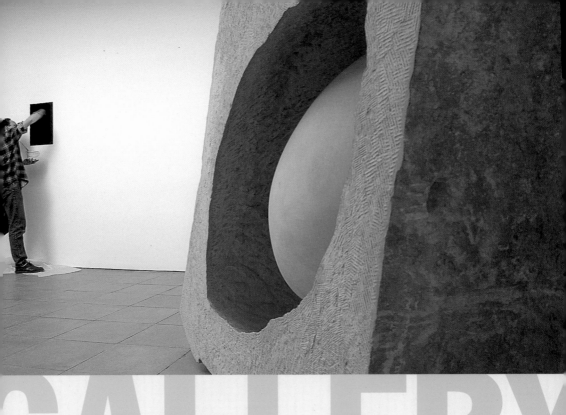

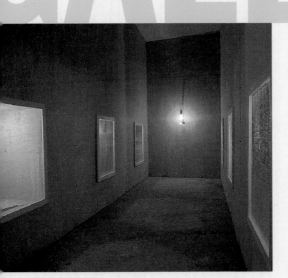

TOP Anish Kapoor installing 'In the Presence of Form II' when it was shown at the Lissom Gallery, 1993.

ABOVE Amanda Wilson's 'his eyes are brown....' at the Museum of Installation (1997) had her family"s fingerprints displayed out of reach behind wire-mesh in the lit apetures of a panelled chamber.

LEFT Three pieces by Richard Deacon which were on show at the Lisson Galley May-July 1995.

1964 Mark Boyle and Joan Hills worked on bomb-sites, throwing plastic frames across derelict areas to discover 'a kind of alternative London where people could be free'; and Gustav Metzger, who had published his 'autodestructive manifesto', held his Destruction of Art Symposium in 1966, which set itself against a society based on the 'production, the selling and maintaining of systems of mass-murder'.

Optimism waned as the 60s drew to a close. The Mods had metamorphosed from Beats to lingering Teds and the Rockers were soon known as Hippies. Heroin-high, Bob Dylan slurred at the Royal Albert Hall to boos and catcalls from the audience and the occupations of colleges in Hornsey and Guilford in the spring and summer of 1968 in an attempt to emulate the political upheavals abroad were soon realised to be futile. Richard Hamilton encapsulated the fading hedonism with his world-renowned image *Swinging London 67* of Mick Jagger and Robert Frazer, handcuffed during their celebrated momentary drug-bust.

By 1968 Lucy Lippard and John Chandler had written about the dematerialisation of the art object and performance artists were growing in numbers, inspired largely by

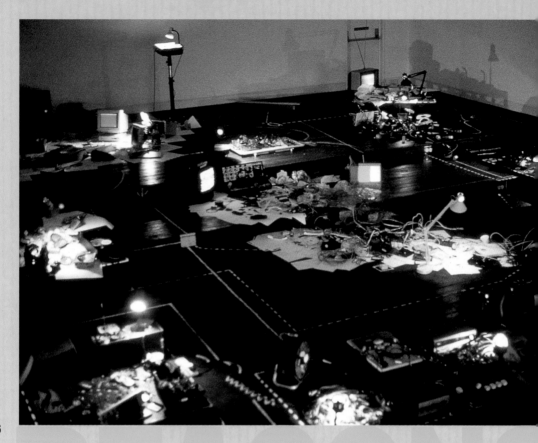

BEACONSFIELD

RUDE MECHANIC
a visualisation of sound in four parts

Panasonic
David Crawforth & Hayley Newman

9 November – 7 December 1996 Thursday – Sunday 12noon – 6pm
£3 project membership with catalogue (valid 7 November – 7 December)
7 November Launch Event with Paul Thomas and squarepusher

guest live inputs programmed as follows

14 – 17 November Jungle Disintegration
14 November squarepusher/Robert Ellis
15 November Koan
16 November Paul Thomas
16 November Alison Goldfrapp
17 November Jimi Tenor

21 – 24 November Pentecostal
21 November Pentecostal Choir
21 – 24 November Tiina Hazikowski
22 November David Cunningham
23 November Robert Ellis
24 November Put Put

28 November – 1 December Analogic
28 November Simon Fisher-Turner
29 November Simon Fisher-Turner/Susan Stenger
30 November Scanner
1 December Bruce Gilbert

5 – 7 December Cubical
5 December open access for Cubase freaks
6 December Kaffe Matthews
7 December David Gilchrist

7 DECEMBER PANASONIC IN CONCERT WITH RUDE MECHANIC
tickets in advance £5 (including £3 membership) limited numbers. 8pm

Beaconsfield, Newport Street, Vauxhall, London SE11
tel:+44 (0) 171 582 6465, fax:+44 (0) 171 582 6486
e-mail: beaconsfield@easynet.co.uk

please note that project membership is essential for entrance

BEACONSFIELD

Tomoko Takahashi

14 nov – 14 dec 1997
fri – sun 12 – 6pm

...iew wed 12 nov 6 – 9pm

...ic by Neill Quinton

...field Newport Street Vauxhall London SE11 6A...
t. 0171 582 6465 t. 0171 582 6486
e. beaconsfield@easynet.co.uk

Beaconsfield is financially assisted by the London Arts Board

BEACONSFIELD

RAX

14 September – 13 October 1996
Wednesday – Sunday 12-6pm

Eija-Liisa Ahtila

Andy Best & Merja Puustinen

Pia Lindman

Pekka Niskanen

Roi Vaara

Preview 13 September 6-9pm

...ember · performances from Roi Vaara and Pia Lindman
...tober & 6 October · performance by Pia Lindman at 3pm
...gallery talk by Taru Mäkelä (director of MUU) at 3.30pm

...field, Newport Street, Vauxhall, London SE11
...0) 171 582 6465. Fax: +44 (0) 171 582 6486
...mail: beaconsfield@easynet.co.uk

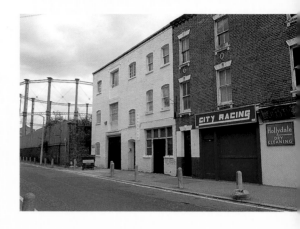

FIELD

FAR LEFT An installation at the Beaconsfield Gallery in Vauxhall by Japanese artist Tomoko Takahashi.

ABOVE RIGHT The front aspect of the Gasworks Gallery in Vauxhall Street in South East London.

Henry Marcuse's advocacy of turning the body into 'an instrument of pleasure rather than labour' and Gilles Deleuze's encouragement to release the body from traditions encoded in physical behaviour.

ARTIST-RUN SPACES TODAY

Many of the performance works in London today still happen in or around artist-run and alternative spaces. Self-promotion is not a new idea – Gustave Courbet was organising his own shows in the 19th century – and this do-it-yourself approach has resulted in significant art venues such as the Adam Gallery, the Cabinet Gallery, Curtain Road Arts and the former betting shop City Racing based in the Oval in South London.

Cubitt Gallery is a partnership between exhibitors and artists, who together select work for the gallery. Found below labyrinthine studios near King's Cross, this is just one venue where the curator of a large museum is successfully side-stepped by curator/artist groups (such as Rear Window and the anonymous BANK) to subvert the traditional curatorial process and give rise to refreshing new insights into artwork.

The Beaconsfield artist-run gallery in Vauxhall shines out from the rest. Established in 1995 by a curatorial group formerly known as Nose Paint, its experimental and relaxed ethos enables artists to bridge the gap between the studio and the commercial. The gallery recently exhibited Tomoko Takahashi, who spent some five weeks installing her show, which was immediately snapped up by Charles Saatchi. She is now represented by the discerning Paul Hodge of the Deptford-based Hales Gallery, whose café funds many of the shows. Other gallery spaces attached to studios include the Tannery, a unique

ABOVE Sound performance artist Hayley Newman at an event staged at the artist-run Beaconsfield gallery.

CITY RACING

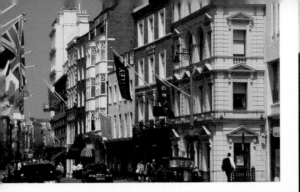

unconverted Victorian factory complex south of the River Thames, and 30 Underwood Street Gallery, a Victorian warehouse in Shoreditch that recently played host to a performance by Hermann Nitsch.

Many of the artists running these spaces are living and working in the East End, attracted there by relatively cheap rents. Emptying warehouses in the area have gradually been converted over the past 20 years into affordable studio spaces. Populated by around 11,000 artists – the most concentrated artistic community in Europe – the area stretches through Bethnal Green, Shoreditch, Bow, Clerkenwell and Whitechapel, where burgeoning financial institutions hang heavy over vibrant Pakistani and Indian communities.

Pioneering galleries in this area include the publicly funded Matt's Gallery. Currently in the ACME studio space in Bow, it was once part of SPACE studios, an organisation set up by Bridget Riley and Peter Sedgley in 1967 to refurbish derelict 19th-century buildings for studio spaces. Other galleries cluster in Beck Road. Interim Art is nestled in among other ACME buildings and was set up by Maureen Paley in the 80s; Factual Nonsense (FN) was a gallery run by the late Joshua Compston, whose aim was to bridge the gap between art, advertising and manufacturing. His art market 'Fête Worse than Death!' in Hoxton Square drew many artists, who exchanged artwork and generally wallowed in bohemia. London Electronic Arts in Hoxton Square has been offering artists the means to make art using video and film since 1976. Its recent move to a 30,000-square-foot building encapsulates the most exciting 90s developments in contemporary art of video and new media art.

Clerkenwell was the location for the 1998 Christie's auction of recent work by British artists. Staged in a 51,000-square-foot ex-brewery, Berry House, a Damien Hirst

TOP LEFT Shops, auction rooms and art galleries dominate the landscape in the Bond Street area.

ABOVE Richard Wilson's '20:50 sump-oil' installation in its original location at Matt's Gallery, now relocated to the Saatchi.

RIGHT Cover of the July-August '98 programme of events at the London Electronic Arts' LUX Centre.

The Lux Centre
2-4 Hoxton Square
London N1

CENTRE FOR FILM, VIDEO + NEW MEDIA

July - August 1998

INFORMATION: 0171 684 0200 · BOX OFFICE: 0171 684 0201

6

DANDY DUST [12-13] · JACK SMITH'S **SECRET FLIX** [10]
GILLIAN WEARING'S PULSE [11] · **WILLIAM BURROUGHS** [8-9]
THE CREATURES [14] · café + wine bar opening at the Lux!

CREATURES OF THE NIGHT

The Lux

medicine cabinet (entitled 'God') sold for £188,500. The auction houses are highly competitive; both Christie's in St James's and Sotheby's in New Bond Street have, until recently, matched each other in their ferocity, with Philips and Bonhams taking more of an interest in antiques than contemporary art.

A CULTURALLY DIVERSE CAPITAL

London's variety in galleries and events is matched by its cultural diversity. In 1988, Brixton's 198 Gallery was set up as a 'black' arts venue, offering room for artists who felt excluded from the mainstream. Having featured artists such as Eugene Palmer, Hassan Aliyu and Faisal Abdu'Allah – who once transformed the gallery into a barber's shop – the gallery, in a less restrictive climate, now supports the careers of younger artists from all backgrounds.

Other more diverse spaces include Gasworks (which mainly exhibits new UK artists), the October Gallery and the Eastern Art Gallery, specialist in contemporary Chinese brush paintings. Funding organisations such as the Institute for International Visual Arts (InIVA) have meant more formalised activities and the 1998 show of the pioneering 60s Caribbean Aubrey Williams, at the Whitechapel Art Gallery, is an example of one of the few institutional solo shows in London of black artists. The London-based African and Asian Visual Arts Archive and the Panchayat South Asian Arts Archive, which are now part of college libraries, guaranteed better-informed debate in the climate of post-colonial discourse of the 80s and 90s. The Hayward Gallery's 'The Other Story' exhibition in 1989 was a watershed in reflecting cultural perspectives in art, as were shows by artists such as Sonia Boyce, Keith Piper, Rasheed Araeen and Chris Ofili, whose blaxploitation-style colourful paintings, using elephant dung, won him the 1998 Turner prize.

Clement Greenberg and Michael Fried were American critics whose writings greatly influenced post-war art movements in London. Though there were home-grown writers such as Herbert Read, the impact from across the Atlantic was such that Greenberg was flown into London by the Kasmin Gallery and Lawrence Alloway left for New York.

RIGHT A 1997 installation piece at the Gasworks by Ian Vail entitled 'Forked Lightning and an Outbreak of Goose Pimples.'

BELOW The 198 Gallery in Brixton, which started as a specifically 'black' project but is now culturally diverse.

BOTTOM 'The Other Story', the ground-breaking show at the Hayward Gallery staged in 1989.

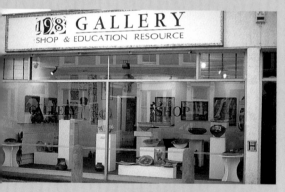

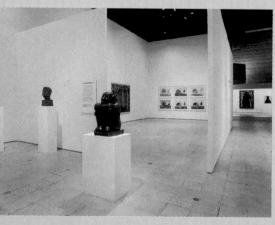

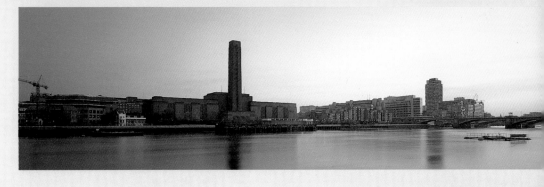

Unlike in the 60s, frenetic art production in London is today paralleled by local critique. The professional critic can be found in most broadsheet and tabloid newspapers, but few command as much respect and influence as the *Guardian*'s perspicacious Adrian Searle or the authoritative Richard Cork of *The Times*. A browse of *Time Out* magazine's Art section will supply sound-bite reviews of current shows, but in-depth interpretations can be found in *Art Monthly* or *frieze* and the artist-led magazines *Everything* and *Untitled*.

The degree to which critics themselves can become the focus of criticism was revealed in 1994 when the populist *London Evening Standard* critic Brian Sewell was vilified by the 35 artists and gallerists for his 'homophobia, misogyny and hostility to contemporary art' in a letter to the paper, which ultimately was most revealing of the artworld's desire for censorship and control of its own image.

Such vitriol will not be found in the listing magazines *Galleries* or *Exhibition* fold-out freebies, though they will clarify any gallery trip to the metropolis. But there are, of course, many other events at various times of the year. Art fairs, degree shows, talks and auctions are happening all the time. There are also artist interventions. Rachel Whiteread's cast of a Victorian terraced house in Grove Road ended with its destruction amid great furor and won her the Tate Gallery Turner prize for the best exhibition.

As the current millennium approaches, art in London is reflecting the ambivalence felt by the artists and galleries of the new generation. Like their predecessors, artists proclaim no interest in emulating artists that went before. Yet this time their proclamations are tinged with a scepticism that holds no counterbalancing desire for change.

TOP The Bankside power station in Southwark, site of the new annex to the Tate Gallery.

ABOVE Art buying of a different kind in the outdoor 'railings' market on London's Piccadilly.

In spite of this, change is inevitable: a new government pledges a commitment to free entry to museums by the year 2000 and the restoration and development of the Serpentine Gallery and the new Tate Gallery at Bankside are concrete examples of the continued expansion of the cultural city. The value in renovating old buildings for galleries only exists, however, as long as there is art to inspire. As Hockney once remarked, 'If we are to change our world view, images have to change. The artist now has a very important job to do.'

RIGHT The eminent art critic and writer Herbert Read at a 'Forty Years of Art' exhibition in 1948.

BELOW Rachel Whiteread's controversial 'House' piece constructed from October '93 to January '94.

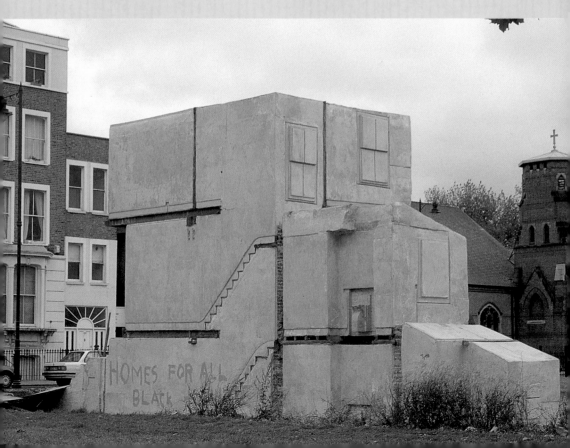

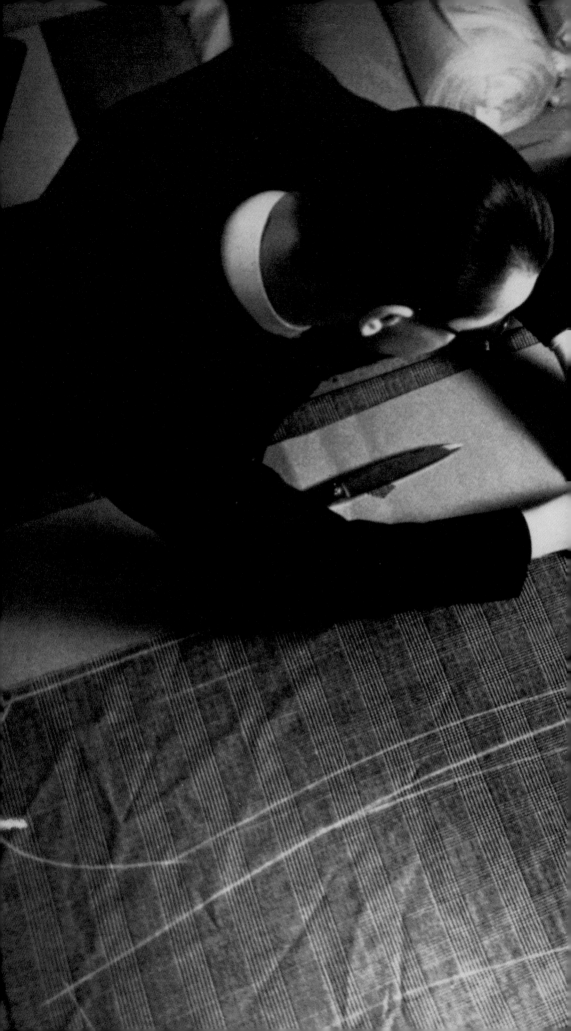

Text: Jessica Stein

FASHION

The home of London's most famous and prestigious name in men's clothing – Savile Row. For years, immense care has been taken over the manufacture of the Savile Row suits. Here a tailor from the 1930s is hard at work on a jacket.

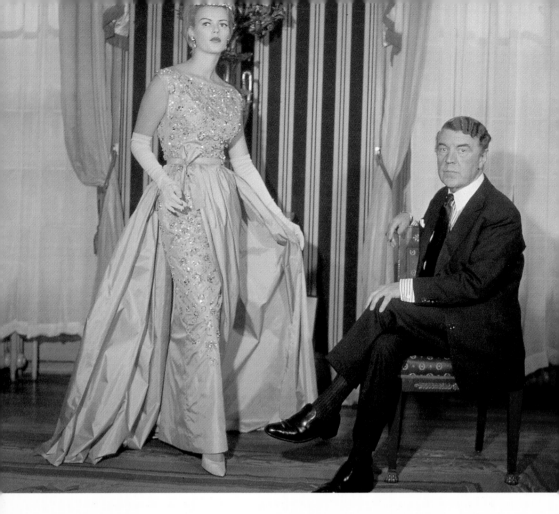

From Aquascutum to YMC, fashion in London is a fusion of historic tradition and directional modernity. Until the First World War, when the rigidity of the British class system became blurred, high fashion had always been centred around the monarchy and its social circle. Linked closely with Paris until the Second World War, court dressmakers had looked across the Channel for design inspiration, ever since their establishment in the 18th century. Now Paris looks to London, with former art school Central St Martin's stars John Galliano and Alexander McQueen heading their couture houses. Also known for producing the finest tailoring in the world and being the leader in street trends, London is indeed the premier fashion capital.

FASHION

THE MONARCHY AND LONDON COUTURE

Until the 1950s, the upper echelon of London society dressed according to the social scene. Couturiers naturally prospered from occasions such as the Chelsea Flower Show and Queen Elizabeth II's coronation celebrations (Norman Hartnell designed her dress), and for all the big names – Lucile, Peter Russell, Victor Stiebel, Molyneux, Digby Morton and Sir Hardy Amies – the Debutante season, which dates back to Queen Victoria's day, was important.

The man who actually invented couture, in 1858, was Londoner Charles Frederick Worth. He forged his career as an apprentice in the London drapery trade before moving to Paris to establish himself. From that time onwards, London's dressmakers, based in the West End, looked to Worth for the latest trends in crinolines, S-bend corsets and hobble skirts. These creations would be modelled in *Vogue* by society women such as Lady Diana Cooper, who were the supermodels of the early 20th century.

LEFT Norman Hartnell, couturier to the royals, with one of his models.

ABOVE RIGHT Modelling a dress by Lucile at a fashion show held at the Hyde Park Hotel, 1920.

RIGHT A 1913 dress by designer Charles Worth, the father of couture.

Before the restrictions of the First World War, London's dressmakers were patronised by the hedonistic Edwardians, who spent their money freely on clothes. The Prince of Wales, a trendsetter in his own right (he set the vogue for Fair Isle sweaters), was the embodiment of such liberal, although exclusive, gaiety.

For the middle classes, clothes that were worn by the upper classes were adapted on a less grand scale by modest dressmakers. For the working classes, women made their own clothes – known as tailor-mades – which were

ABOVE John Galliano took over as head designer at Christian Dior in 1997 and launched one of Dior's highly successful collections. The look was one which combined old with new and European with Oriental.

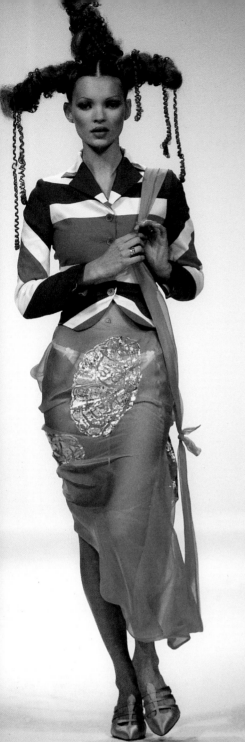

practical for work. Men had one suit, which they wore on weekends.

In 1906, London's first so-called fashion school opened. However, it was not centred around design, instead it was to service the wholesale trade based in the East End. It was not until 1948, with the arrival of the fashion school at the Royal College of Art, that the pivotal change in fashion design – a move away from couture – came about. London's art schools are, with good reason, known to be the best in the world. Former Central St Martin's students are now leading the way in the top Paris couture houses. Galliano is positively shining at Dior with his unique sense of theatrical style and original use of colour; McQueen has turned Givenchy on its head with his idiosyncratic sense of modernity (often bordering on the bizarre); and Stella McCartney has done away with the former, rather tired, Chloe, reinventing her as a sexy, fun-loving babe.

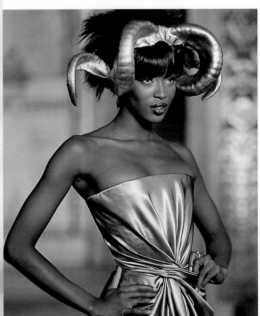

ABOVE Kate Moss models Galliano's own collection – spring/summer '93. Red, white and blue was a celebrated feature on the catwalks in the 1990s.

ABOVE RIGHT Naomi Campbell in McQueen's weird and wonderful range for Givenchy.

RIGHT Stella McCartney's creations revamped the house of Chloe and were an instant success.

McQUEEN

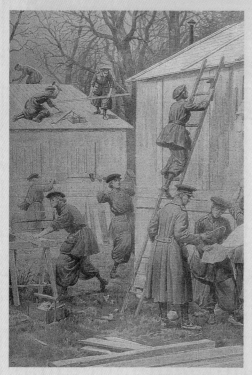

With the First World War came a new-found independence for women. For the first time they experienced the freedom to wear trousers and – for the upper-middle classes – the empowerment of paid work. This was reflected afterwards in the Flapper era, when women adopted short skirts and wild abandon. Department stores paid keen attention to these trends, in preparation for the time when the financial shortages of the war would come to an end.

In the 1920s Selfridge's opened its highly successful bargain basement, which catered to those with few financial resources – in post-war London only the upper classes had money to spend on clothing. Selfridge's was also the first store to cater to teenagers when it opened Miss Selfridge in the 1960s, which today, alongside Top Shop, Oasis and Warehouse, is a leader in interpreting catwalk trends for the masses.

ABOVE During WWI, women could finally wear clothes that were comfortable and practical. Women soldiers doing carpentry work, 1917.

RIGHT Early on in the century, the suffragettes suffered much humiliation and intolerance in order to further their cause.

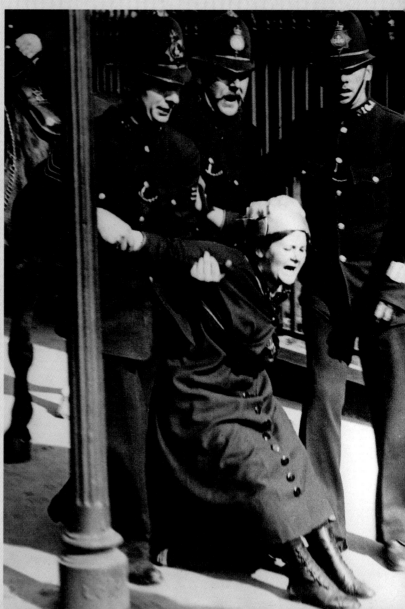

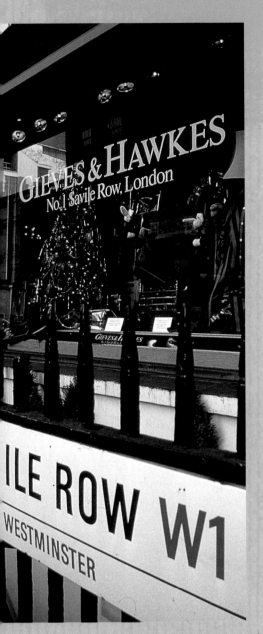

Marks & Spencer opened in the 1930s, introducing what it still does so well today: good-quality middle-of-the-range clothing. However, to give the company 'designer kudos' in the 90s, it has employed leading London visionaries such as Tania Serne of Ghost and Paul Smith as consultants.

For as long as there is a monarchy and people with money, the elitist world of couture will continue to live on. The late Diana, Princess of Wales, was an international fashion icon, breathing a whole new lease of life into London couture. Her famous wedding dress, designed by the Emmanuels in 1981, was a romantic reinvention of a Worth/Hartnell crinoline gown. She wore clothes by Bruce Oldfield, Jasper Conran and Amanda Wakeley, but patronised in particular Catherine Walker.

SAVILE ROW

Renowned for the world's best tailors, everyone from Madonna and the late Gianni Versace to Japanese businessmen have come to London for a touch of bespoke magic.

Today Savile Row, its adjacent pinstripe strip Jermyn Street and established names such as Hardy Amies, Gieves and Hawkes, Anderson and Sheppard (where McQueen learnt a trick or two) make the area as vital as when Henry Poole (he's still there) first landmarked the sharply cut area in 1846. Even though some of the new tailoring cognoscenti have branched further afield, with the witty tailor Timothy Everest sprawled over three glorious Georgian floors in Spitalfields and Charlie Allen in Islington, Savile Row still has the same elitist, luxurious allure as it did in the late 40s. Post-war men, who had no London designer equivalent to Dior's New Look, flocked to this pocket of Piccadilly for fashionable attire.

Honouring its rich culture, 90s bespokers such as Ozwald Boateng turn traditional codes of craftsmanship on their head – Boateng uses shocking colours and tailoring tricks such as hidden buttons. The same wit applies to Richard James, perhaps now the

Savile Row favourite, as he appears to be the tailor of choice of UK pop stars from Liam Gallagher to Elton John. James is the 90s equivalent of Tommy Nutter, who opened in Savile Row in 1969 and positively revolutionised tailoring with his modern and glamorous approach – he made John Lennon and Yoko Ono's white wedding suits.

At the same time as the 'Nutter revolution', Rupert Lycett Green, designer and owner of Blades (which is still there), started fusing more bohemian, Eastern styles with traditional London tailoring. Favourbrook pay homage to his inventiveness today by offering Nehru-collared jackets.

BELOW Teddy Boys in North London – 'hanging out' in the street, 1956.

BOTTOM Selfridges puts on a show to present the latest in Utility clothing, 1945.

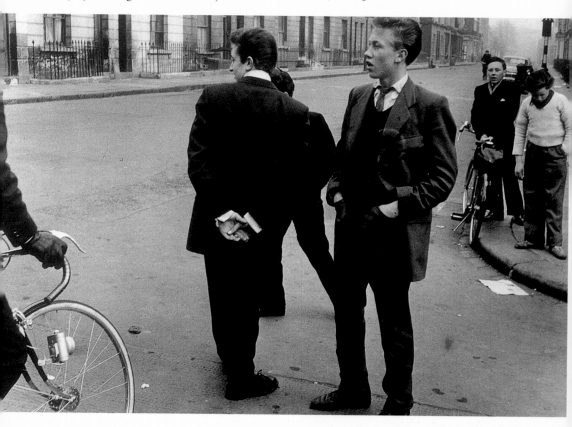

Nowadays, most London tailors offer bespoke suits for women as well as men, plus a range of off-the-rack suits. Paul Smith was a key player in turning the off-the-rack suit into a highly sought fashion item. With his modern take on tradition, use of fine fabrics and expertise in the cutting department, his suits carry the same kudos as a Savile Row bespoke. Some 20-odd years after opening his first London shop, he now offers bespoke tailoring on the top floor of his latest venture, Westbourne House in Notting Hill Gate.

Fashion for men before the 1950s was limited. The defining London sub-culture,

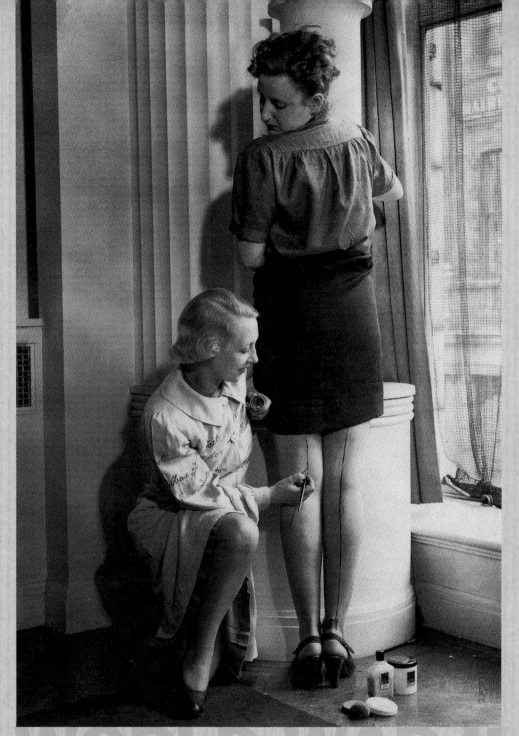

WORLD WAR II

the Teddy Boy – an East End spin on
Savile Row tailoring then coined 'the New
Edwardians' – began the gradual relaxation
of the strict dress codes that went before. The
Teddy Boy along with the emergence of the
'Teenager' in America and the 'Beatnik' in
Paris, pioneered what was to become the
changing face of fashion.

MARY QUANT

The dawning of a new age in fashion had
been on the cards in London since the end of
the Second World War. With the war came a

cut-off period from Paris and inevitable shortages and clothes rationing, and London for the first time was truly forced to use its own design talents. Digby Morton, Norman Hartnell and Victor Stiebel designed CC41 (Civilian Clothing 41), otherwise known as Utility wear. As the war ended, so in theory did London's strict dress codes and with that the rigid class structure. Although couture still lived on, at this time replicating versions of Dior's New Look for those who could afford it, younger generations thought this way of dressing was outmoded.

The Debutante era came to a close in the late 1950s and London's couturiers began to design for department stores such as Debenhams. With the quality of mass-produced clothes in London reaching a high standard, thanks to the turnover of Utility clothing, and with London's art schools producing a bunch of radical young designers, the Edwardian way of being seemed even more antiquated than it had after the First World War.

Mary Quant and her husband, Alexander Plunket Green, opened their boutique (the first of its kind) on the King's Road in 1955. Without question Mary Quant, with her intuitive design sensibilities – she was the first person to use fabrics such as PVC – opened the door for other like-minded, mainly art students, to change the face of fashion. Her miniskirt of 1965 was revolutionary and of its time, unlike the short skirts of the Flapper in the 1920s, which appeared to shock. Quant – with her Vidal Sassoon bob and her miniskirt – would have a lasting and classless effect, unlike the Flapper fashion, which came and went.

Alongside Mary Quant the 60s revolutionaries comprised Jean Muir, Sally Tuffin, Marion Foale, Alice Pollock's Quorum, John Stephen, the Fulham Road

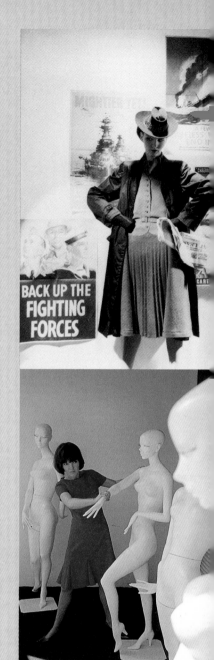

ABOVE Mary Quant, who invented the ubiquitous miniskirt during the '60s.

TOP Photographer Lee Miller captures the combination of war and fashion.

RIGHT Christian Dior's New Look became a phenomenal success after the strict dress code of war.

THE NEW LOOK

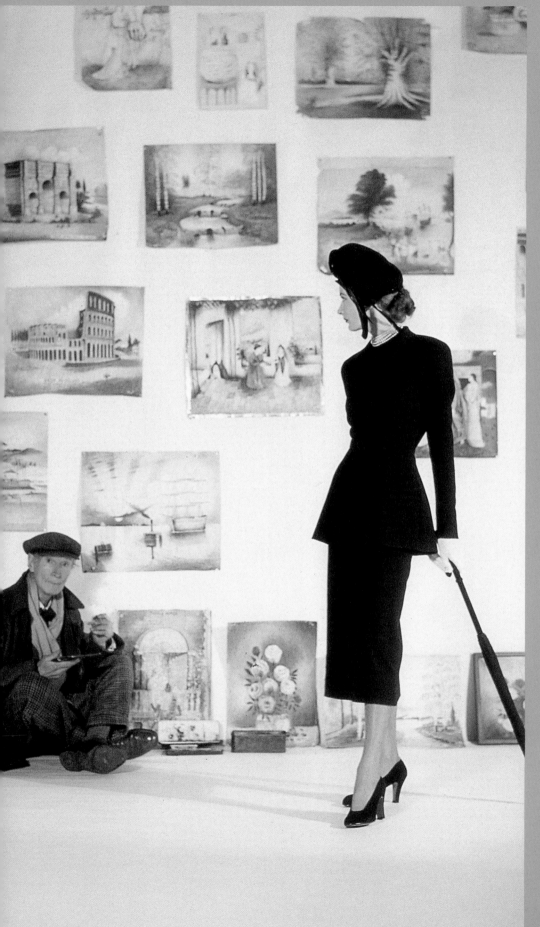

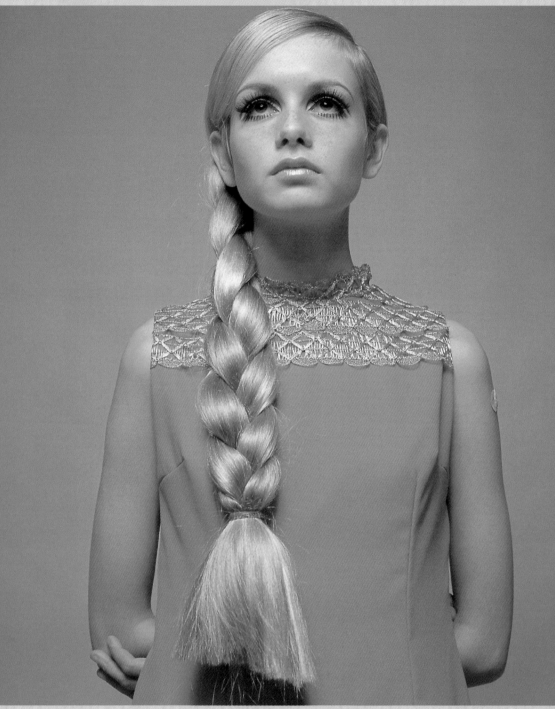

ABOVE The face of the 1960s – Twiggy's wide-eyed, skinny look was what millions of girls aspired to in this decade.

RIGHT Swinging London was home to many trendy areas including the fashionable Carnaby Street.

Clothes Shop run by Zandra Rhodes and
Sylvia Ayton, Barbara Hulanicki's Biba,
Mr Fish and Ossie Clark.

London was the mecca of cool, swinging
with chic boutiques scattered along the King's
Road and Carnaby Street, populated by hip
musicians such as The Rolling Stones, The
Beatles and their girlfriends – Marianne
Faithfull, Anita Pallenberg, Jane Asher –
and hip photographers such as David Bailey
and his beautiful model girlfriend Jean
Shrimpton. Dressing based on gender was
gone, as Mick Jagger proved when he went
on stage wearing a white mini-dress over
trousers. Mods and Rockers took the place of
Teddy Boys and Jean Shrimpton and Twiggy
forged the cult of the supermodel. Twiggy, in
particular, was the face of the 60s, pioneering
the way for the waif-like models of the 90s,
such as Kate Moss.

There are echoes of the swinging decade
in the way London is now. In the 60s the
Labour government was in power with
Harold Wilson in the driving seat; now the
popular culture-loving Tony Blair holds
Downing Street's reins. With *Vanity Fair*
putting celebrity couple Liam Gallagher and
Patsy Kensit on the cover, London is truly
being hailed as the swinging city once again.

Like Quant and her contemporaries,
today's new breed of cutting-edge fashion
designers – Antonio Baradi, Owen Gaster,
Alexander McQueen, Hussein Chalayan,
Clements Ribero and Pearce Fionda – are
all art school luminaries. London's bi-annual
fashion week is a must for all fashion editors
and buyers. And with the recent launch of
Menswear Week, the international fashion
desks will be emptier than ever.

Fashion and music are currently fusing,
just as they originally did in the 60s. Pop stars
such as Jarvis Cocker, Damon Albarn, Oasis
and The Spice Girls are all fashion icons of
the 90s. The Spice Girls are in fact not unlike
The Beatles (who when not shopping in
London's chic boutiques went to meet the
Maharishi), as they pop off to meet Nelson
Mandela in between placing orders in Gucci.

With the current boutique revival in Pont
Street, where Rachel Riley, Liza Bruce and
Agent Provocateur (the pop star Louise shops
for her matching bras and panties here) are
based, together with Brompton Cross's Tokio
and the King's Road's Mimi's, the Chelsea girl

BELOW Justine de
Villeneuve photographs
girlfriend Twiggy, 1973.

BOTTOM Designer Ossie
Clark, with model, working
on one of his creations.

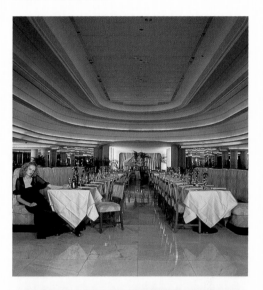

is indeed alive once more. The 60s trend of
fusing second-hand clothes with the new is
once again enjoying a heyday. A rummage
through the Portobello market is as popular
among the new wave of aristocrat models,
such as Iris Palmer and Stella Tennant, as
it is for tourists by the dozen.

VIVIENNE WESTWOOD AND PUNK

The most influential sub-culture to
emerge out of London was punk. Nineteen
seventy-six was the year that angst-ridden
unemployed kids took their frustration
out on society through a style of music and
fashion which aimed to shock. Dresses made
from black plastic garbage bags, slashed jeans,
neon-scuzzy knitted mohair sweaters and
safety-pin jewellery adorned the spiky-haired
anarchists who hung around the King's Road.

The Sex Pistols were the band of the
moment and Malcolm McLaren was their
manager. He and Vivienne Westwood were
an item at the time and the Pistols hung out
in their King's Road shop, Sex, later called
Seditionaries: Clothes for Heroes. The Pistols
were invariably the best-dressed punks on the
block, as Westwood kitted them out in her
now-famous bondage trousers and other
stylish punk attire.

By the end of the 70s, punk's unique
style had, like all street trends, become
widespread, which was thanks partly to
Zandra Rhodes, who elevated the look to

LEFT The unique,
aristocratic British model
Stella Tennant, 1997.

RIGHT Vivienne Westwood
and Malcolm McLaren – the
pioneers of punk.

VIVIEN
& MALC

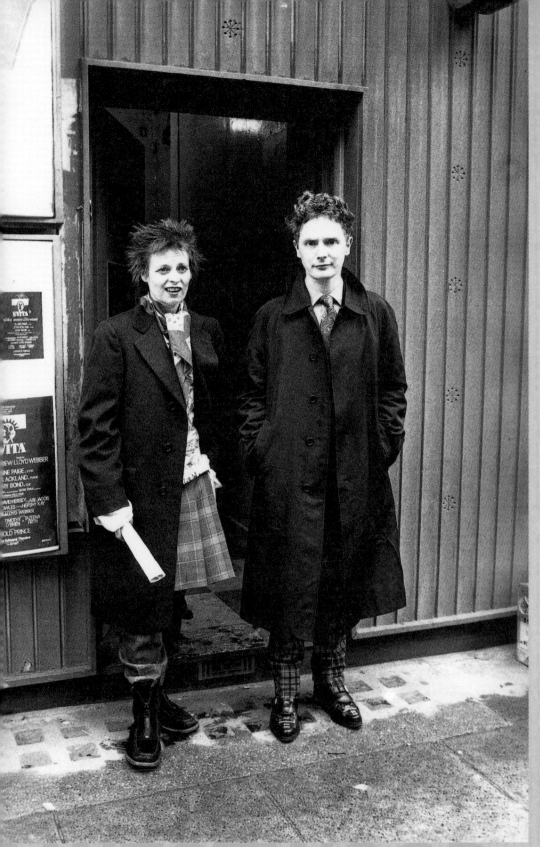

WESTWOOD
MCLAREN

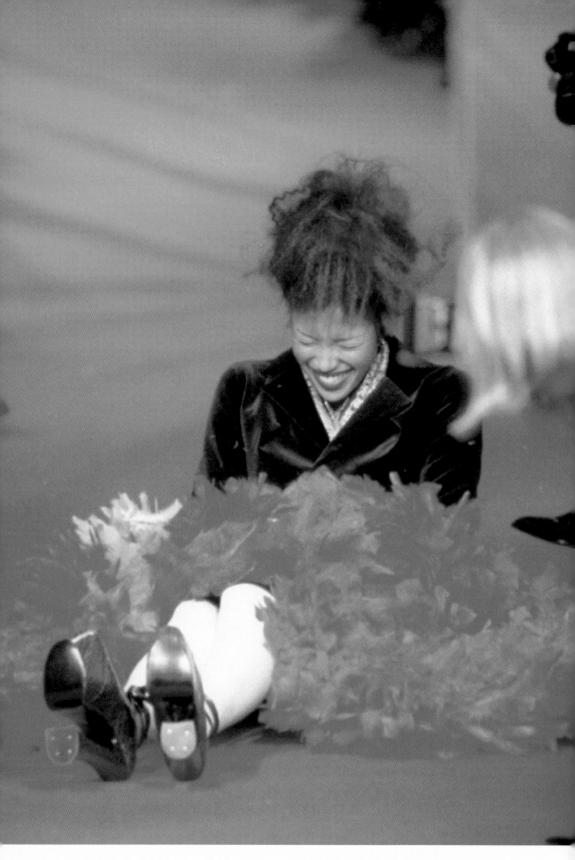

ABOVE Naomi Campbell
shows her sense of humour
as she famously falls in her
platforms at a Westwood
fashion show.

RIGHT Zandra Rhodes
provided another take on
the punk theme.

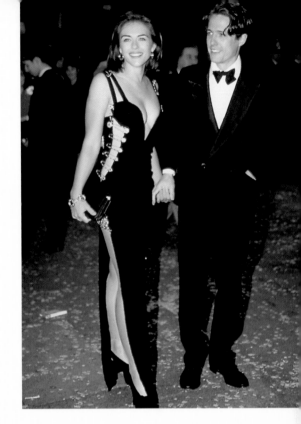

RIGHT Actress Elizabeth Hurley with boyfriend Hugh Grant in her infamous Versace safety-pin dress.

high fashion. Nineteen ninety-four saw a punk revival when Liz Hurley stepped out in Versace's now-famous safety-pin dress.

Aside from her influential alignment with punk, Westwood has been consistent in using London street culture to reinvent Britain's rich fashion traditions – teatime, school uniforms and fabrics such as Harris Tweed have all featured in her collections since she began designing under her own name in 83. Alongside Galliano, her love of theatre and masterful use of tailoring has continued to be applied to her unique collections under her three labels, Gold, Red and Man. Her platform shoes – which Naomi Campbell fell off during one of Westwood's triumphant Prêt-à-Porter shows in Paris – her buxom corsets, mini-crini and, of course, bondage trousers have all helped to render her one of the greatest fashion designers of all time.

ENGLISH ECCENTRICS

By the late 1970s other important London designers were starting to emerge. The political Katherine Hamnett – known for

slogan T-shirts such as the nuclear disarmament inspired 'Stay Alive in 85', and her sexy, sparkly, glamorous little show-girl dresses – Helen Storey, John Richmond, Scott Crolla, John Galliano, Jasper Conran and Joseph all played a significant part in London's fashion tapestry during the Thatcher years.

London's street culture continued to carve its signature upon mainstream trends. From the Edwardian revival in the 80s with the frilly shirts of the New Romantics to the smiley-faced T-shirts and no-fashion, fashion dungarees of Acid House, the city's pavestones have been a must for designers such as Gaultier (who checks into London couturier Anouska Hempel's Blakes Hotel) searching for inspiration.

Taking trends to the next level, today's hip up-and-coming designers, when not inconspicuously hidden in places like Berwick Street (Vexed Generation), are bought up by Browns' directional boutique in South Molton Street, Browns' Focus. The clever urban label YMC hangs alongside Vivienne Westwood's Red Label and Hysteric Glamour. Hype, formerly known as Hyper Hyper, in Kensington High Street has always supported the new and unexploited. It now has a rival with the launch of America's Urban Outfitters, who are also promoting the best of London's cutting-edge talent.

In the 1980s when chic Londoners couldn't get enough of hip Japanese designers such as Comme des Garçons and Issey Miyake, the Japanese were coming to London by the planeload. The older generations were buying up what they could from Aquascutum and Burberry, both founded in the early 1850s, and the younger generation were picking up what they could from Vivienne Westwood and Paul Smith.

In the late 80s Patrick Cox's shop in Sloane Square became a serious destination – his 'Wannabe' loafer was a status symbol, much like a velvet-trimmed Voyage dress is today, if you can get into the Fulham Road shop to buy one (you need a membership card).

Manolo Blahnik has been enjoying an ongoing success as the godfather of footwear since he opened his Chelsea shop in 1971. His divine shoes have undoubtedly become an international indulgence for all those who

ABOVE Shoes by Emma Hope, one of the leading British shoe designers to be seen in London today.

ABOVE A new style of shopping – you have to produce an exclusive membership card to shop at Voyage.

LEFT Katherine Hamnett models one of her message T-shirts.

ATHERINE HAMNETT

GIBSON

appreciate luxury and glamour. And his inherent style has been an inspiration to other London shoemakers, Johnny Moke, Emma Hope and Jimmy Choo.

For over a decade, Joseph's clever talent for buying just the right designers' clothes at the right time, as well as designing just what you want to wear – trendy silver reflective trousers, velvet pinstripe overcoats – have turned his shops on the Brompton Cross, Sloane Street and Old Bond Street into fashion meccas. Department stores, such as Harrods, Harvey Nichols and Liberty's, have always housed designer talent. Founded in 1875, Liberty's, however, holds a reputation for being slightly more ethnic and cutting-edge, promoting textile-orientated designers in the 60s such as Thea Porter and Bill Gibb and now stocking Elspeth Gibson and YMC.

Fashionable Londoners utilise the city's eclectic mix of styles to create the perfect look for the late 90s. The look consists of the right balance of designer clothes mixed with pieces from the high street and clever vintage finds. Coupled with the unique, often eccentric, London way of throwing things together, here you'll find a style that is envied and copied all over the world.

With its abundance of influential designers, superior craftsmanship, rich historical tradition, excellent art schools and innovative street styles, it's no wonder London is the modern-day centre of fashion.

LEFT From the 1998 Autumn/Winter collection by contemporary designer Elspeth Gibson.

RIGHT Alexander McQueen made an impact with these wide trousers at the 1998 Givenchy Spring/Summer collection.

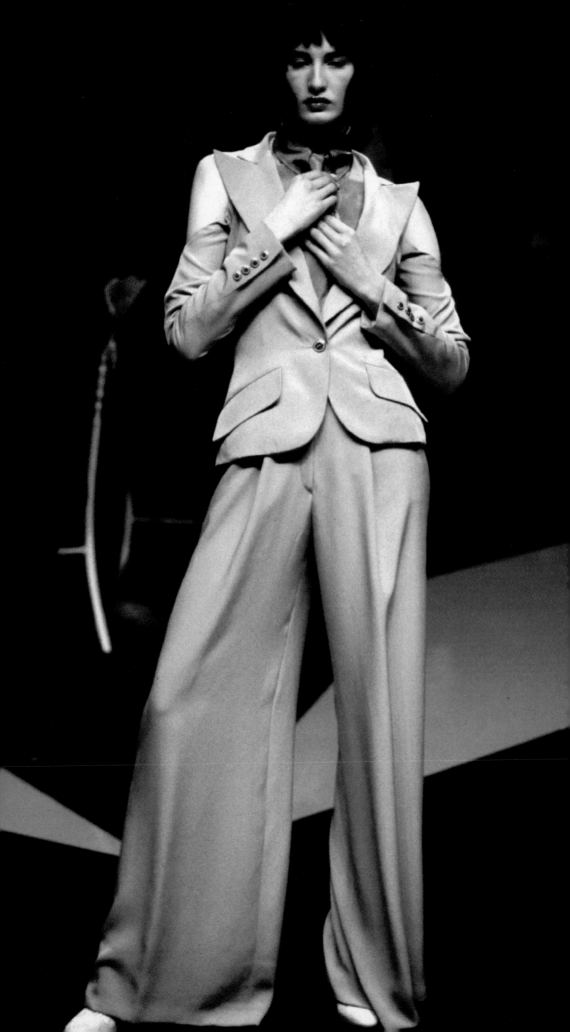

FESTIVALS

London life is a rich tapestry of traditional celebrations and modern festivals. From white-gowned Druids to the vibrant Caribbean 'mas', from state and military pageants to Chinese lion dances and firecrackers – all can be found on the streets of this cosmopolitan city.

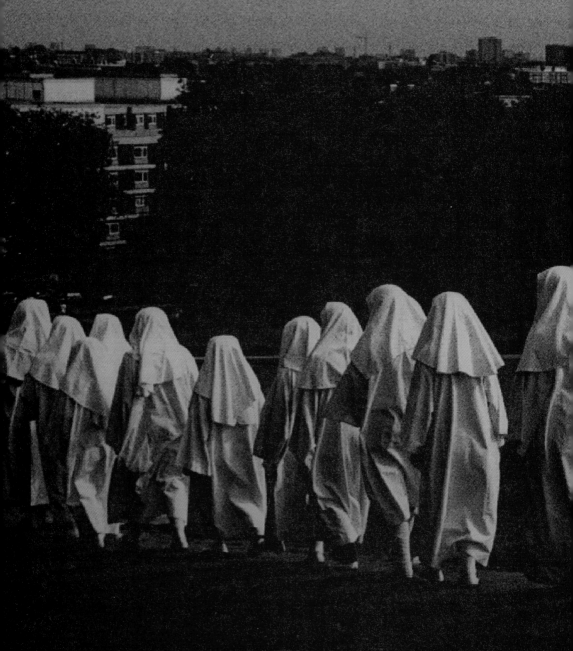

Text: Nigel Cawthorne

& RELIGION

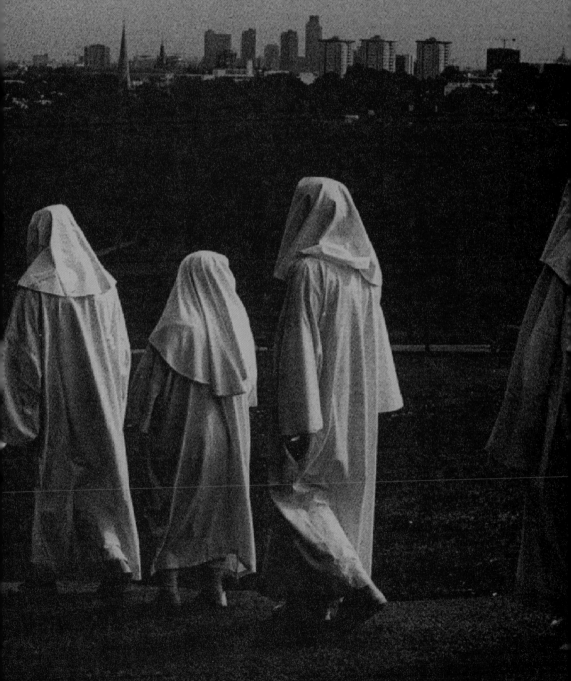

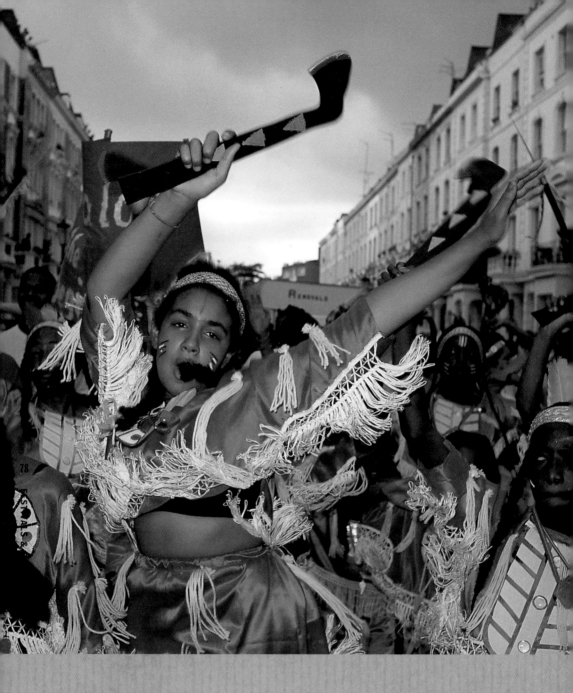

very August Bank Holiday weekend, London plays host to Europe's largest street festival. On the last weekend of August, the Notting Hill Carnival brings over two million people out onto the streets of Notting Hill in west London for a street event second only to the carnival in Rio.

FROM STREET CARNIVAL TO STATELY POMP

Begun in the 1960s by immigrants from Trinidad, the Notting Hill Carnival was a West Indian festival before transmogrifying into a truly multicultural event. Headline acts now come from Afghanistan, Bulgaria, Russia, the Philippines, Khurdistan and Bangladesh, as well as the Caribbean, Africa and Latin America.

However, the carnival retains some of its Trinidadian traditions with its 'mas' or masquerade. Competing teams in extravagant costumes parade around the streets of Notting Hill, along with steel bands and calypso artists. There are also static stages where headline artists perform. The streets are lined with stalls selling exotic food, and huge

LEFT & BELOW Revellers at the Notting Hill Carnival enjoying the extravagant costume parade. The street carnival is the second largest in the world and takes place over the August Bank Holiday weekend. This West Indian festival has become a major multicultural event.

NOTTING HILL
CARNIVAL

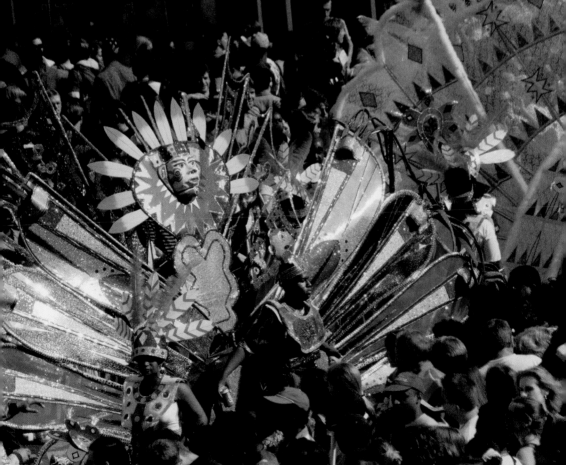

A Reminiscence of the Lord Mayor's Show.

DRAWN BY F. MATANIA

THE LITTLE PRINCES PASSING THE COUNCIL CHAMBER OF PRINCE HENRY IN FLEET STREET

Thousands of people were drawn to the City on Wednesday of last week to witness a very picturesque Lord Mayor's Show. The inclusion of a Shaksperean pageant was un-
doubtedly a popular thing, though the crowd seemed to regard the display as intended to amuse rather than to appeal to its historical sense, and took full advantage of the opportunity
for facetiousness. But whatever the point of view the pageant formed a striking series of pictures of the London of past days and the people who frequented it. That consum-
mate villain in history, Richard Duke of Gloucester, was undoubtedly the masterpiece of the pageant. He rode a tall charger and was dressed in black velvet and fur-lined
coat. On either side of him were to be seen his two small nephews, young Edward V. and the young Duke of York, mounted on their frisky ponies, ready to be led away to
the Tower and to their doom. Apart from the pageant all the familiar features of previous shows were to be seen in the procession

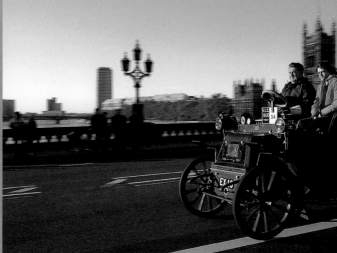

LEFT & BELOW The Lord Mayor's Show evolved in medieval times. The ornate coach was built in 1757.

RIGHT The House of Lords during the 1912 State Opening of Parliament.

OPPOSITE, BOTTOM LEFT Guide for the 1951 Festival of Britain exhibition.

OPPOSITE, BOTTOM RIGHT The London to Brighton Veteran Car Rally takes place each November.

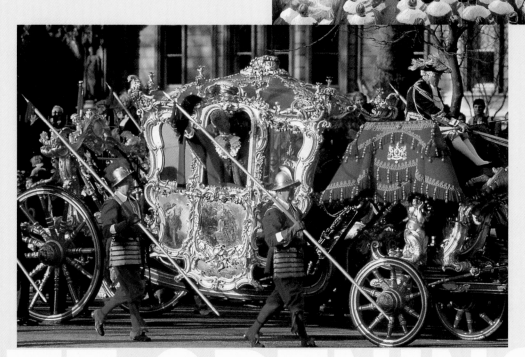

static sound systems playing jazz, soul, reggae, hip-hop, funk and soca – a fusion of soul and calypso, the traditional music of the carnival.

Contrast this with London's stately Lord Mayor's Show, which has its roots in the 13th century. On the second Saturday in November, the newly elected Lord Mayor of the City of London travels by coach in a procession to the Royal Courts of Justice in the Strand, where he is sworn in before the Lord Chief Justice and the Judges of the Queen's Bench Division.

The Lord Mayor's coach was built in 1757 and decorated with ornate panels painted by the Neo-classical master Giovanni Battista Cipriani. Pulled by six horses, it is suspended from four thick leather braces that sway back and forth precariously as it progresses. The coach weighs nearly three tons and, until 1951, had no brakes.

Traditionally, the Lord Mayor was accompanied by a procession of all the citizens of the City. Nowadays, however, the procession has a theme, such as 'Transport through the Ages', 'The World Is Our Market', 'Exports' and 'The City and the Sea'.

London is renowned for its pageants. At the beginning of each parliamentary session, the Queen travels in full regalia by coach from Buckingham Palace to the Palace of Westminster for the State Opening of Parliament, where she makes a speech in the House of Lords, outlining the government's programme for the forthcoming session. Their Lordships also turn out in their ermine-trimmed robes and coronets, making the State Opening of Parliament one of the great spectacles of the British state.

The Queen is more soberly attired at eleven o'clock on Remembrance Sunday – the

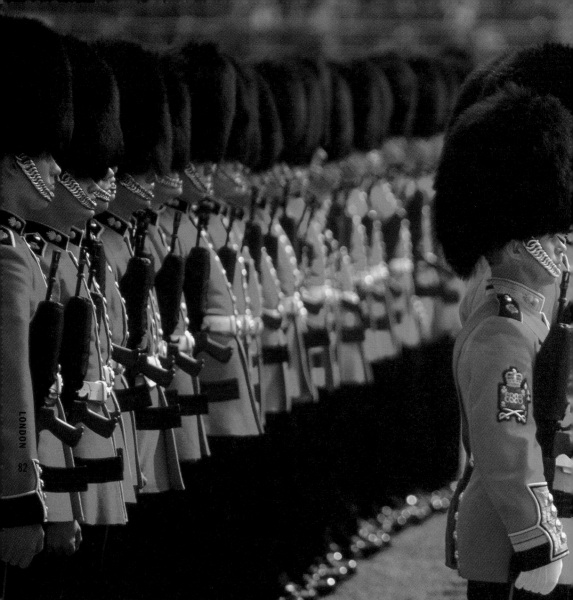

REMEMBRANCE SUNDAY

Sunday closest to 11 November, Armistice Day. This is when the Queen, other members of the Royal Family and senior politicians gather at the Cenotaph to commemorate the fallen of the two world wars. They lay wreaths and there is a march-past of veterans.

The Queen traditionally appears on horseback in the uniform of colonel-in-chief for the Trooping of the Colour, which is held in June to celebrate the sovereign's official birthday. She rides down the Mall to inspect her foot guard in Horse Guards Parade. The colour of one of the eight brigades is then trooped. Historically, the ceremony had great military significance – the brigade's flag was shown so the soldiers would recognise it and rally to it in the heat of battle.

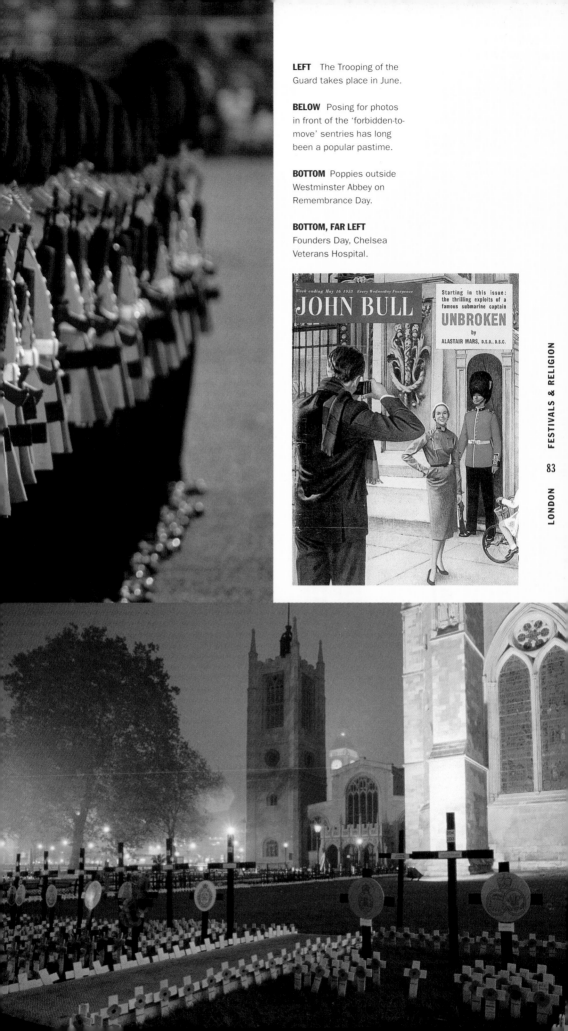

LEFT The Trooping of the Guard takes place in June.

BELOW Posing for photos in front of the 'forbidden-to-move' sentries has long been a popular pastime.

BOTTOM Poppies outside Westminster Abbey on Remembrance Day.

BOTTOM, FAR LEFT Founders Day, Chelsea Veterans Hospital.

London's most popular military pageant is the Changing of the Guards. This can usually be seen every other day in the summer at 11.30am at Buckingham Palace and at 11am at Windsor. The guards are changed daily at Horse Guards, at Tilt Yard on the Whitehall side of the Horse Guards building, at 11am Monday to Saturday and 10am on Sunday.

POPULAR PASTIMES

Another ceremony that has roots in the 18th century is the celebration of the spring and autumn equinoxes by London's Druids. The spring equinox is celebrated on Tower Hill and the autumn equinox on Primrose Hill. The hour-long ceremonies, held at noon Greenwich Mean Time, were begun in 1717 and the two sites were chosen because they were identified as megalithic mounds.

The site at Tower Hill was a traditional speakers' corner where citizens of London could come to air their grievances. It now finds itself on the roof of a McDonald's which has been installed under the arches below, and is no longer used as an open-air forum. However, Speakers' Corner at the corner of Hyde Park near Marble Arch is still in full swing on Sundays, when people with all sorts of unusual ideas find a ready audience. Interestingly, both the Speakers' Corner at Hyde Park and the one at Tower Hill are adjacent to traditional places of execution. With few exceptions, most of those imprisoned in the Tower of London were executed outside its walls on Tower Hill, while common criminals were taken by cart from Newgate Prison, now the site of the Old Bailey, to be hanged at Tyburn, which is near modern-day Marble Arch.

The celebration of Guy Fawkes' Night, 5 November, dates back to the 17th century. It commemorates the foiling of the Gunpowder

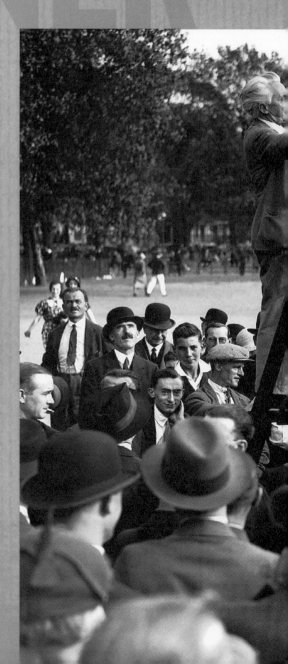

ABOVE RIGHT London's Druids celebrating the autumn equinox on Primrose Hill, the site of an ancient megalithic mound.

RIGHT Speakers' Corner at the Marble Arch end of Hyde Park has long been a popular forum for free speech. The corner is near the original site of the Tyburn execution gallows.

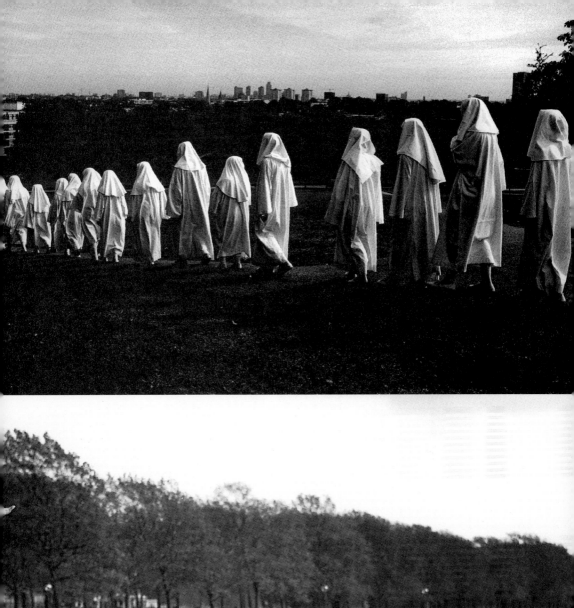
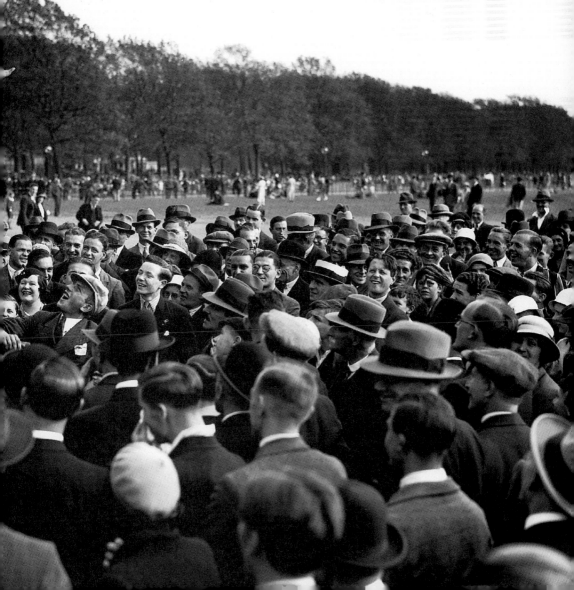

Plot. Guy Fawkes and his co-conspirators planned to blow up King James I, his queen and his eldest son in the Houses of Parliament on 5 November 1605, by filling the cellar with 20 barrels of gunpowder. In 1606, Parliament declared that there should be a celebration on 5 November each year in thanksgiving. For weeks before, children ask for 'a penny for the guy' – though they expect considerably more – to buy fireworks. Traditionally, they display an effigy of Guy Fawkes, which is burnt on a bonfire as the centrepiece of a fireworks party.

Throughout London organised fireworks displays and bonfires are set up in many of the city's parks. There is one on Primrose Hill and the City of London stages a fireworks display along the river as part of the Lord Mayor's Show celebrations.

A RELIGIOUS MELTING POT

Divali, the Hindu Festival of Light, is also celebrated with fireworks in the park, in the predominately Asian west London suburb of Southall. Sikhs celebrate Divali as the commemoration of the founding of the Golden Temple at Amritsar, the release of the sixth guru Hargobind, who had been imprisoned by the Mughal emperor Jehangir in Gwalior Fort, and the martyrdom of Bhai Mani Singh, the custodian of the Golden Temple, in 1738. For Hindus though, the festival, which usually occurs around October, marks the New Year in the Vikram system of dating. Hindu temples and Hindu homes mark the festival with lines of lanterns.

Since 1980, Chinese New Year has been celebrated in Chinatown around Gerrard Street in London's West End. Several teams of Lion Dancers perform. Firecrackers are let off and, around Leicester Square, there are performances of Chinese opera, traditional Chinese music and martial arts. Up to 100,000 people attend.

The West End Great Synagogue in Great Cumberland Place is the oldest Reformed synagogue in London. But it had a problem when it came to celebrating Sukkot, the Feast of the Tabernacles, in September or October. As it is in the densely built-up West End of London, there is no space outside to erect a sukkah, or tabernacle, as required by the Torah. The synagogue got round this by building their sukkah on the roof of the

RIGHT Lion dancers move through the streets of Chinatown during the Chinese New Year celebrations, performing their ritual dance outside homes and businesses.

BELOW Traditional Chinese opera and dancing are performed in Leicester Square as part of the New Year festivities.

BELOW RIGHT 1950s magazine illustration of Guy Fawkes' Night. Firework displays are accompanied by bonfires, where an effigy of Guy Fawkes is traditionally burned.

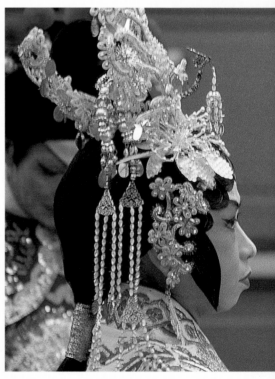

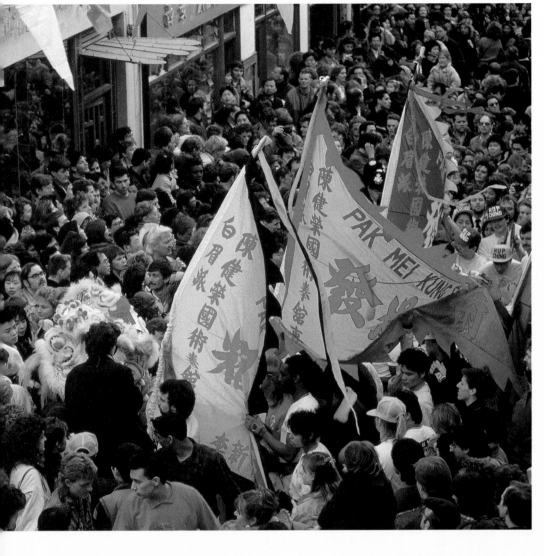

Week ending November 6 1954
Every Wednesday Fourpence

JOHN
BULL

RONNIE NOBLE, TV newsreel cameraman,
begins his story of world-wide adventure SHOOT FIRST! "CASTLE MINERVA"
VICTOR CANNIN

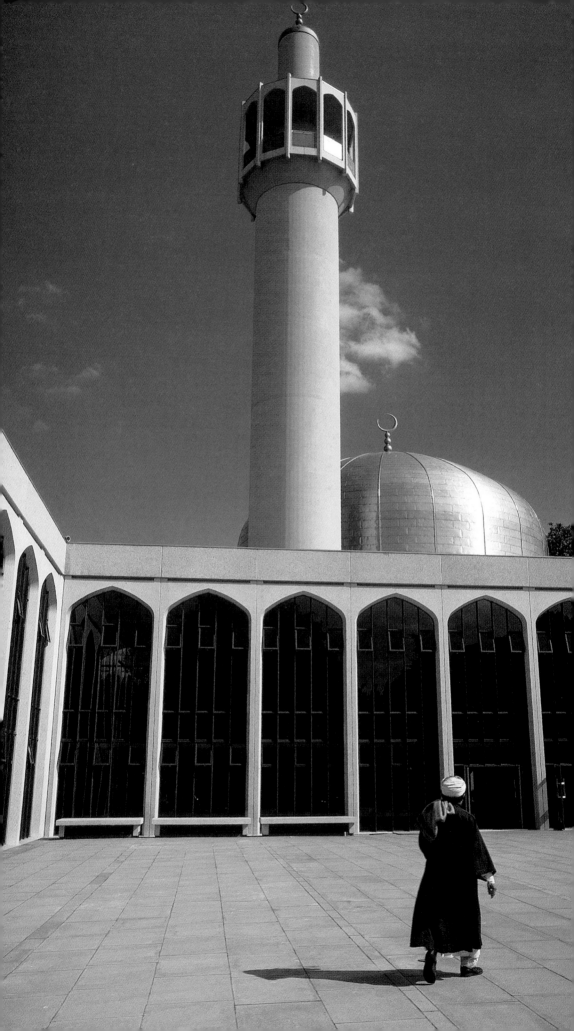

building. The West End Great Synagogue is also noted for its beautiful brass Hanukiyah.

The oldest synagogue in London is the Bevis Marks Synagogue near Aldgate in the City. Established in 1657, it is noted for its Spanish influences, brought to London by Jews escaping persecution by the Inquisition in Spain and Portugal. Announcements are made and hymns are sung in ladino, a mixture of Old Spanish and Hebrew, the Sephardic equivalent of Yiddish. Worshippers there still wear top hats.

At different times each year, as govereпed by the Arabic calendar, Muslims flock to the mosque in Regent's Park wearing new clothes for Eid ul-Fitr, the Festival of Breaking the Fast after the end of Ramadan. The day starts with dawn prayers, then families are required to give generously to charity. After prayers they have a good breakfast, the first proper one they will have had for the 30 days of Ramadan. The other principal Muslim festival celebrated there is Eid ul-Adha, the Festival of Sacrifice marking the end of the time of the Hajj, the annual pilgrimage to Mecca. This occurs some time after Eid ul-Fitr, and traditionally, a lamb is sacrificed, swiftly with a single cut, with its head directed towards Mecca, while sections of the Quar'an are read out.

The coronation of a monarch and other great occasions of state, such as royal weddings and funerals, take place in Westminster Abbey. But the Abbey has its own special day, 13 October. This is St Edward's Day. Although there had been a church in this vicinity since at least 785, Edward the Confessor, who was canonised in 1161, laid the foundations of the current Abbey in 1050.

Edward was King of England from 1042 to 1066, but in the early part of his reign he was forced into exile in Normandy by the Danes. He vowed that, if he returned to England safely, he would make a pilgrimage to St Peter's in Rome. Once back in England though, he found he could not leave his people. The Pope agreed to release him from his oath, provided he restore the monastery at Westminster, dedicated to St Peter. Edward replaced the Saxon Church at Westminster with one in Norman style, which was consecrated in 1065; when Edward died the following year, he was buried there.

OPPOSITE This beautiful mosque in Regent's Park is London's largest Islamic place of worship.

TOP The entrance to St Edward's Chapel in Westminster Abbey, 1845.

ABOVE The stone of Scone, upon which Scottish monarchs were crowned, was brought to England by Edward I. It is kept in the base of the Coronation Chair in St Edward's Chapel, and is still used for the coronation ceremonies of British sovereigns.

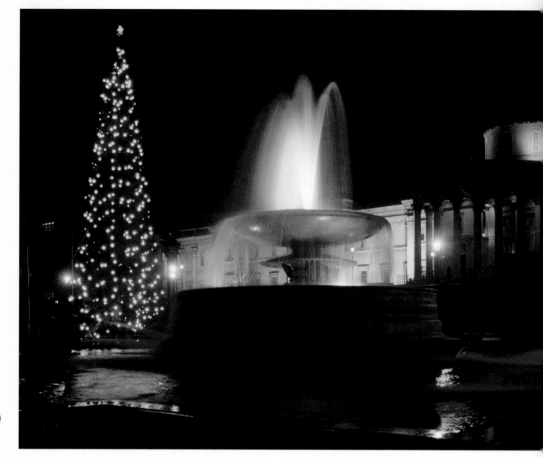

His body has been moved twice, on 13 October 1163 and 13 October 1269, when the Abbey was being rebuilt. He now lies in the Chapel of St Edward the Confessor, in the inner sanctum of the Abbey. His shrine is surrounded by the bodies of five kings and four queens. Since the dedication of the chapel in 1269, it has been a place of pilgrimage and the steps have been worn away by the knees of pilgrims. The special service takes place on 13 October, rather than his original saint's day of 5 January, because that is the date he was moved.

Nearby, the Catholic Westminster Cathedral stages an ecumenical event known as the Passion on Victoria Street on Good Friday. The participants gather at Central Hall Westminster at 11am. Then a procession of around 2,000 people walk down Victoria Street to the Cathedral where an open-air service is held in the piazza outside. A collection is taken for the homeless, before the congregation returns up Victoria Street.

SEASONAL CELEBRATIONS

Christmas is celebrated each year with the installation of a huge Christmas tree in

ABOVE & BELOW The huge Christmas tree in Trafalgar Square, an annual gift from the people of Norway, is a token of thanks for Britain's help during the Second World War. Carols are sung around the tree.

RIGHT Regent Street's Christmas illuminations.

Trafalgar Square at the beginning of December. It is sent by the Norwegian government in recognition of the help Britain gave to the Norwegian people during the Second World War. The New Year celebrations also take place in Trafalgar Square. The Square is closed to traffic and revellers gather around the fountains, inured to the cold by alcohol.

St George is the patron saint of England but his saint's day, 23 April, is not widely celebrated. However, that day also happens to be the birthday of William Shakespeare and the Globe Theatre in Southwark, a reconstruction of Shakespeare's original Globe that stands on the same site, organises three events. The Globe hosts the Spearshaker

Lecture at Middle Temple Hall, where a well-known figure is invited to give a lecture on a Shakespeare-related topic.

On the Friday following Shakespeare's birthday a memorial service is held at Southwark Cathedral and on the weekend closest to the birthday there are 'Sonnet Walks' from Westminster Abbey to the Globe. Along the way actors recite sonnets written by the Bard.

May Day is celebrated by a march from Highbury Corner to Clerkenwell Green, organised by the Trades Union Congress. London trade unions also hold a free fair in Finsbury Park in the name of international solidarity. Pubs around London often mark May Day with displays of Morris dancing.

ABOVE Karl Marx's tomb in Highgate Cemetery. Delegates from the embassies of Communist countries used to hold a ceremony there on Marx's birthday on 5 May – only the Chinese still attend.

RIGHT The Round Reading Room in the British Museum, where Marx wrote all his great works.

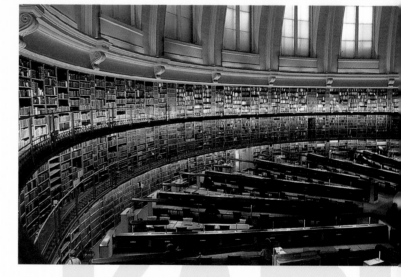

KARL
MARX

Organised labour used to have another day out for Karl Marx's birthday on 5 May. Marx spent more than half his life in London. He wrote all his great works in the Round Reading Room of the British Museum in Bloomsbury and was buried in Highgate Cemetery in 1881. During the Communist era, he was honoured each year with a ceremony at his tomb attended by delegates from the embassies of the various Communist nations. But since the Berlin Wall came down, only the Chinese turn out.

The Friends of Highgate Cemetery – the charity that owns and runs the cemetery – is a little unhappy about the fact that the cemetery is primarily known for this defunct ceremony. The cemetery is in day-to-day use and some 168,000 people are buried there, including such other luminaries as George Eliot, Sir Ralph Richardson, Dr Jacob Bronowski and Michael Faraday.

SECULAR FESTIVALS

London is celebrating the millennium with a year-long festival at the specially constructed Millennium Dome. Its centrepiece is a show with the theme 'Time's Arrow', which takes visitors from the origin of the universe in the Big Bang, through the evolution of mankind and human history up to the present day, using live actors, virtual reality and other special effects.

An interactive exhibition based on the human body and housed inside a huge human sculpture dominates the Dome. An area is also set aside for spiritual reflection in a garden and landscape of blue-tinted crystals.

Virtual reality rides and interactive exhibits take visitors through the future of education and work, while in the Dreamscape visitors float on boats designed as 16-seater beds along a river of dreams to a fantastic world which features a giant aquarium and a surreal dream cityscape. The Living Island features a typical British seaside resort, while a Serious Play zone has rock climbing, slides and other physical attractions. Over 70,000 people a day are expected.

Historically, the Millennium Experience finds itself up against some stiff competition. In 1951, the Festival of Britain, which celebrated the reconstruction of Britain after the Second World War, attracted 8½ million people to its site on the South Bank during

BELOW Aerial view of the Millennium Dome, photographed in October 1997 before the enormous roof was put in place. The dome will be the focus of celebrations for the arrival of the new millennium.

BOTTOM The Dome of Discovery, and the Skylon on the right, were built on the South Bank for the Festival of Britain in 1951. The original dome is reflected in the new Millennium Dome.

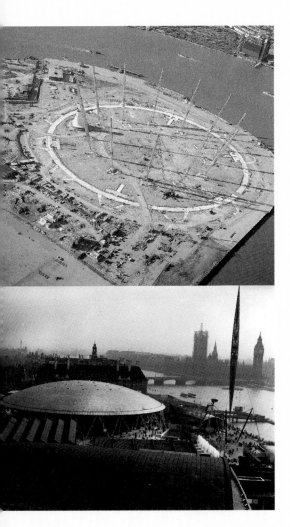

the five months it was open. Almost as many visited the festival's pleasure gardens and the funfair at Battersea.

The Festival of Britain was famous for its Dome of Discovery and the Skylon, which see their reflections in the Millennium Experience. However, when the Conservatives won the election in 1951, they closed down the Festival of Britain, believing that it was too closely associated with the post-war Labour government. Its attractions were pulled down and destroyed. Only the Festival Hall remains.

The Festival of Britain itself was opened on the centenary of the Great Exhibition of 1851, which attracted six million visitors. This represented no less than 17 per cent of the population of Britain, many of them brought to London by the new system of railways. The exhibition was organised by Queen Victoria's consort Prince Albert and was housed in the newly built Crystal Palace in Hyde Park. Designed in 10 days by former gardener Sir Joseph Paxton, who subsequently lent his name to a pub in nearby Knightsbridge, it was a giant greenhouse nearly 2,000 feet long and 400 feet wide.

The building was ahead of its time. Using a cast-iron skeleton and acres of glass, it was made from prefabricated sections, reflecting the industrial produce that was the theme of the exhibition. On show were locomotives, steam hammers, sewing machines, photographic equipment, gold-prospectors' trays from California, Colt's celebrated revolver, Henry Bessemer's revolutionary new

BELOW LEFT The grand entrance to the magnificent Crystal Palace, built for the Great Exhibition held in Hyde Park in 1851. The cast-iron and glass palace reflected the industrial theme of the exhibition.

BELOW A traditional Punch and Judy performance being held at Covent Garden in honour of Punch's birthday.

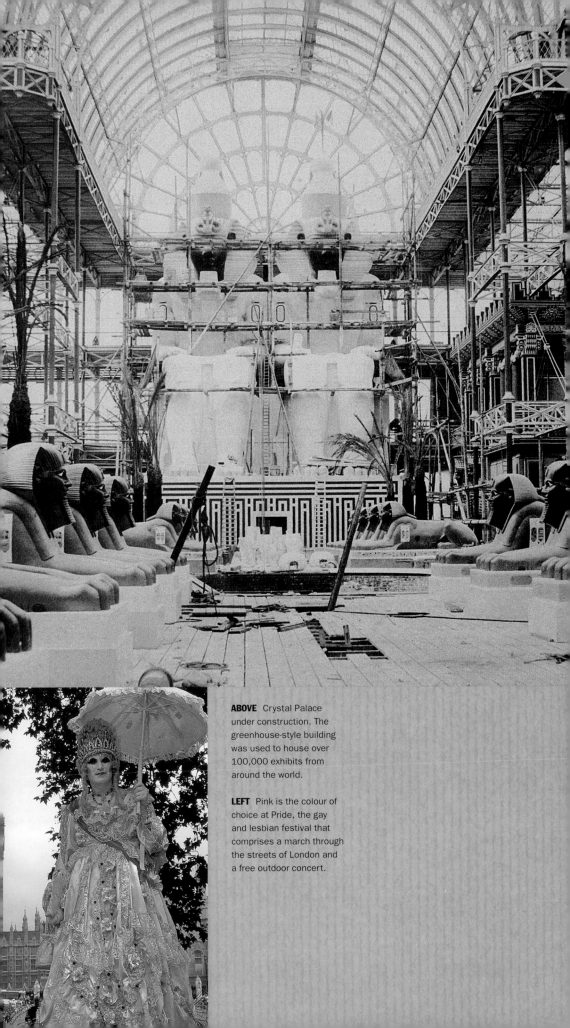

ABOVE Crystal Palace under construction. The greenhouse-style building was used to house over 100,000 exhibits from around the world.

LEFT Pink is the colour of choice at Pride, the gay and lesbian festival that comprises a march through the streets of London and a free outdoor concert.

LONDON'S GREATEST SALE.

An Absolutely Genuine Event.

ONE WEEK ONLY.

HARRODS SALE
Begins Jan. 11,
Ends Jan. 16.

Special Fast Trains will run from various parts of the Country at Excursion Fares.

Country Ladies should write for particulars at once.

Harrods Sale is recognised as a Shopping Event of National Importance.

Practically no job goods are specially bought for it, only regular and standard goods being offered.

Sale Books Post Free.

HARRODS Ltd., Brompton Rd., London, S.W.
RICHARD BURBIDGE, Managing Director.

ABOVE Poster advertising the Harrods January sale, probably London's greatest secular festival.

BELOW LEFT Pampered pooches abound at the Crufts Dog Show, held in March each year.

BELOW RIGHT The Christmas Day swim in the Serpentine in Hyde Park is not for the faint-hearted.

RIGHT Button-bedecked pearly Kings and Queens celebrate the Harvest Festival at the church of St Martin-in-the-Fields in Trafalgar Squre.

steel-making process and Joseph Whitworth's new screw gauges. The Crystal Palace was the model for the buildings used to house the Cork Exhibition of 1852, the New York City Exposition of 1853, the Munich Exhibition of 1854 and the Paris Exposition of 1855.

After the Great Exhibition, the Crystal Palace was moved to Sydenham in South London where it housed shows, exhibitions, concerts and football matches. It burned down on the night of 30 November 1936, but the main towers remained standing until 1941, when they were demolished due to fears that they were being used as a landmark by incoming German bombers.

Currently London's greatest secular festival is probably the Harrods sale in Knightsbridge. Over 250,000 people enter the store on the first Saturday of the sale, compared to 35,000 on a normal day. In 1998, over £14 million was taken on that first Saturday, traditionally the busiest day of the sale. That year one of the first items to be sold was a Blancpain diamond bracelet watch reduced from £129,950 to £64,975. One Russian buyer bought ten washing machines and ten tumble dryers. It cost £3,000 to ship them to Russia.

It was 1988 that was the record-breaking year though. A record 30 tons of cheese, including 5,360 whole Bries, were sold by the food hall. A new record was set for the dash from the front door to the china department. Ian Birch, an accountant from Taunton, made it in just 13 seconds. The china department also made record sales. One man spent a breathtaking £66,400 on Limoges china – though none of it was in the sale!

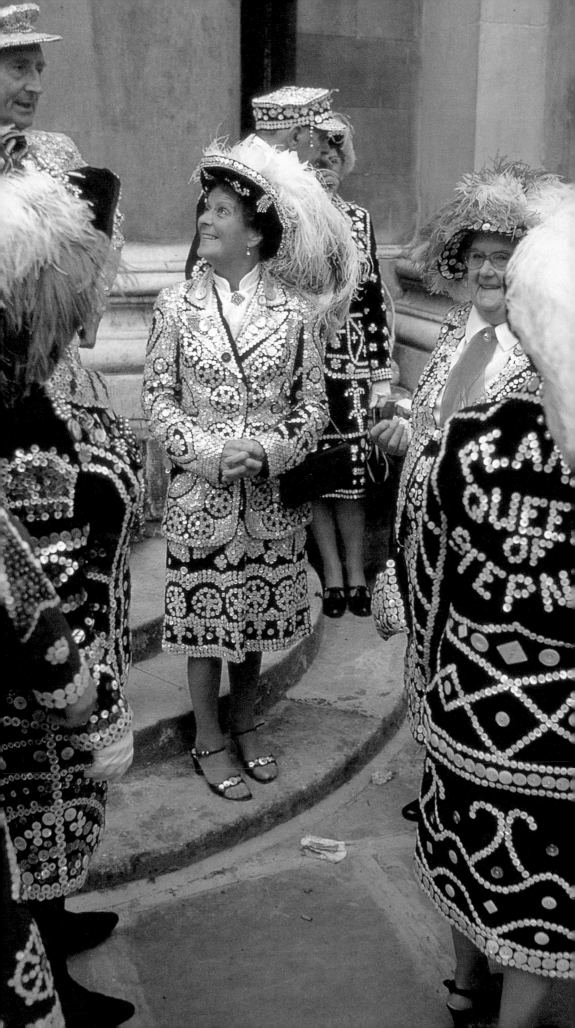

JELLIED
EELS

Britain's culinary reputation has come a long way si►
the heyday of the jellied eel stall, though such tasty
traditional fayre can still be found on the streets of
London, alongside the more recent international arri►
on the eating and drinking scene.

FOOD & DF

Text: Sue Jamieson

NK

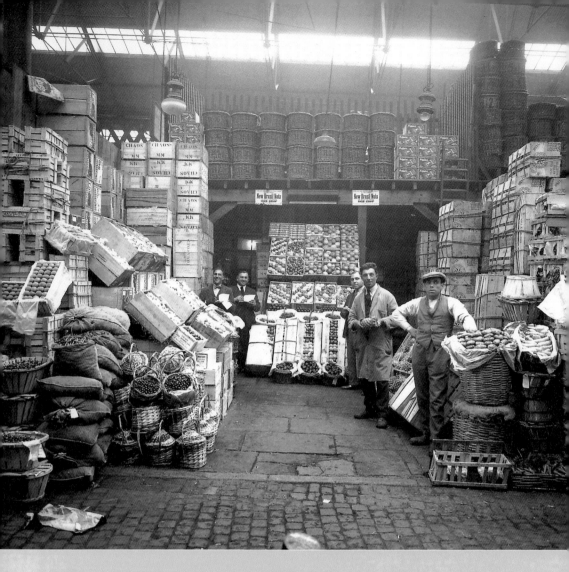

Once the laughing stock of the culinary world, Britain has shot to the top in the last ten years, with London at the heart of its ascent. From 24-hour bagel bakeries and myriad curry houses, to Michelin-starred restaurants and world-class markets, the British capital is buzzing with culinary expertise and enterprise. Start the day with the Great British Breakfast, lunch on the river or snack in the park, take tea at the Ritz – and warm up for cocktails and dinner at one of the numerous world-class restaurants to be found in this wonderful gourmet melting pot.

ABOVE Fruit and vegetable traders at Spitalfields market in May 1928. Today, farmers from across the country gather here to sell organic produce.

ABOVE A matchbook from the Sea Shell restaurant, purveyors of Britain's best-known contribution to world cuisine.

BELOW LEFT Billingsgate fish market has provided a pungent early morning wake-up call for Londoners for the past 800 years.

BELOW RIGHT Vegetable display at Berwick Street market in Soho.

COSMOPOLITAN CUISINE

The difference a decade or so has made to eating and drinking in London is probably more dramatic than in any other city in the world. Before then, London 'eating out' extended to low-key wine bars and Italian bistros, grand hotel restaurants, fish and chip shops, greasy spoon cafés and, of course, traditional pie and mash shops. Today, this cosmopolitan city offers a huge range of cuisines and places to eat, some would argue the largest choice in the world. There's Italian, French, Spanish, Polish, Asian, Chinese, Thai, Indonesian, Japanese, Jewish, Middle Eastern and Caribbean to name just a few, and these can be enjoyed either in restaurants or as take-aways.

For London's rise to culinary stardom is not simply limited to eating and drinking out. Its busy inhabitants have realised that good food can be prepared quickly at home, as long as the basic ingredients are available. A constant exchange between consumers and the food suppliers over the last ten years ('Have you got sun-dried tomatoes? No, but we can get them for you. Lemon grass? Certainly.') has seen specialist food shops proliferate – even supermarkets have rushed to ensure their own 'home-made' pesto sauce, fresh pasta, oils, Thai herbs and Japanese sushi are on the shelves to meet demand.

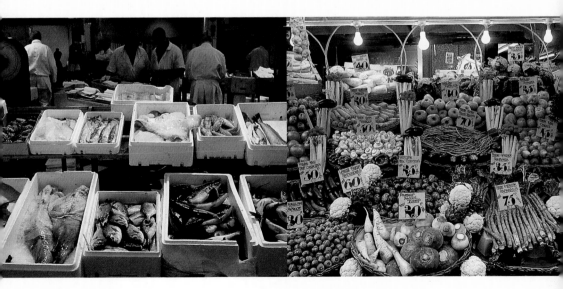

MARKETS AND FOOD HALLS

Perhaps the best way to start a gourmet tour of London is to visit the markets where life starts well before dawn. And of these Covent Garden, for fruit, vegetables and flowers, is probably best known. New Covent Garden, today situated at Nine Elms just south of Vauxhall Bridge, is sadly a far less romantic place than the cobbled pavements and misty arches portrayed in the popular London-based musical *My Fair Lady*. But 'Bloomin' Eck!', wouldn't Eliza Doolittle be amazed at the wondrous selection of produce available now. Alongside potatoes, cabbages and greens are avocados, squash, aubergines, courgettes, mangoes, passion fruit and pineapples – the list is endless. Here, you'll see top restaurateurs choosing their fruit and vegetables according to what's freshest and best, society hostesses and caterers stocking up for that evening's glittering event, and local grocers doing their daily run.

A similarly lively start to the morning can be experienced at Billingsgate, London's thriving fish market, where trading begins at 5am and continues to 9.30am. Some 55

BELOW The thriving market in Brixton is packed with delicious Afro-Caribbean produce such as plantains, yams and sweet potatoes.

SMITHFIELD

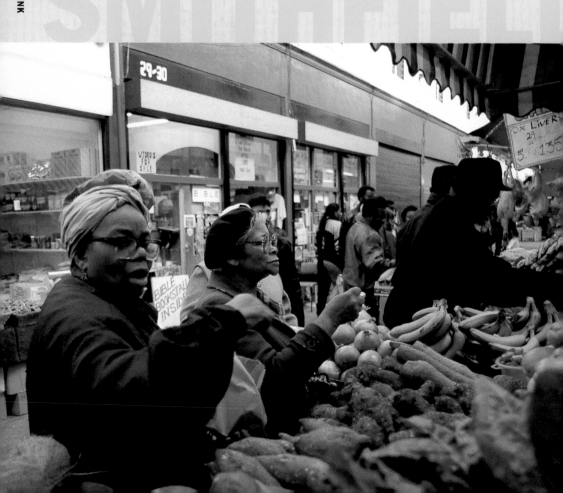

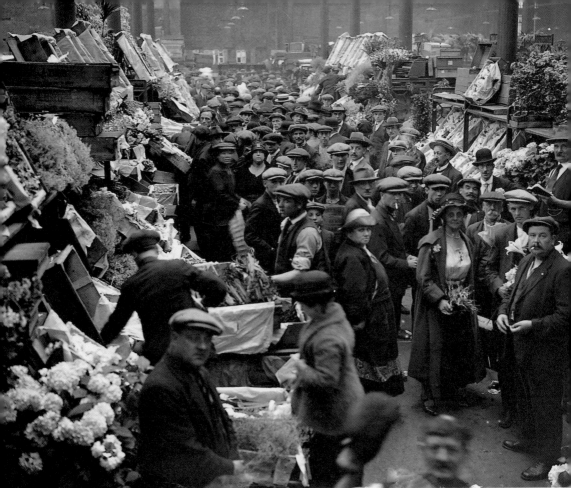

traders compete for business on the floors of this historic market (whose origins go back 800 years), selling cod, haddock and plaice from the North Sea and exotic imports from warmer waters.

For meat the market is Smithfield, and while wandering around warehouses of carcasses is not many people's idea of fun, it's a great place for an early morning breakfast, with several cafés catering for the early risers. Alcohol is even served from 7am (lunchtime to traders who have been up all night) at the famous Fox & Anchor pub, so if jet lag is playing havoc, start the day here.

There are hundreds of other local markets dotted throughout the capital – the noisy, cheerful Berwick Street market is a burst of colour and life in the narrow, grey streets of Soho, and Portobello in Notting Hill, while best-known for its antiques, also has a range of food stalls as well as excellent cafés and restaurants. Brixton market is one of the most vibrant in south London, its stalls packed with plantains, yams, sweet potatoes, chillies and other Afro-Caribbean imports.

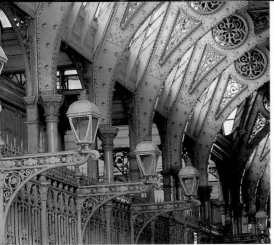

TOP Flower stalls at Covent Garden market, 1925. The original site of this world-famous flower, fruit and vegetable market now plays host to a plethora of craft, gift and antique stalls.

ABOVE Smithfield is the world's largest meat market. The attractive architecture and early morning cafés and pubs make a visit to this carcass-fest well worthwhile.

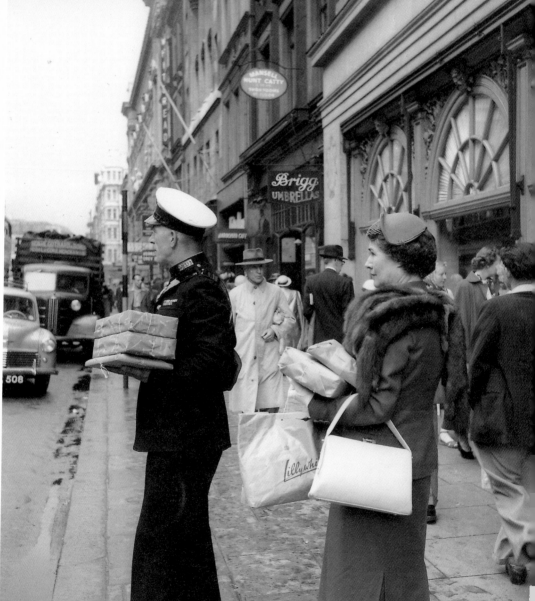

For those who prefer not to get up at dawn, or are worried about deciphering the Cockney stallholders' sales patter ('Apples and Pears!' means stairs, not the fruit) there are scores of specialist shops in which to buy food in more controlled conditions. Two stand out in particular. First, Harrods' glittering food halls with their magnificent tiled walls and marble counters. From croissants to sushi, haggis to freshly made boudin-blanc – all can be found here. Equally impressive is Fortnum & Mason on Piccadilly. Established as a simple grocer's stall in 1707 by William Fortnum and Hugh Mason, the crystal-chandeliered food hall is today one of the most prestigious in the world. Own-brand teas, coffees, preserves and chocolates make perfect presents but best of all is the Fortnum & Mason hamper, the gift everyone hopes someone will send them for Christmas. Between the two, geographically at least, is the stylish Harvey Nichols food hall, selling a range of fresh and other foods on the fifth floor alongside its restaurant and café.

In addition to these large stores are the smaller specialists found all over the capital. For cheese visit Paxton & Whitfield on Jermyn Street (just behind Fortnum's), which specialises in artisan-produced cheeses from Great Britain and France. Some 200 cheeses are available at this unique cheesemonger, which has been trading (from 93 Jermyn Street) for the same number of years. Fine Italian food can be found at Carluccio's in Neal Street, Covent Garden, run by Antonio Carluccio, restaurateur and television presenter; his particular passion is for funghi (mushrooms), including truffles. Sticking with luxury, continue to Caviar House on Piccadilly, where the best selection of Beluga, Oscietre and Sevruga can be bought. Or head for Bibendum on Fulham Road for lobster and oysters, sold from an old French van amid the mosaic glory of Michelin House, one of London's most beautiful buildings.

ABOVE, FAR LEFT Paxton & Whitfield cheesemongers, which sells over 200 cheeses together with a fine selection of wines, was founded in 1797.

ABOVE The spectacular Edwardian marble food halls at Harrods are one of the major attractions for visitors to this world-renowned department store.

LEFT A Fortnum & Mason commissionaire helping a woman with her shopping in Piccadilly, illustrated in *The Picture Post*, 4 July 1953. The Fortnum & Mason hamper is still the Christmas gift of choice.

FOOD & DRINK

105

LONDON

ABOVE A distinctive 'Michelin Man' stained-glass window in Terence Conran's Bibendum restaurant, situated in the magnificent Michelin House in South Kensington.

RESTAURANT REVIVAL

Bibendum is also a landmark in London's restaurant revival, being one of the first restaurants established by Sir Terence Conran, international design guru and doyen of the London eating-out scene today. Since Bibendum opened in 1987, the Conran empire has expanded to include more than ten establishments across the city, each reflecting a winning formula of stylish interior, quality cuisine (modern British on the whole) and buzzing atmosphere. Quaglino's in St James's is the epitome of the 'Conranesque'. A rebirth of the world-famous Quaglino's of the 1930s and 50s, today's vast, gleaming restaurant is reached, filmstar-like, by a sweeping marble staircase from the mezzanine bar. Huge flower displays, angled mirrors and a part-glass wall through to the kitchen add theatrical elements to this stunning interior, where some 7,000 people eat every week. Indeed, so well designed is every detail of Quag's that even the Q-shaped ashtrays are sought after, some disappearing into diners' pockets at the end of the night!

But you can't have a successful restaurant without a good chef and here, too, the British capital has come into its own. Once all budding chefs made the pilgrimage to Paris to work their gruelling apprenticeships in the top Michelin-starred establishments. Now most sous-chefs descend on London, where many of the leading figures in haute cuisine – British and foreign – are based. The Roux brothers, Nico Ladenis, Pierre Koffman, Bruno Loubet, Christophe Novelli, Alastair Little, Antony Worrall Thompson, Gordon Ramsey and the UK's own 'enfant terrible' Marco Pierre White are just some of the influential characters on the London scene today and many have several restaurants on the go – look them up in two of the most useful guides to London's restaurants, *Harden's* and the *Time Out Eating and Drinking Guide*, both published annually.

BIBENDUM

RIGHT A recent addition to Conran's empire of epicurean delights is the Zinc Bar and Grill. The distinctive ashtrays and matchbooks have proved to be popular Conranesque 'collector' items.

BELOW The stunning interior of Quaglino's brasserie attracts over 7,000 visitors every week. Mirrors, marble and glass walls make dining there a theatrical experience that delights all the senses.

CONRAN

ABOVE The restaurant and brasserie on the eighth floor of the Oxo Tower offer spectacular views across the River Thames, including an illuminated St Paul's in the evenings.

RIGHT The Ivy in the heart of London's Theatreland serves traditional dishes in exemplary surroundings. It's a good place to spot the stars – if you can manage to book a table, that is.

BELOW RIGHT This lovely view of the Windows on the World dining area through the impressive chandelier is excelled by the panoramic vistas from the 28th floor of the Park Hilton Hotel.

Food apart, there are many other reasons for visiting restaurants and here again London can offer a little of everything. For star-spotting it is difficult to beat the Ivy in Theatreland, a welcoming and cosy place – if you can book a table. Shopaholics can combine haute couture with haute cuisine at Nicole's (Nicole Farhi's New Bond Street outlet), the Fifth Floor (restaurant and café) in Harvey Nichols, and cafés in DKNY and Emporio Armani.

For restaurants with views try the Oxo Tower. From eight floors up there's a fantastic view over the City and the West End; it's particularly impressive at night when the buildings across the river, including St Paul's Cathedral, are floodlit. From 28 floors up the scenery gets even better – at the Windows on the World restaurant in the Park Lane Hilton the panoramas are breathtaking, but be prepared to pay for the privilege of eating in front of them. For magnificent interiors visit the Criterion, the sparkling, neo-Byzantine mosaic-bedecked restaurant on Piccadilly Circus. And for staple British dishes and surroundings, or classic Anglo-French cuisine, enjoy the magnificent dining rooms of the prestigious Savoy, Connaught or Dorchester Hotels.

BUDGET LONDON

At the other end of the scale London offers some of the most varied budget meals thanks to the enormous influence of immigrants and their cuisines from all over Europe and the East (Mid and Far). London's most famous good-value meal is homely pie and mash (potato), still served in simple 'shops' (some established as far back as 1860). Locally caught eels, which were cheap and plentiful, were the usual pie filling but they have been gradually replaced by minced beef. Today, eels are still served, either stewed or jellied, and with or without pie and mash. The essential accompaniment is green 'liquor' – a salty, parsley-based 'gravy' – or chilli vinegar for extra pep. Those on tight budgets (pie and mash is one of the cheapest dishes to be found in London), or who simply love jellied eels, should head south of the river to find the oldest and most characterful shops, such as Manze's on Tower Bridge Road.

BELOW A street stall selling pots of jellied eels and other seafood in 1951. Such stalls can still be found in London today, some of the best located south of the river.

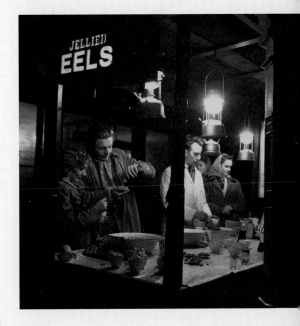

JELLIED EELS

The great British take-away

FISH & CHIPS

Fish and chips are just as traditional and as cheap, and even easier to come by. Each area has its favourite 'chippie', open until late, serving this deliciously comforting combination wrapped in paper and sprinkled with salt and vinegar, ketchup or sauce.

Competition for these two British dishes now comes in many forms. The pizza has made its mark here as in many countries outside Italy, with hundreds of pizzerias (including chains like Pizza Express) and small Italian restaurants across the capital, not to mention the stalls around touristy areas such as Oxford Street.

From further east are the Greek and Turkish kebab houses, serving thick slices of lamb in warm pitta bread to take away. It's worth spending a little more time, and money, to sit down and enjoy the subtly flavoured cuisine at one of the Greek or Turkish tavernas. There are many Greek restaurants around Soho, in particular Charlotte Street, while some of the best Turkish establishments can be found in north London, around Highgate and Islington. Meze, a selection of hot and cold starters, is the best way to sample the exotic flavours.

OPPOSITE Fish and chips – the great British take-away. The local 'chippie' is still a thriving institution across the capital.

FAR LEFT Indian restaurants proliferate on Brick Lane. The food of the sub-continent has had a major influence on British cooking, and Indian restaurants and take-aways are a popular choice with diners across the country.

LEFT An illustration from the 25 March 1939 edition of *The Picture Post*, showing tagliatelli being made in an Italian shop in Soho.

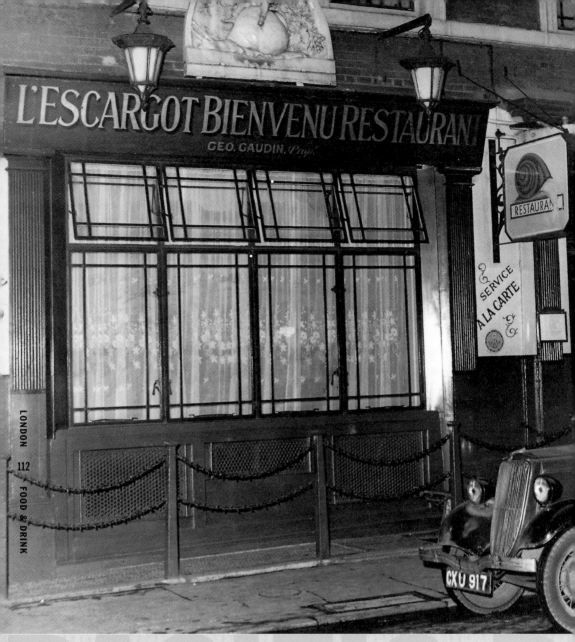

LOOKING EAST

Continuing eastwards, the aromatic spices of Arabia and Persia have gradually infused themselves into London's culture. There's a large Arab community around Hyde Park, many families spending the summer here to escape the searing heat back home. Walk down Edgware Road late on a summer evening and it is hard to believe you are in London: Arab families, from grandmothers to newborn babies in prams, promenade up and down this busy street, shopping and feasting on meze, kofta and tagine at the numerous Arabic restaurants.

But it is India, the old British colony, that has had the largest influence on British cuisine. The rich flavours of the vast sub-continent first hit British shores in the late 18th century, when the East India Company started sending home spices and condiments. Now there are Indian restaurants everywhere – in London the best-known areas for Indian cuisine are Westbourne Grove in west London, and Brick Lane, just to the east of the City, where rows of restaurants serve cheap, fast, albeit somewhat formulaic curries. To discover the subtleties of regional style travel out of the centre, specifically to Tooting in south London, or Southall to the west. Back in town more upmarket Indian restaurants, some offering a modern twist on the classic Indian dishes, are a welcome development; the Anglo-Indian Chutney Mary on the King's Road is one example.

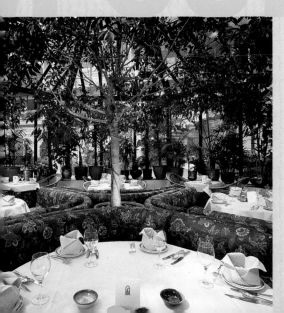

OPPOSITE L'Escargot in Soho, 1957. This French restaurant has been packing in the crowds for the past 70 years.

ABOVE The exotic flavours of Moroccan food can be readily enjoyed in this cosmopolitan capital.

LEFT Chutney Mary's dining room is a lush conservatory replete with tropical plants. The restaurant specialises in Anglo-Indian cooking, fusing elements of both culinary traditions in a hark back to colonial days.

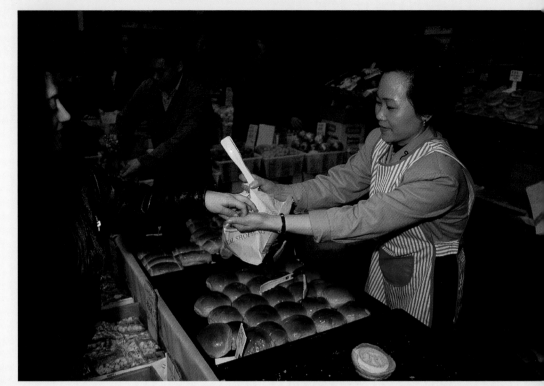

ABOVE Restaurants are not the only way to experience Chinese food in London. There are also numerous Chinese supermarkets selling authentic ingredients as well as stalls and small stores selling delicous steamed and roast buns.

BELOW Gerrard Street's Chinatown provides a taste of the Orient in the heart of London. New Year celebrations and an autumn carnival keep this city-within-a-city thriving.

Also mixing old with new, as well as the East with the West, are the cuisines of Thailand, Indonesia, Vietnam and Malaysia, which have assumed a major role in what has become popularly known as 'Pacific Rim' or 'fusion' cuisine – a marriage of Far Eastern flavours with Australasian, American or European ingredients. This light, fresh style of cooking, featuring lemon grass, coriander, star anise, wasabi and other Eastern herbs, spices and essences, has been enthusiastically welcomed by the receptive London audience, who look to chefs such as New Zealander Peter Gordon of the Sugar Club and Bali Sugar and Jean-Georges Vongerichten of Vong for inspiration.

For a taste of China simply head to Chinatown in Soho. On turning into Gerrard Street, you'll be transported 7,000 miles east. Complete with pagoda-style telephone boxes and gateways and Chinese supermarkets, selling everything from bamboo shoots to bean pastes, this is the centre of Chinatown, which spreads out into the neighbouring Lisle Street and Wardour Street. In noisy surroundings feast on dim sum, the delicious Cantonese snacks, or enjoy a full Chinese banquet with friends. While most of London's restaurants are Cantonese-owned, there are also some that specialise in Peking and Sichuan dishes.

One of London's most exciting culinary developments is the growth of Japanese cuisine. At first extortionately priced, Japanese food at the cheaper end of the scale is now available, notably in the wacky conveyor-belt restaurants where colour- and thus price-coded plates pass before the diners to be picked off at random. The bill at these kaiten-zushi (revolving sushi) restaurants is worked out by adding up the empty plates. The first such establishment was Moshi Moshi Sushi, perched above Liverpool Street Station. Hot on the block now is gadget-packed Yo! Sushi in Poland Street. At the top end of the scale Nobu in Mayfair offers delicious modern versions of Japanese dishes such as sashimi in stylish surroundings.

LEFT A bowl of noodle soup topped with seafood and vegetables from Wagamama's, a popular noodle bar within a canteen-style setting.

BELOW Moshi Moshi Sushi, the first of the conveyor-belt sushi bars in London. Perched above Liverpool Street Station, it attracts a brisk trade in City workers.

TIME FOR TEA

No visit to London is complete without taking afternoon tea, with or without cucumber sandwiches. While 'Tea at the Ritz' seems to run off the tongue, most of the other large London hotels serve afternoon tea in the British fashion – that is, with sandwiches, scones and cakes. At the Ritz, tea is served in the bright, open Palm Court; cosier options are Brown's Hotel with its armchairs and sofas, the Lanesborough, in its conservatory, or the Dorchester.

If you prefer to make your own tea, head straight for Twinings at 216 Strand. First opened in 1706 by one Thomas Twining, the shop on the Strand is still owned by Twinings, now a major international brand, and sells a huge selection of speciality teas. There's also a tiny tea museum which charts the history of tea in Britain.

Coffee drinkers can now safely come to London – no longer do they have to suffer watery cups of instant. Espresso machines have replaced catering jars as quality cafés have taken over the capital. Some chains have been imported from, or inspired by, the US, such as Seattle Coffee Co and Starbucks, others model themselves on their neighbours, the French, for example Café Rouge. Alongside coffee most will serve snacks and cakes (from muffins to patisseries) throughout the day, and place chairs and tables outside from which to watch the world go by. Many will also sell snacks to take away. The traditional British sandwich of white bread plus filling has evolved to include baguettes, ciabatta and focaccia. Bagels have made their mark throughout the capital too, and one of the best places for them is Brick Lane Beigel Bake, open 24 hours a day – the bagels don't come much fresher than this.

ABOVE The Seattle Coffee Company offers quality caffeine to Londoners.

BELOW LEFT A sugar packet from Prêt à Manger, a chain of sandwich and coffee bars catering to the lunch crowd.

BELOW RIGHT Café Rouge on Greek Street, Soho. French-style cooking can be enjoyed at a leisurely pace while people-watching from the tables outside.

ABOVE Nothing quite sums up 'Britishness' so well as Tea at the Ritz. Sumptuous surroundings, impeccable service and delightful tea-time treats make this a welcome respite from a busy shopping spree.

TEA AT THE RITZ

BEERS, WINES AND SPIRITS

As British as afternoon tea is the pint in the pub, but finding the perfect place to enjoy this traditional pastime can be difficult; too often the old-fashioned boozers lack the charm of the flower-bedecked, log-fire, friendly local pubs that are romantically portrayed by the tourism office. Happily there are some great examples worth heading for among London's 7,000 or so pubs.

In the City the Blackfriar is a striking Arts and Crafts style pub, built on the former site of a monastery; hence the bronze reliefs of friars to be found in the ornate mosaic and marble decor. Winning few prizes for interior decor, but famous nevertheless, is the French House in Soho, thus named because it was the unofficial headquarters of the Free French movement during the war. Post-war it became popular with writers such as Dylan Thomas and has enjoyed a loyal literary following ever since.

Until recently serious beer drinkers could visit the Sun, in Lamb's Conduit Street, which served a large selection of real ales – it's now an imitation 'Irish' pub, another victim of standardisation and the disappearing tradition of public houses not tied to specific large-scale breweries. For an insight into how true British ale is brewed, visit one of London's independent breweries. Both Young's in Wandsworth, south London (founded 1675), and Fuller's in Chiswick (established 1845), are still family affairs and organise tours by appointment.

Good pub food (and this means much more than scampi and chips) is more difficult to find but there has been a gradual improvement in this area with the appearance of new-style pubs concentrating on creative food. The Eagle in Farringdon is one example, and serves inspired Mediterranean dishes; the Anglesea Arms, in Shepherd's Bush, is another, combining an old-fashioned pub atmosphere with great food. The Windsor Castle, in Notting Hill, is just one of many appealing local pubs and serves good

TOP Charles de Gaulle's old drinking haunt the French House in Soho is now popular with London's literary denizens.

ABOVE The Atlantic Bar and Grill's plush interior is matched by the selection of drinks available.

RIGHT This old-fashioned etched window perfectly represents the appeal of the traditional English pub, which coexists happily with its modern counterparts.

ATLANTIC BAR
LEICESTER SQUARE

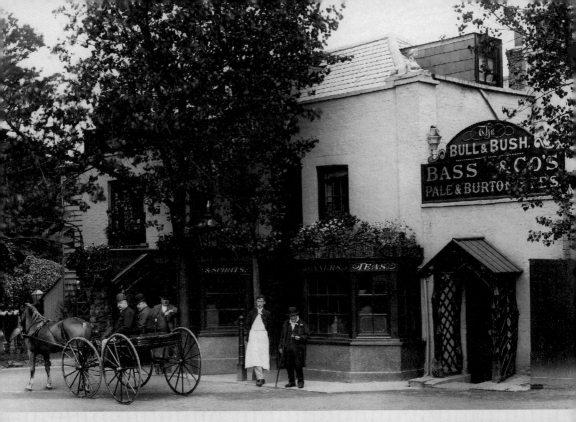

food, beer and wine in its beer garden or cosy, wood-panelled bars. But there are many more and it's a case of trusting your instinct; if a pub looks busy, has clean tables, a well-kept garden and relaxed-looking customers, it is probably safe to enter.

London is also packed with wine bars, ranging from the traditional candlelit vaults or basements, such as Gordon's in Villiers Street and the now legendary (almost 30 years old) Cork & Bottle near Leicester Square, to bright modern outlets listing an impressive range of wines, many of which are sold by the glass. Image-conscious drinkers have several hip bars to choose from, where they will find stylish surroundings, trendy customers and designer drinks (bottled beer, specialist vodkas, lots of Champagne). Some of the liveliest are attached to restaurants, such as Quaglino's, Mezzo, the Metropolitan Bar and the Atlantic Bar and Grill. For a quieter pre- or post-prandial cocktail, the larger hotel bars combine a little romance and a touch of glamour.

A valid criticism of London is its limited 'late' nightlife. Normal licensing laws allow alcohol to be served up to 11pm, after which you must seek out a bar or restaurant with an extended licence allowing them to serve alcohol until 1, 2 or 3am at the latest. Ice-cream is easier to come by – Häagen-Dazs on Leicester Square is open until 1am at

TOP The Bull & Bush, of music hall fame, in its early days. Public houses have never lost their popular appeal as places to drink and socialise.

ABOVE Bar Italia opened on Frith Street in Soho in 1949. Not only can you buy coffee there 24 hours a day, you can also watch TV while you drink it.

weekends – and coffee is available 24 hours a day at the Soho institution Bar Italia (established 1949), as is the television!

The other option is to buy your own wine or spirits and this is probably the best city in which to do so, for Britain offers one of the largest ranges of both. With few vineyards of its own, this small island has had to import all its wine for centuries and now sells wines from across the globe in off-licences, supermarkets and wine merchants.

One of the most traditional merchants is Berry Bros & Rudd, at No 3 St James's Street. Established more than 300 years ago, in 1698, it has traded at the same site, under the same family ownership, ever since. Little has changed in No 3, which was originally set up as a grocer's store; the wonderfully atmospheric shop has uneven floors, wood-panelled walls lined with old invoices and lists, and a huge weighing beam, inscribed with the words the Coffee Mill, hanging from the ceiling. These giant scales were a major attraction at Berry Bros & Rudd in its early years; from 1765 onwards famous people came to be weighed and their weights were recorded in leather-bound volumes. Napoleon III, Charles James Fox, architect John Nash, Osbert Sitwell and the Aga Khan are just a few of Berry Bros' weightwatchers.

In addition to selling fine wine, the merchant also produces the successful international whisky brand Cutty Sark. But for a much larger choice of Scotland's golden spirit there is no need to travel much further. Milroy's in Soho has one of the best whisky selections in the country – over 500 brands, mainly single malts.

ABOVE A vintage display at Corney & Barrow.

RIGHT The Collection restaurant and bar in South Kensington is housed in a warehouse-style setting.

FAR RIGHT Berry Bros & Rudd wine merchants, originally a grocery store, still trades from the same atmospheric surroundings as when it first opened.

THE COLLECTION

264 BROMPTON ROAD, LONDON SW3 2AS
TELEPHONE 0171 225 1212 · FAX 0171 225 1050

BERRY BROS & RUDD

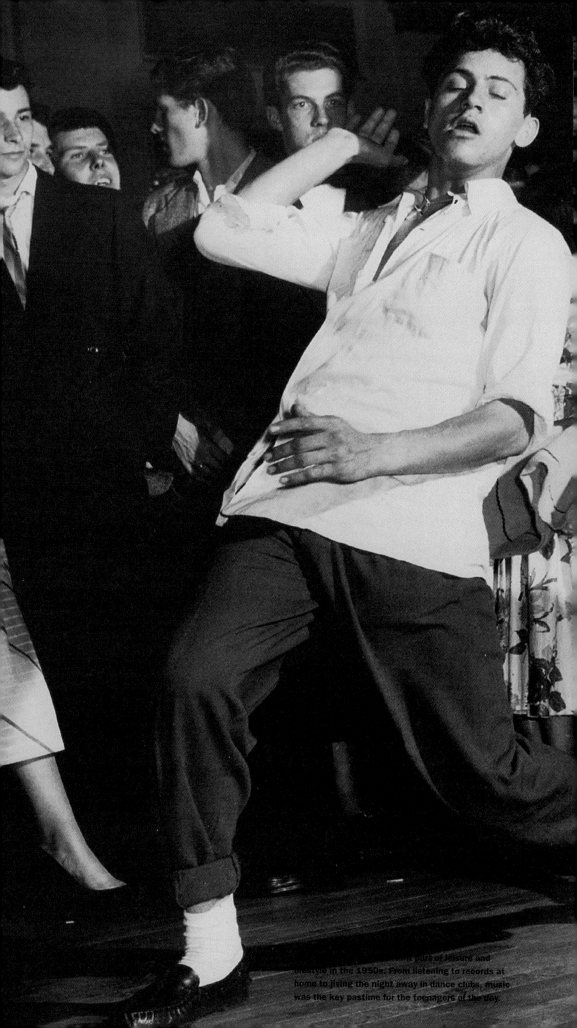

Music became an important part of leisure and lifestyle in the 1950s. From listening to records at home to jiving the night away in dance clubs, music was the key pastime for the teenagers of the day.

MUSIC

London's musical map is a haunted topography. Amid the
frenetic activity of present-day singers, players, composers
and programmers, the ghosts from 2,000 years of
organised noise crowd in. Buskers in the West End stand on
paving stones concealing the bones of medieval balladeers.
In the East End, reverberations from underground drum and
bass clubs fuse with the sound of 17th-century church bells.

BIG BEN

A MUSICAL MOSAIC

Despite being burdened with a pre-19th-century reputation as capital city of 'a land without music', London has turned itself into one of the concert, opera and pop capitals of the world. Within the profusion of venues ranging from the most grandiose on the planet to the funkiest in the freeworld, the city has absorbed global forms with determined open-mindedness.

Greater London's 616 square miles hold four prestigious orchestras, two international-level art centres, two legendary opera companies, over 20 West End musicals, a dizzying profusion of pop groups and on a Saturday night 49 listed nightclubs spanning 70s disco to Asian breakbeat.

The conservation of the city's heritage and the making of history take place next door to each other. At the administrative and political hub of Westminster, Parliament Square's looming clock tower 'Big Ben' chimes with a refrain from Handel's *Messiah*. The German composer lived and worked in London from 1711 and is buried in the solemn grandeur of Westminster Abbey on the other side of the Square. Yet at the 1997 state funeral of Princess Diana in the Abbey it was Elton John's rendition of 'Candle in the Wind', rewritten as 'England's Rose', that articulated the mourners' grief.

The walls dividing state and street have become thin and this cultural permeability is present in London's musical atmosphere. In 1977, while the more patriotic citizens celebrated the Queen's Silver Jubilee, punk rock seditionaries The Sex Pistols held a boat party on the Thames playing their notorious chart-topping anti-monarchy anthem 'God Save The Queen' beneath Big Ben.

Twenty years later New Labour Prime Minister Tony Blair invited backstreet rock magnates Oasis into his official residence at 10 Downing Street to celebrate the redefiniton of London as the swinging capital of 'Cool Britannia'. Thomas Augustine Arne, the 18th-century composer of 'Rule Britannia' would have been surprised at the party's popular balladeer-biased guest list. The patriotic hordes who sing along to Arne's composition at the Royal Albert Hall's classical season climax (The Last Night of the Proms) were also no doubt bemused by the recognition given to mere guitar groups.

OPPOSITE The face of Big Ben – the clock tower standing tall in the Houses of Parliament.

BELOW Prime Minister Tony Blair – the leader of cool Britannia in the 90s, meets another face of the generation, Noel Gallagher.

Yet the art snob values of the Victorian e
which supported the 1871 construction of
the magnificent but formerly acoustically
appaling Royal Albert Hall have long since
crumbled, as have many of the venues from
that time. Musically and architecturally, the
London musical skyline is now truly an
egalitarian mosaic.

DOMES AND SPIRES

The Royal Albert Hall stands on the south
side of Hyde Park, providing London with
symbol of the culturally mutating nature of
the city. Kensington Gore's glass-domed ov
was built in memory of Queen Victoria's
husband and originally served as a venue
for state events and classical conductor
showmanship. A proportion of the 8,000
tiered seats were privately owned. By the
1960s, however, it was hosting rock shows.

Janice Joplin played her British debut
there. Through the 80s and 90s former pur
groups such as Siouxsie and the Banshees o
the antipodean crooner Nick Cave have bee
slotted in beneath the now lowered (and

BELOW The Royal Albert
Hall, where many major
musical events are held
including the annual Proms.

ABOVE Major indie star Nick Cave in concert.

acoustically improved) ceiling, as has the occasional wrestling bout. The dome is still, however, a prestige venue, hosting one of the biggest and best classically orientated global musical festivals in the world – the Promenade Concerts from July to September.

The Albert Hall's vertigo roofed counterpart across town is St Paul's Cathedral. Situated at the top of Ludgate Hill in the City of London, the Sir Christopher Wren-designed landmark is a gateway into London's musical past. Aside from the formidable tradition of choral religious music upheld here, there are lunchtime organ recitals allowing the public an echo from the 17th century when Handel and Mendelssohn played in the cathedral. Only Westminster Abbey rivals St Paul's for monuments to musicians. Elgar, Henry Purcell, Benjamin Britten and Noel Coward are remembered in Westminster, while Ivor Novello is commemorated in Wren's masterpiece and Arthur Sullivan (of Gilbert & Sullivan) is buried there.

In among the banking and commercial buildings of the City area around St Paul's are a further 52 Wren-designed churches with ancient organs and some with bells rescued from the Great Fire in 1666. The official definition of a Cockney (loud, indigenous East Londoner) is

someone born within the sound of Bow Bell; however, it should be taken into account that the latter has moved from church to church over the centuries (currently hanging at St Mary le Bow in Cheapside).

Although he would have failed the Cockney test, George Frederick Handel played on many East End organs in the 18th century while simultaneously acting as one of the main figures to infuse London society with a taste for Italian opera.

The tradition of London's church music is still very much alive in the form of lunchtime concerts at, among others, St Mary Le Bow, St Martin's in the Fields (Trafalgar Square) and events at the ornate Roman Catholic Brompton Oratory in South Kensington.

ARIAS AND BOMBSITES

London's operatic tradition stretches back to the 17th century, when it caught up with the rest of Europe thanks in part to Henry

Purcell's 'hit' with *Dido and Aeneas* in 1689. The epicentre for the world of Wagner and Verdi has been the Royal Opera House in Covent Garden, where George II famously started a tradition by standing up in the Hallelujah chorus of Handel's *Messiah*.

The imposing classical building of today dates back to 1856 and standards have been rigorously maintained due to controversial state subsidies. A renovation scheme forced the Royal Opera company to perform in alternative venues in the late 90s and amalgamation with the city's less pretentious but equally formidable company the English National Opera was proposed. In 1998 the ENO put down temporary roots at the landmark Edwardian theatre the Coliseum in St Martin's Lane, but the fight over the city's most elevated import continues.

Contemporary relocations of opera to more accessible venues, such as promoter Harvey Goldsmith's stadium opera shows at

BELOW The Royal Albert Hall – hosting the ritualistic Last Night of the Proms.

MUSIC

129

LONDON

the modern West London hangar Earl's
Court or Pavarotti's July 1991 'ice-cream
tenor' outdoor event in Hyde Park, have
provoked heated debate.

If metropolitan opera is overfunded and
under-appreciated, orchestral music has
achieved a healthy balance of accessibility and
commerciality. Were it not for the Second
World War, London's concert-going public
might have been less spoiled, but the space-
clearing schemes of Hitler's Luftwaffe and the
eventual defeat of Germany produced two
multi-purpose complexes.

Gift wrapped in concrete walkways the
South Bank Centre was begun in 1951 to
coincide with the nationally cheering post-
war Festival of Britain. Its transpontine
location by the Thames has a long association
with theatre. Shakespeare's Globe was nearby
as well as other Elizabethan playhouses (a
replica of the original Globe has been built
near the sight). Though the architectural
merits of modern constructions such as
Denys Lasdun's Royal Festival Hall have
been questioned, the complex has provided
immense cultural sustenance for the art-
loving Londoner.

Toscanini described the musical
centrepiece Royal Festival Hall as the finest
auditorium in the world. The gaping stage is
home ground to the London Philharmonic
Orchestra and also the Philharmonia
Orchestra, but the yearly programme of
events extends way beyond a symphonic
remit. At the smaller Queen Elizabeth Hall
and the intimate Purcell Room (both added
to the complex in 1967) even more eclectic
delights are available, from jazz and avant-
garde rock to African xylophone quartets.
The South Bank Centre also encompasses
the Hayward Gallery, Royal National
Theatre, National Film Theatre and
Museum of the Moving Image.

Heading east into the City, the office
blocks in the vicinity of Liverpool Street
Station stand back to make way for the 35-
acre Barbican and the geometric concrete
of its focal arts centre. Begun in 1958 and
completed in the 80s, the venue multiplex
and surrounding apartments fill the gap
cleared by bombing during the Blitz.
Although the halls, theatres and walkways
are a navigational maze, the stages support
a feast of music. Debussy makes way for

ABOVE The Pavarotti concert in Hyde Park – even the rain couldn't dampen the spirit.

LEFT An early illustration of one of the many music halls in London, The Canterbury.

Saturday 12th September, Hyde Park, London.

BBC PROMS in the PARK 98

Live on stage Montserrat Caballé, Paco Peña Flamenco Dance Company, Concert Orchestra, hosted by Terry Wogan • Last Night of the Proms Finale relayed live from the Royal Albert Hall and the BBC on giant screens in the park. Tickets: £10.50+ booking fee. Ticket Hotline: 0171 413 3571 (24 hours)

BBC

With Wayne Marshall, Tasmin Little and the BBC

Gershwin. Brass bands precede bluegrass. And in the resident London Symphony Orchestra (currently under conductor Sir Colin Davis), the centre can boast the best orchestra in the capital.

On a far smaller scale but closer to the centre, the Institute for Contemporary Arts on the Mall is a slightly weirder post-war cousin to the big complexes. Founded in 1947, it weaves an adventurous musical schedule into its dance and visual arts events.

Although London can lay claim to some of the first 'concerts' in Europe, thanks to John Banister's 1672 pay performances (predating those of Vienna by 100 years), it's left to churches to provide deeply historical settings. The converted baroque church St John's in Smith Square holds excellent recitals and chamber concerts round the corner from the Houses of Parliament. Many of the older classical venues have been superseded over the years. The Hanover Square Rooms, famous for Bach's performances, were demolished in 1900. The major 19th-century concert hall St James's (Dvorjak, Tchaikovsky and Liszt appeared) was forced to close. And the original home for the 'Proms', the Queens Hall, was bombed in 1941.

KENWOOD

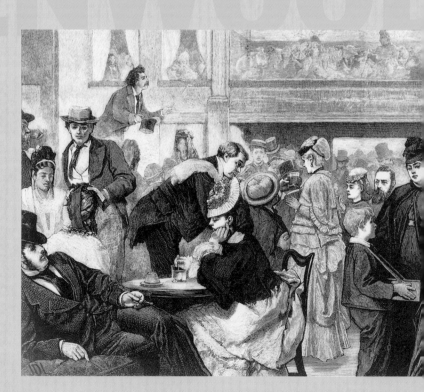

RIGHT The interior of the lively Mogul music hall situated in Leicester Square, later known as the Middlesex.

OPPOSITE An outdoor, lakeside concert at Kenwood House on Hampstead Heath.

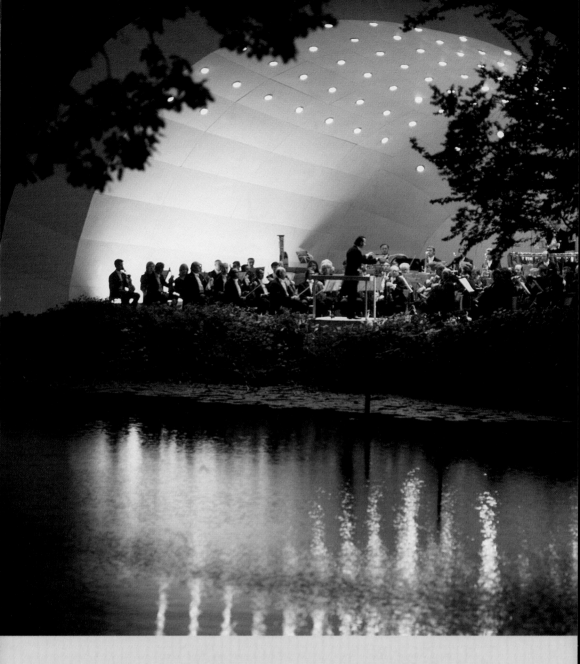

The venerable Wigmore Hall, however, survives from 1901 to bring high-powered string quartets and 'important' baroque pieces into the same alabaster and marble setting that welcomed Segovia and Rubenstein. For the fairweather classical fan, a less demanding environment is provided by Kenwood House's lakeside concerts on Hampstead Heath.

MUSIC HALL

Hackney publican Charles Morton is credited with being the founder of London's 19th-century music halls, establishing a popular song revue at his Old Canterbury Arms in 1849. By 1890 14 million music hall tickets a year were being sold in London and a huge development of theatrical venues had taken place. Of the 64 ornately inclined velour and gold theatres standing in 1913, many still function today, although the parlour ballads, comic patter, baboons and strongmen have mostly gone. Frank Matcham's London Coliseum (1904) found itself babysitting the English National Opera in the late 90s. Most have been given over to theatre or have been

swamped by the American-influenced musicals which superseded 'variety' after the First World War.

Memories of the distinctly British tradition represented by Ivor Novello and Noel Coward during the interwar years linger around the Strand and Covent Garden theatres. Novello lived above the Strand Theatre on Aldwych and many of his musicals were performed at the Theatre Royal on Drury Lane, subsequently famous for musical extravaganzas such as *Oklahoma!*, *My Fair Lady* and *42nd Street*. Noel Coward stayed frequently at the Savoy Hotel on the Strand next to the extant Savoy Theatre with its tradition of Gilbert & Sullivan. Coward's operetta *Bitter Sweet* opened in 1929 at Her Majesty's Theatre on the Haymarket, the same Victorian baroque edifice where Wagner's *The Ring* was introduced in 1882.

The bulk of the tourist-friendly musicals take place in the West End – the area to the west of the City, south of Oxford Street and north of the Strand. Major theatres such as the South Bank's Royal National are also, however, referred to as West End, in recognition of their importance. The main artery for greasepaint and gauche melodies runs diagonally from Piccadilly Circus, dividing Soho from Leicester Square. Shaftsbury Avenue has the Lyric at the bottom end, built in 1888 for light opera, and at the top stands the Shaftsbury, the most recent addition in 1911. In between are the Apollo, the Gielgud and the Palace.

Intended by its creator Richard D'Oyly Carte as a home for English opera, the looming Palace (1891) is a pivotal theatre for musicals. *The Sound of Music* ran from 1961 to 1967. In the 90s it was taken over by the endless run of Claude-Michel Schonberg's *Les Misérables*. Through the 70s, however, it was the triumphal flagship for the British composer who has annexed the West End ever since – Andrew Lloyd Webber. After a steady beginning with *Joseph and His Amazing Technicolour Dreamcoat* in 1968, Webber's *Jesus Christ Superstar* opened at the Palace in 1971 and ran for 3,357 performances. By 1991 he had no fewer than six shows running simultaneously in the West End, including *Evita*, *Cats* and *Phantom of the Opera*.

ALDWYCH

LEFT The talented and charismatic Ivor Novello in his London flat during the 1930s.

BOHEMIA

Thomas Edison invented the 'phonograph' in 1877, but by 1914 the music business in London was still mostly a matter of dots and quavers. Dance music in London meant doing the tango or the Boston at a hotel ballroom and printed parlour songs for the domestic piano were still selling well. However, either side of the First World War the influence of America and particularly black American music began to be felt.

In 1919 the publishing heart of London was Denmark Street, a small side street off the Charing Cross Road at the edge of Soho. Nowadays the publishers have mostly gone, replaced by guitar and keyboard shops, but historically it twinned itself with New York's Union Square publishing area, even borrowing the nickname Tin Pan Alley. A February 1919 advert for a tune titled 'At The Jazz Band Ball' by the Original Dixieland Jazz Band, placed by the Denmark Street song publishers Darewski, seemed innocuous enough. Yet it foreshadowed a sea change in the London music scene.

The Original Dixieland Jazz Band were the first real jazz outfit from America to tour in England. The all-white band from New Orleans arrived in April 1919 and played at London's Hippodrome, helping to open the way for the American-influenced dance band craze of the 20s. Post-First World War escapism filled up venues like the Savoy Hotel and the Embassy Club and gave a boost to the fledgling record industry. Through the 30s baton-waving big band leaders like Joe Loss and Billy Cotton filled out clubs such as the Café de Paris.

Louis Armstrong and Duke Ellington both made pivotal appearances in the 30s at the London Palladium on Argyle Street (the theatre is still busy today with musical and showbiz stars).

After the Second World War, the big dance bands lost ground to improvisational jazz and, encouraged by the interaction with American troops stationed in the UK, the London underground scene began to embrace bebop. In 1948 Carnaby Street's The Club hosted nights of transatlantic bohemia. One of the key figures there was tenor saxophonist Ronnie Scott, who went on to found London's pre-eminent jazz club, which bears his name.

LEFT What used to be the music publishing heart of London – Denmark Street.

BELOW The original Dixieland Jazz Band circa 1919.

RIGHT The venue now known as the Wag Club in Wardour Street has had a chequered history, first as the Flamingo jazz club in the 50s, then the Whiskey à Go Go – London's first disco – in the mid 1960s.

blowup.demon.co.uk

blow up

Saturdays @ the Wag Club, Wardour St, Soho, W1

presents live..

25th July **THE BOWLING GREEN**
1st Aug **VELOCETTE** plus DJ BOB STANLEY
8th Aug **DESMOND DEKKER** & THE ACES
15th Aug **SUSHI 4004** LAUNCH PARTY

featuring Le Hammond Inferno, Konishi (Pizzicato 5), Tanaka (Fantastic Plastic Machine)

Doors 10pm- 5am (last admission 3.30am) · Bands onstage 11.30pm
Admission: £8/£6 members & concessions B4 11pm, £10/£8 after, £3 after 3am (R.O.A.R.)
Advance tickets available from Stargreen (0171) 734 8932

ABOVE British jazz saxophonist Ronnie Scott, playing outside his famous jazz club in Soho, London.

RONNIE SCOTT'S

Ronnie Scott's was sited in Gerrard Street before it moved to its current Soho address at 47 Frith Street. The 50s supper club-style ambience has been consistent over the years, as has the high calibre of the performers. On a non-jazz night in 1970 Jimi Hendrix played his last notes there, jamming with the Eric Burdon Band. Scott himself died in 1996 but his club is still the best place to see top modern jazz names. One block east, Dean Street's Pizza Express has added to Soho's jazz cool with a substantial contemporary programme. Away from the West End, the Vortex in Stoke Newington and Camden's chrome and glass Jazz Café offer the chance of checking out the next generation of Courtney Pines and Steve Williamsons.

ENORMADOMES AND COFFEE SHOPS

Attendance at 20th-century rock Valhalla has gradually required longer Tube journeys. London's largest amphitheatre, the 100,000-capacity Wembley Stadium, lies in an otherwise undistinguished north-west London suburb. The indoor Wembley Arena sits next to the sports giant, and the modern London Arena has been stranded in the East End. Earl's Court Exhibition Centre in West Kensington provides a less alienating venue for mass rock'n'roll. Oasis played there in 97 and Pink Floyd staged 'The Wall' for six nights in 1980.

Dotted around the boroughs, mid-sized workhorse venues such as Brixton's Academy, the Shepherd's Bush Empire (formerly a BBC TV centre), Hammersmith's Labatt's Apollo, plus the midtown Astoria on Charing Cross Road are more likely to accommodate the spirit of rock'n'roll.

The mass market has not, however, skewed the location of the creative crucible. Despite attempts in the 60s to relocate to Chelsea (King's Road) and the brief mid-90s 'Britpop' drift to Camden, the real rock'n'roll heart of London has remained close to Soho since Bill Haley and His Comets came to Britain in 1957 and played at the Dominion Theatre on Tottenham Court Road.

A three-minute walk from the Dominion delivers up Old Compton Street, where, in the 50s, coffee bars and skiffle clubs were thronged with newly self-confident teenagers slicking back their hair in imitation of Elvis Presley. Vince Taylor ran a notable

LEFT Camden's popular Jazz Cafe, where many future stars first started out.

ABOVE Oasis' often acerbic lead singer Liam Gallagher playing at Earls Court.

rock'n'roll club, the Top Ten Club on
Berwick Street, while the first wave of
British wannabe rock'n'rollers – Cliff Richard,
Tommy Steele and Adam Faith – practiced
their craft at the Two I's coffee bar on Old
Compton Street.

As the rockin' 50s unfurled into the
swinging 60s, the British tradition of
recontextualising black American music got
properly underway. In the late 50s US blues
players like Muddy Waters and Big Bill
Broonzy began appearing in London. In
March 1962 Rolling Stones founder Brian
Jones saw Muddy Waters play at the
Marquee Club (then on Oxford Street)
and was inspired to form a rhythm and blues
band. With a little help from Liverpool's
The Beatles, who arrived in town in 1963,
the metropolis set off towards be-ins, bed-
ins and flower power.

Beatlemania officially commenced after an
October 63 televised performance from the
London Palladium. For a decade The Beatles
lived, played and recorded in the capital –
Abbey Road Studios in St John's Wood was
their main recording base throughout their
career. The last ever Beatles performance took
place on the roof of the defunct Savile Row
Apple Corps building in January 1969.

CARNABY
STREET

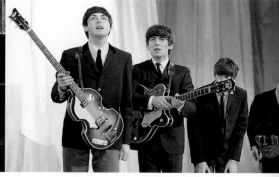

While Carnaby Street provided the fashion
epicentre of 'Swinging Soho', Wardour Street
was the musical main drag. The Beatles
recorded in the street's Trident Studios, St
Anne's Court. In the mid-60s, The Who's
Pete Townsend lived at No 87. The Marquee
Club, by then at No 90, saw early shows by
virtually the entire history of rock and pop –
David Bowie, The Who, Pink Floyd, Led
Zeppelin. When it moved to Charing Cross
Road in the late 80s, the Marquee remained
influential. Oasis played one of their last club
shows there before it shut down in the 90s.

RIGHT Christmas
decorations in Carnaby
Street, 1967.

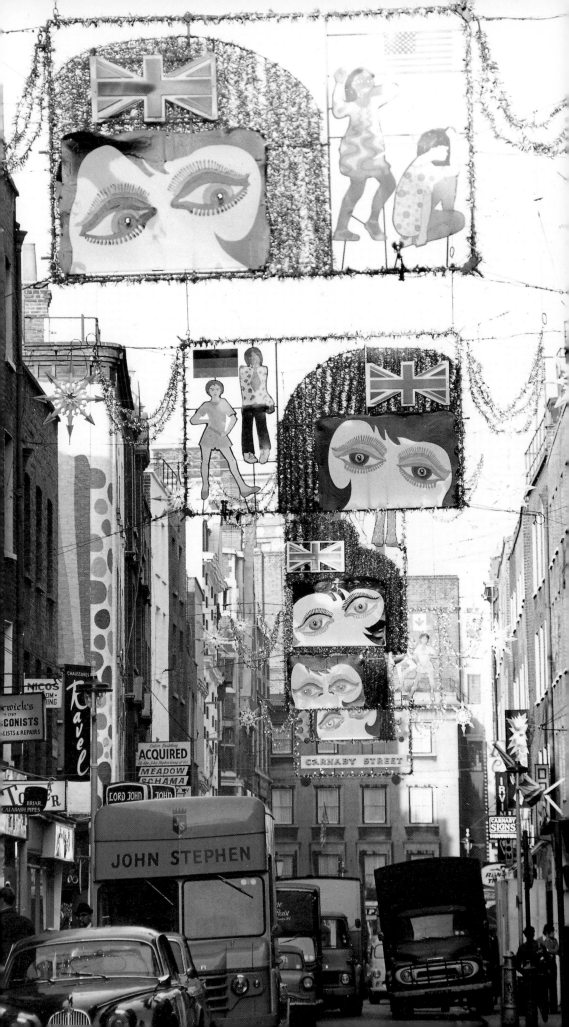

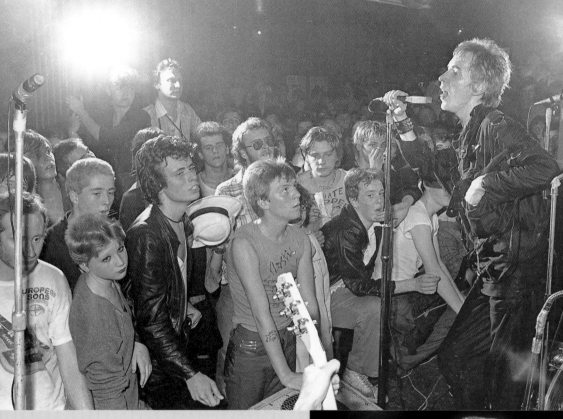

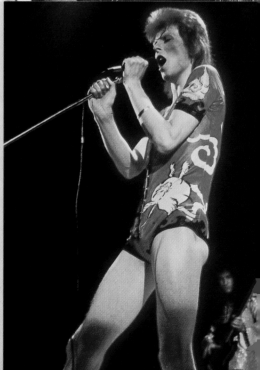

ABOVE The Sex Pistols playing at the 100 Club in 1976.

RIGHT David Bowie as Ziggy Stardust.

TOP RIGHT Sex Pistols' manager Malcolm McLaren showing the acts playing at the 100 Club.

ZIGGY STARDUST

ABOVE The 'Pistols signing up with their record company in front of Buckingham Palace.

London's swinging decade finished off with psychedelic clubs flourishing. The UFO club on Tottenham Court Road and Middle Earth in Covent Garden spawned 'progressive' rock bands. The house band at UFO – Pink Floyd – recorded their debut album 'Piper at the Gates of Dawn' in 67 in Abbey Road at the same time as The Beatles were recording 'Sgt Pepper'. Floyd's 'head rock' floated influentially over the early 70s, as did the giant inflatable pig which they suspended from Battersea Power Station for the cover of their 1976 'Animals' LP.

SAFETY PINS AND ECSTASY

As progressive and heavy rockers from Led Zeppelin to Yes paraded across 70s London stages like the Lyceum Ballroom and Finsbury Park's the Rainbow (both now closed), the most significant cultural seeds were being planted elsewhere by the critically dismissed 'glam rockers'. David Bowie's famous 'Ziggy Stardust' album cover was shot in Heddon Street, Mayfair, in 1972. The twisted rock narcissism within (not to mention the spiky hair without) invented much of the sham showbiz formula for the later punk rock.

Bowie killed off his Ziggy character in 1973 at the Hammersmith Odeon but continued to be influential for a decade. Two years on, in a risqué clothes shop on the King's Road in Chelsea, band manager Malcolm McLaren put together the defining group of the 70s, the Sex Pistols.

Fronted by the neo-Dickensian non-singer Johnny Rotten, they were a quintessentially London mix of pose and poison. They played their first show in St Martin's School of Art on Charing Cross Road in 1975 and split up before the end of the decade. By then, however, an entire movement had boiled over from seedy Soho clubs like the Vortex, the Roxy and jazz bunker the 100 Club to scandalise a nation with safety pins and swearing and (more constructively) to embrace reggae music, which had been a feature of London life since post-war immigration from the Caribbean.

Despite the political posturing of the Clash, whose 1979 album 'London Calling' broke the American Top 30, punk did not destroy capitalism. In fact, the independent record labels and legions of bands unleashed

fed the capital with an overabundance of pop noise. In the early 80s, the New Romantics tried to reclaim tunes and glamour and partially succeeded through the success of stars like Boy George. The Culture Club front man started his career as a 'gender bender' shock figure in 'Bowie Night' Soho clubs like Covent Garden's briefly reigning Queen Street rendezvous Blitz.

Mid-80s London was awash with pop bands ranging from local electronic boys Depeche Mode and Camden ska poppers Madness to Manchester's the Smiths. Indie pop (theoretically independent label pop)

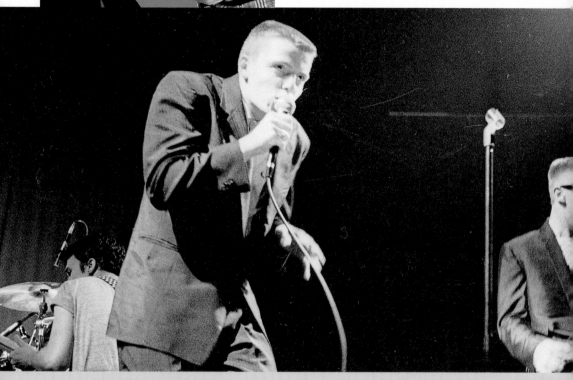

ABOVE Suggs, lead singer of Madness doing his recognisable dance moves.

TOP Keith and Maxim – the weird and wonderful frontmen of The Prodigy.

RIGHT Heaven nightclub in London's Charing Cross.

filled out small venues like Camden's Bull and Gate, the Islington Powerhaus and the Water Rats on Gray's Inn Road. The city's major post-60s lurch towards the 21st century, however, took place with the arrival of acid house in 1987.

Just as black American rhythm and blues had been taken up by Britain's hedonistic teenagers of the 60s, the soulful electronic disco of Chicago (and later Detroit's harder techno) was imported into London's clubland and championed. Key venues were Shoom in the basement of a West End YMCA, and Future in Heaven at Charing Cross, where the mix of American house, Balearic anthems from Ibiza and the recently arrived drug Ecstasy established the contemporary dance

dynamic and sparked off a boom in DJ-worshipping nightclubs.

In the mid-90s bands such as Suede and Blur located themselves stylistically within the Cockney pop sound of Bow Bells. The Britpop 'war years' when Manchester's Beatles-loving emergent rock gods Oasis were pitted against Blur, suggested a revitalisation of pop. But Oasis moved to London and settled into traditional artistic and rockstar roles after 1995's best-selling '(What's The Story) Morning Glory' (the album cover was shot in Soho on the corner of Noel Street and Berwick Street).

The forward-looking developments in London's popular music scene have almost all come from the clubbing sector. International bands like the Prodigy and the Chemical Brothers found their original audiences among the city's ravers and clubbers. Premier league dance venues such as the Ministry of Sound in south London spread laterally into magazines and record labels. Inventive new styles proliferated, from drum and bass to Brit-hop.

Irrespective of genre, the monumental creative energy of London's music scene shows no sign of abating. On a visit to London in 1839 Richard Wagner complained about the noise of the organ grinders in Soho. He would be even less pleased by the samples, riffs, rhythms, chimes and Internet café clicking emanating from the area's current mix of secular and devotional venues. Yet the cultural cacophony is the sound of happily racially mixed dynamism.

The £750 million end-of-century party venue, the Millennium Dome, will squat out in East London for the early part of the 21st century. The main dome is the size of 13 Royal Albert Halls and a 'baby dome' is to be a concert site. It is unlikely that London's haunted and hybridised music scene will fail to fill up any such overgrown parlours of the future.

MADNESS

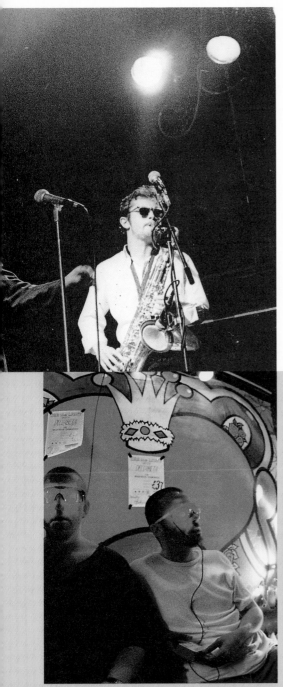

ACID

SPORTS

Text: Adam Ward

The ball boys (traditionally recruited from Dr Barnardo's orphanages), and more recently ball girls, at the annual tennis championships at Wimbledon, have become as established an institution as the matches themselves.

& LEISURE

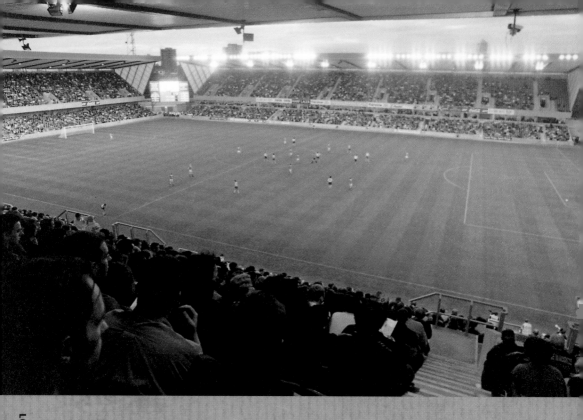

London, it can be argued, is the capital city of sport. Association football, or soccer if you prefer, is the world's best-loved game – an audience of 1.7 billion people tuned in to the televised 1998 World Cup final – and has its origins firmly rooted in London. The game's first governing body – the Football Association – was formed at a meeting in a London tavern in 1863, and the FA still has its head office in London's Lancaster Gate. Furthermore, the FA Cup, which is not only the oldest but also the most celebrated knock-out cup competition in the world, was the brainchild of Charles Alcock, secretary of the FA. The inspiration for this event was a competition Alcock had enjoyed while a pupil at Harrow School in north London.

THE ROYAL COCKPIT

EARLY DAYS

Whether you agree that London is the sports capital of the world or not, it is certainly a city that makes time for sport. Today, Londoners enjoy 12 professional football teams, ten senior rugby clubs, two international cricket grounds, numerous boxing venues and many prestigious sporting events, including the Wimbledon Tennis Championships, the London Marathon and the University Boat Race. The origins of London's rich and varied sporting tapestry can be traced back to medieval times, to the days when bear-baiting was a popular pastime on the banks of the Thames – fortunately no longer the case today.

In medieval London, the distinction between sport and criminal activity was not always obvious. Football was already a popular sport for the masses, but a lack of goals, rules and general organisation meant that it was more 'rampage through the streets' than 'beautiful game'. Sport-related public disorder was commonplace and a 16th-century case in which three youths were imprisoned for 'outrageously and riotously behaving themselves at football play in Cheapside' was typical.

By the 17th century, gambling had begun to dominate London's sporting scene and most popular sports offered the opportunity of a wager. Cockfights attracted huge crowds of gamblers ready to bet their wages on the brawn of a fowl. Human fighting was also big business for bookmakers, and as well as bare-knuckle contests, London played host to sword, stick and cudgelling bouts. Fighting between men and dogs and even unisex pugilism was avidly consumed by London's voracious fight fans in the 17th and 18th centuries.

ABOVE LEFT British soccer stadia have been improved in recent years; here the New Den at Milwall FC's Senegal Fields ground.

ABOVE An etching by Thomas Rowlandson of a bare-knuckles boxing bout between fighters Ward and Quirk in London in 1812.

RIGHT Cock fighting at the Royal Cockpit in 1820, drawn and engraved by the contemporary illustrators I.R. and G.Cruickshank for Pierce Egan's documentary book *Life in London*.

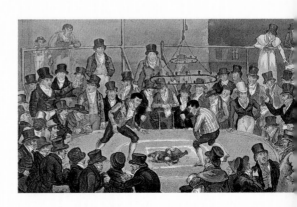

The sport of cricket also became popular in the 18th century. Cricket was initially a sporting pursuit for the common man, and it was not until the 1730s that gentlemen stooped so low as to take the crease. The first recorded game played by a London team was between the Gentlemen of Sevenoaks and the Gentlemen of London in 1734. The leading team in the early days of the sport was the White Conduit Cricket Club, which began playing at Dorset Square and in 1788 changed its name to Marylebone Cricket Club. By the early 19th century, MCC matches were watched by crowds of around 5,000, although a lot of spectators were attracted by the opportunity for gambling rather than through a love of the game. Cricket was London's first commercial sport, but before long, many of the city's games and pastimes had dragged themselves out of the backstreets and into the public eye.

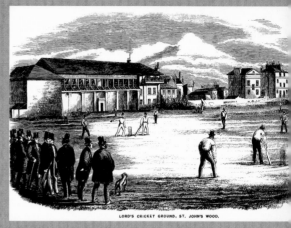

LORD'S CRICKET GROUND, ST. JOHN'S WOOD.

ABOVE Cricket being played at Lord's Cricket Ground in St John's Wood in 1858, a picture from the *Illustrated News of the World*.

BELOW The FA Cup and League double-winning Tottenham Hotspur team from 1961, with captain Danny Blanchflower (front row with ball).

THE ROUND BALL KEEPS ROLLING

Commercial sport flourished in the wealthy climate of England's capital city during the 19th and 20th centuries, and the undisputed winner in the race to the bank was soccer football. London demonstrated its love of

TOTTENHAM HOTSP

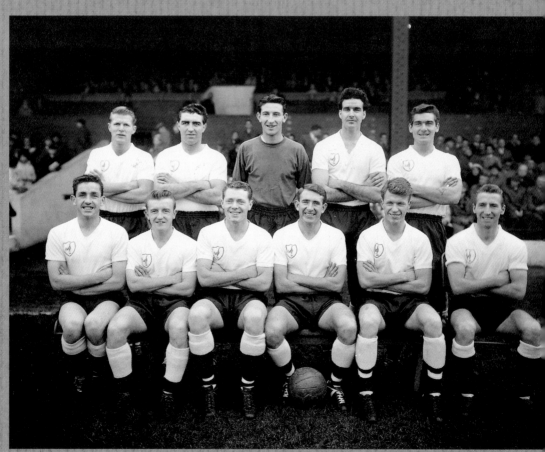

football in 1923 when more than 200,000 fans attended the first FA Cup final at the new Wembley Stadium in the north-west of the city. The envy of the football world, the stadium would host many great matches during the 20th century, including the 1966 World Cup final when the host country won.

In the early days of organised football in Britain, it was the north-west of the country that enjoyed most success. However, by the 1930s the axis of power had drifted south and arrived at Arsenal Football Club. Football had come home, even if Arsenal had moved home – the Gunners had switched from south London to north London in 1913.

Arsenal have rarely endeared themselves to the supporters of the city's other teams. Firstly, they had the nerve to dominate English football in the 1930s, winning seven major trophies under the guidance of legendary manager Herbert Chapman. Before that, however, the club had outraged north London rivals Tottenham Hotspur when, by dubious means, they successfully gained promotion to the First Division at the expense of their neighbours who were fighting for re-election.

The Second World War interrupted Arsenal's run of success and from 1950 to 1970, the Gunners managed just two major trophies. Rivals Tottenham seized the moment and in 1961 won both the FA Cup and the League – the first team to do so since Aston Villa's 'Double' in 1897. Spurs had achieved what the pundits had thought impossible and they had done it in style. Further cup successes followed but it was rivals Chelsea who were to be London's soccer style kings of the late 60s and early 70s.

Chelsea won three trophies between 1965 and 1971, but the manner of their victories was more significant than the triumphs themselves. The west London club had a star-studded line-up and their players were the city's first superstar footballers. The likes of Alan Hudson and Peter Osgood were household names in the 1970s and fans copied their hairstyles as readily as their footwork. However, by the mid-1970s Chelsea, along with the rest of London's football teams, were beginning to struggle. Football hooliganism had become a national problem too, and London thugs were among the worst offenders. The game closed ranks

TOP Nobby Styles, Bobby Moore, Geoff Hurst and Martin Peters with the World Cup after England's 4-2 win over W. Germany; Wembley Stadium, 1966.

ABOVE Chelsea striker Peter Osgood, a firm favourite with the fans, in action at the Stamford Bridge ground during his heyday in the early 1970s.

and reduced its profile as it tried to exorcise its unruly demons.

By the early 1990s, football had successfully reinvented itself – gone were the hooligans and in came the sponsors, all-seater stadia and satellite television cameras. The Premier League was born and among its 22 teams were five London clubs. Inevitably, Arsenal were the team who adapted most quickly to the 'new football'. Not only were they the best supported and most affluent of London's clubs, they were also the first to win the new Premier League in 1998.

GAMES FOR GENTLEMEN

Although the round ball dominates England's sporting scene, many Londoners prefer a game that involves a less spherical focus. In Britain, rugby comes in two varieties: League and Union. Rugby League is a popular sport in the north of England, but has struggled to establish itself in London. Rugby Union, by contrast, has been played in England's capital since the 1870s and has a staunch and loyal following.

London teams Blackheath, Richmond and Harlequins were among the founder members of the Rugby Union in 1871. In the early years of the sport, Harlequins enjoyed a position of both power and influence, and in 1909 the Rugby Football Union invited the club to play its fixtures at their newly opened Twickenham ground. Attendances for international matches were disappointing at this time, and by sharing Twickenham with Harlequins – who were well supported – the RFU hoped to increase their own gate figures. The arrangement was successful and Harlequins still play some of their matches at RFU headquarters.

Throughout the 20th century, Harlequins' success on the field has been matched by that of their London rivals Wasps. In 1871 Wasps had been invited to join the RFU as a founder member, but because of a mix up failed to attend the inauguration meeting. The club's luck changed in the 1940s, however, when military conscription brought a wealth of rugby talent to London. Wasps were to benefit most and bolstered their squad with Welsh internationals Vivian Jenkins and Harry Bowcott.

Successful or not, all of London's senior Rugby Union clubs had to cope with major

ABOVE The Blackheath Rugby Union team of 1895-6; a century later, striped rugby shirts have become something of a fashion item.

change in 1996. The arrival of
professionalism brought a higher profile,
more sponsorship and increased television
coverage. But the changes would not end
there. Both Wasps and Saracens would soon
have new owners and close associations with
Football League clubs. Wasps, who now play
their home games at the ground of Queen's
Park Rangers Football Club, quickly adapted
and won the first League Championship of
the professional era in 1997. Saracens, now
resident at Watford Football Club's Vicarage
Road ground, have also made great strides
and, after winning promotion to the First
Division in 1989, are now firmly established
as a major force in the game.

For most fans of the oval ball in London,
club rugby is of little importance, and while
the domestic game struggles to attract big
crowds, the international game is booming.
In particular, the Five Nations Cup (an
annual round-robin event competed for
by England, France, Wales, Ireland and
Scotland) attracts massive interest. England
play their home games at Twickenham, and
although the stadium has a capacity of
74,000, match tickets are extremely hard to
come by. Fortunately, many London pubs
and bars screen Five Nations matches live,
thus providing a perfect way to spend a
Saturday afternoon for many thousands
of ticketless 'rugger' fans.

Another popular sport in the capital is
cricket. 'Capital game – smart sport – fine
exercise,' was the astute judgement of an

ABOVE The modern-day
game – England versus
France during the annual
Five Nations Cup at
Twickenham in 1995.

unnamed cricket fan in Charles Dickens'
The Pickwick Papers. This 19th-century view
is still widely held today, and cricket remains
London's sport of choice for the summer
months. In Dickensian London, cricket
centred around the Marylebone Cricket Club
and their Lord's ground in St John's Wood.
The MCC had arrived at Lord's in 1814, by
which time the club was already the most
powerful force in the game.

Today, there are four major counties who
play matches in Greater London. Each of
these counties – Essex, Kent, Middlesex and
Surrey – have had their share of great players,
but Middlesex and Surrey have achieved most
success. Legendary batsman Sir Pelham
(Plum) Warner laid the foundations for
Middlesex's success while he was captain from
1908 to 1920. In 1947 Middlesex won their
first County Championship for 26 years as
Bill Edrich and Denis Compton each made
over 3,000 runs. Compton would become
one of London's greatest sportsmen – not
only was he the nation's premier batsmen,
he was also an accomplished footballer who
would go on to win the League
Championship with Arsenal in 1947–48.

Despite the best efforts of Compton and
Edrich, Middlesex's spell at the top of county
cricket was brought to a close when Surrey
registered their first County Championship

DENIS COMPTON

TOP RIGHT Cricket (and
football) superstar Denis
Compton (right) with Bill
Edrich, walking out to open
the batting for Middlesex at
the Oval in 1947.

RIGHT Veteran Surrey
County Cricket Club player
Stuart Surridge who
captained the team for five
seasons from 1952.

BOTTOM A test match at Lords in 1998 between England and South Africa; like football stadia, cricket grounds have been greatly modernised of late.

BELOW The Surrey team of 1959 which included the Bedser twins, Alec and Eric (front row centre and second left), and Jim Laker (front, second right).

LORD'S

win for 38 years in 1952. Led by captain Stuart Surridge and inspired by the bowling of Alec Bedser, Jim Laker and Tony Lock, Surrey dominated county cricket in the 1950s, and the Championship remained at the county's Oval headquarters until 1959. As with Rugby, the main event for most cricket fans is the international game. London hosts four international matches – two Test matches (five-day games) and two one-day matches – each year. Fixtures against Australia and the West Indies attract most passion and one-day games are particularly popular, although tickets are both expensive and rare.

DAYS FOR THE DIARY

At certain times of the year, London's sports fans forget their normal leisure pursuits and immerse themselves in pastimes that are happily ignored at all other times. Wimbledon fortnight is the most significant of these sporting special occasions and takes place at the grandly named All England Lawn Tennis and Croquet Club.

Wimbledon is regarded – in Britain at least – as the world's premier tennis event and interest in London is massive, with fans arriving from dawn on each day of the

ABOVE LEFT A detail from 'A Ladies' Day at Lord's: A Typical Scene at a Great Cricket Match' from *Sphere* magazine, August 1902.

ABOVE RIGHT By way of contrast, an inflatable sheep is held aloft by a member of the crowd at an England versus Australia match at the Oval in 1997.

RIGHT West Indies captain Viv Richards during the cricket World Cup final, when his team defeated England at Lord's in 1979.

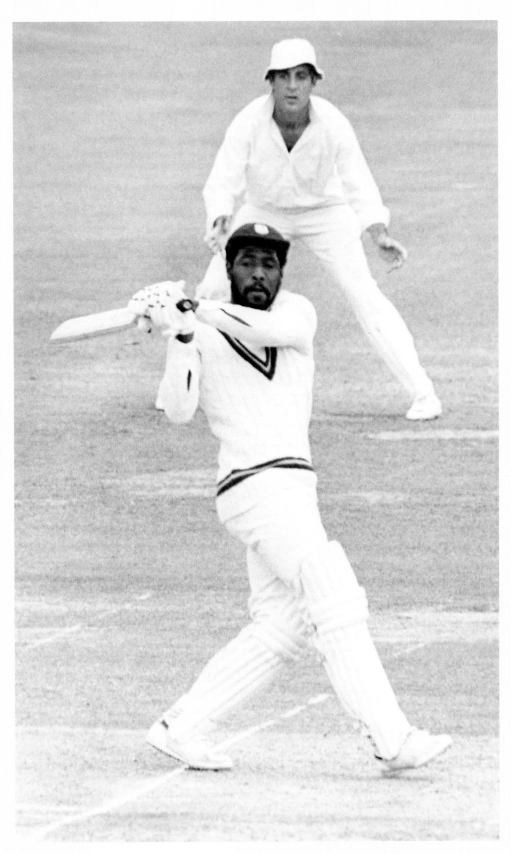

VIV RICHARDS

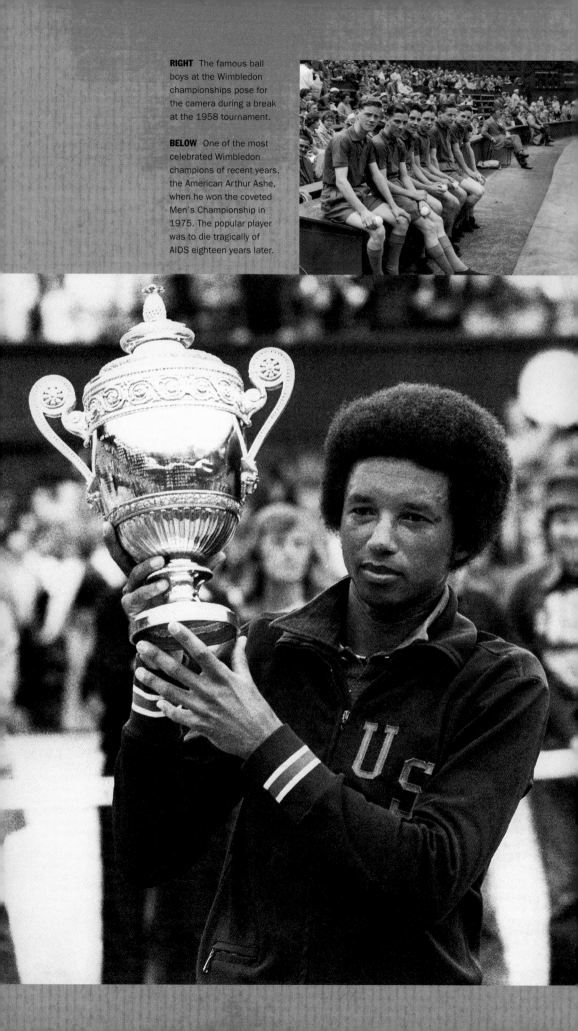

RIGHT The famous ball boys at the Wimbledon championships pose for the camera during a break at the 1958 tournament.

BELOW One of the most celebrated Wimbledon champions of recent years, the American Arthur Ashe, when he won the coveted Men's Championship in 1975. The popular player was to die tragically of AIDS eighteen years later.

championships. English players, however, have rarely given the crowd at Wimbledon much to cheer about. The last Englishman to win the singles title was Fred Perry in 1936 and the most recent English ladies winner was Virginia Wade, who triumphed in 1977. In the 1990s, English players have fared reasonably well, Tim Henman reaching the semi-finals in 1998 after progressing to the last eight in the previous year's tournament. However, the lack of an English champion has undoubtedly helped create Wimbledon's special atmosphere. Without an obvious focus for their adulation, the crowd reserve their applause and support for those whose skill and efforts deserve it. Players such as Bjorn Borg, John McEnroe and Andre Agassi have all been well supported at Wimbledon, and in turn have given many of their best performances at the championships.

A date in London's sporting diary is also reserved for the annual University Boat Race. The race was first held in 1829 when Oxford beat Cambridge on a course from Hambledon Lock to Henley. The current course stretches for 4.5 miles between Putney and Mortlake and has been used for more

ABOVE LEFT An illustration from *John Bull* magazine in 1951 showing the teams in the University Boat Race approaching Hammersmith Bridge on the Thames.

ABOVE RIGHT A view of the enormous numbers taking part in the annual London Marathon race, which draws participants from all walks of life and raises hundreds of pounds for a variety of charities.

Entrance Row Seat No.
E **D** **061**

W. Renshaw

THE LAWN TENNIS CHAMPIONSHIPS 1990
WIMBLEDON

Admit Bearer to
WEST OPEN STAND
CENTRE COURT
to view such matches as may be played on
FRIDAY 6th JULY
Play commences at 1 p.m.
unless otherwise notified
in the Press £33.00 incl VAT

For conditions
see reverse A.E.L.T.C. This portion does not admit
to Ground without passout

than 150 years. Cambridge have dominated the race in recent years, but for many neutral supporters the most entertaining happening would be a repeat of the 1912 race that saw both boats sink.

Another, more modern, event worthy of mention is the London Marathon. The race was the brainchild of Chris Brasher and John Disley and was first staged in 1981. In the first year it attracted 6,000 entrants, but ten years later there were 20,000 competitors at the start line in Greenwich, waiting to run the 26-mile course to Westminster. The race is now one of the most prestigious marathons in the world, and as well as attracting many top-class athletes, it also draws huge numbers of charity runners.

PLAYING THE GAME

Sport in London is not just about consumption, it is also a matter of active participation. The city may provide many other leisure distractions, but Londoners still find time to play sport. The famous Hackney marshes in east London host hundreds of fiercely contested amateur football matches each weekend, as they have done for more than a century. However, few local authorities can afford to set aside acres of open land and, for most Londoners, sport must take place in relatively confined areas. Municipal sports centres provide facilities for swimming, badminton, squash and indoor football, and in most cases subscription levels are high.

OPPOSITE TOP The London world boxing champ Henry Cooper in training at the famous gym above the Thomas à Beckett pub, in 1970. To his right is twin brother and trainer George.

BELOW The scene for generations of Londoners' amateur football matches – held mainly on Sundays – rows of football pitches across the otherwise bleak Hackney Marshes.

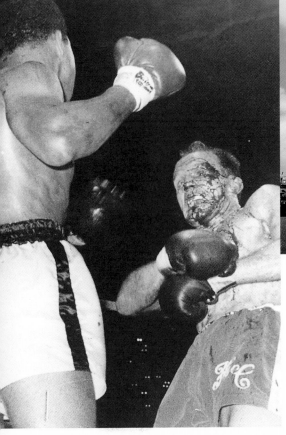

ABOVE Henry Cooper in his defeat by Cassius Clay (Mohammed Ali) in a 1966 World Championship bout staged at the Arsenal FC football ground at Highbury.

ABOVE RIGHT Cooper in front of the Thomas à Becket, Old Kent Road.

Fitness gyms are a favourite, if expensive, sanctuary for the city's health conscious, while for others the boxing gym retains its appeal. Successful London-based fighters such as Frank Bruno and Nigel Benn have inspired the city's youngsters to keep sparring, just as Henry Cooper did in the 1960s. Cooper's left hook applied to the jaw of Cassius Clay at Wembley in 1963 sent the American onto the canvas for the first time in his career and made the Cockney heavyweight a national hero.

Boxing remains big business for bookies, but for serious Cockney gamblers, the only place to be is 'down the dogs'. London's four dog tracks attract a real cross-section of punters, with hardcore gamblers studying

the form alongside youngsters enjoying a
night out in the cheap end.

THE WORLD IS WATCHING

American culture has always had a significant
influence on London life and this is just as
true of sport as it is of music, cinema, food
or fashion. In the 1980s, American football
became an occasional sight in London's parks,
but with rugby and soccer both already
established the game struggled.

The most significant US sporting export,
however, is basketball. The appeal of this
fast-growing game is multifarious. Firstly,
basketball can be played in a relatively small
area – a hoop in a school playground is all
that's needed. Secondly, it is a fast, high-
scoring game that provides plenty of
opportunity for skillful play. Finally, and
most importantly, basketball is cool. Wesley
Snipes, Ice-T, Michael Jordan and Dennis
Rodman have all helped make basketball
the stylish sport for young Londoners.

London is England's centre for sporting
glory and hosts annual cup finals for Rugby
League, Rugby Union, football and cricket.
The city has also had the opportunity to
demonstrate its sporting passion to the
world by hosting a number of international
showpiece occasions.

The first three cricket World Cup finals
were held at Lord's, with England losing the
second final to the West Indies in 1979.
Twelve years later, England were back in a
world cup final on home soil, although this
time the sport was Rugby Union and the
venue Twickenham. England were defeated
again, Australia emerging victorious after a
thrilling final. But it has not all been failure
in the capital for England's sporting teams.

ABOVE The dog racing at
Walthamstow Stadium,
with its bars and
restaurants, has become
something of a trendy
leisure destination for a
new generation of fans.

LEFT The old school of
dog racing is typified in this
picture of greyhound Mick
the Miller, undergoing pre-
race massage at his
Walton-on-Thames kennels.

BELOW Rollerblading is a
very recent addition to
leisure activites to be seen
around London's parks and
other open spaces.

MICK THE MILLER

In 1966, England hosted the football World Cup and under the guidance of manager Alf Ramsey progressed to the final, where they faced West Germany at Wembley Stadium. The final saw unknown West Ham striker Geoff Hurst become the first man to score three goals in a World Cup final as England ran out 4–2 winners. England's Wembley triumph in 1966 was all the sweeter for London's football fans because the goals had all been scored by Londoners, Martin Peters adding a strike to Hurst's hat-trick. The captain, Bobby Moore, was also a Cockney.

Thirty years after England's World Cup win, London was given the honour of hosting the final of soccer's European Championships at Wembley. On this occasion, England's hopes were destroyed in the semi-final at Wembley when they were knocked out of the competition by Germany.

Despite the disappointment of defeat in 1996, London had proved once more that it was a city capable of hosting the world's biggest sporting events.

And as football's ruling bodies plot where to hold Europe's first World Cup of the new millennium, England is bidding to bring the tournament back to the country where football began. No doubt if England succeed and host another World Cup, the final will take place in London and sport can come home once more.

ABOVE A programme for a 1998 local football derby between London rivals Chelsea and Arsenal.

ABOVE RIGHT The famous first-ever FA Cup Final at Wembley, 1923, when a lone policeman on a white horse cleared the crowds off the pitch before play.

RIGHT The panoramic 'Derby Day' (1856) painted by William Powell Frith.

DERBY DAY

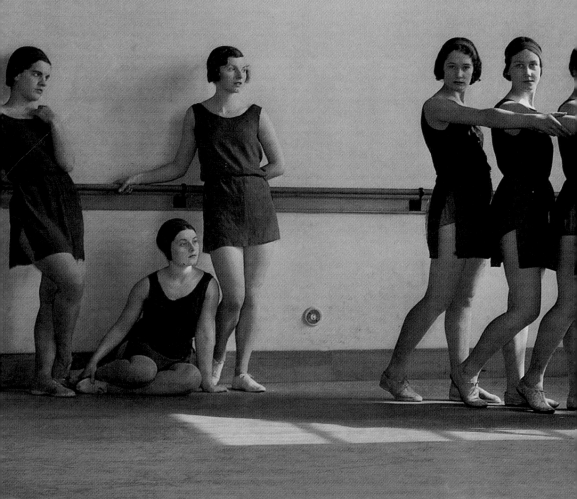

THEATRE

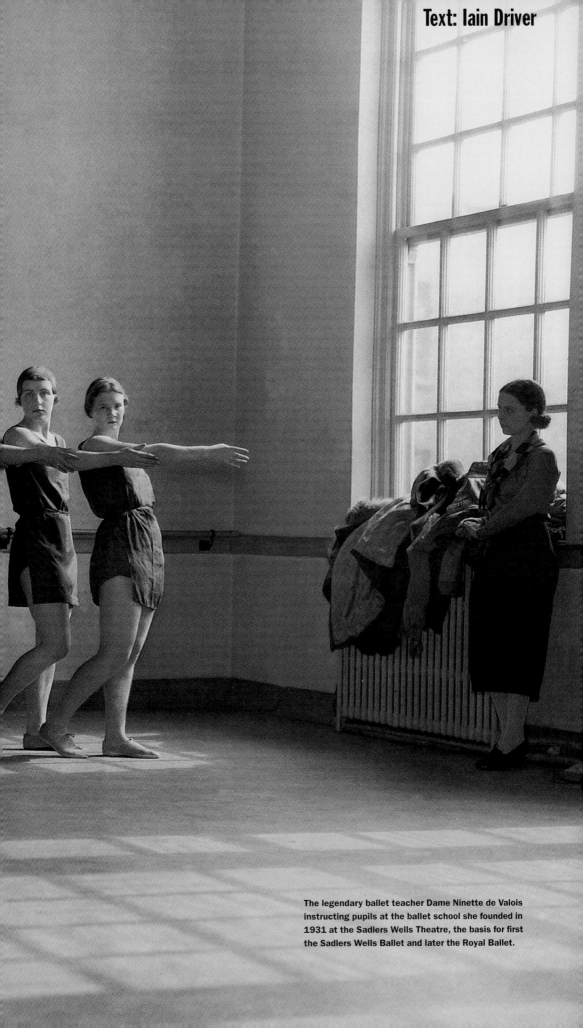

Text: Iain Driver

The legendary ballet teacher Dame Ninette de Valois instructing pupils at the ballet school she founded in 1931 at the Sadlers Wells Theatre, the basis for first the Sadlers Wells Ballet and later the Royal Ballet.

F few cities have as rich a theatrical history as London. From the street shows of Covent Garden to the glamour musicals of the West End, from the subsidised theatres of the South Bank to the smoke-filled pub theatres of Camden, the range and quality of London's theatrical landscape convey a vibrancy and belief in the power of the stage that is difficult to match anywhere else in the world.

SHAKESPEARE AND THE GLOBE

With more than 40 West End commercial theatres, two great subsidised companies, countless small and fringe venues, and world-class opera and ballet, the performing arts in London at the end of the 20th century are one of the city's greatest assets. The success has been built on a unique and unbroken tradition that goes back more than 500 years.

The earliest entertainments in London were provided by street performers – not unlike those found in the Covent Garden piazza today. Jugglers, acrobats and puppet shows mingled with exhibitions of bear-baiting and cock-fighting. Medieval morality plays were performed on carts and later in Inn Yards – events that proved as unpopular with the City Fathers as they were popular with the general public (the difference of opinion between official and popular taste is another tradition that has continued).

OPPOSITE A doorman at the Palladium looking through the ticket kiosk window. The Palladium was the most famous of London's 'Palaces of Variety'.

LEFT The Lyric, Apollo and Globe Theatres on Shaftsbury Avenue.

ABOVE The musical *Oliver!*, based on Charles Dickens' popular novel, playing at the Albery Theatre on St Martin's Lane.

RIGHT The history of theatre can be traced back to medieval street performers. The tradition still holds strong, though hairstyles may have changed somewhat.

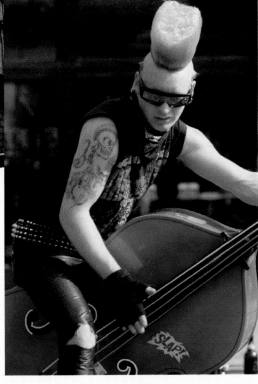

In 1574 the first company of professional actors was given royal permission to perform within London's city walls. The Earl of Leicester's men were named after their patron and were led by the actor James Burbage. Burbage, a carpenter as well as an actor, saw the need for a permanent home for his company and in 1576 he built London's first theatre. Called simply 'The Theatre' it began a trend that led to the appearance of a rash of open-air playhouses, including the Fortune, the Swan and the Rose.

In 1599, the year that James Burbage died, the lease on the Theatre expired. Frustrated by the constant opposition from the Lord Mayor, Richard Burbage (James' son, now in charge of the company) took the timber from the old Theatre, in Shoreditch, to Southwark, on the south side of the Thames. Here, beyond the city boundary, he built the most famous theatre of the day. He called it the Globe, and its resident playwright was William Shakespeare.

Shakespeare's life is shrouded in mystery. The lack of hard biographical evidence has led to various theories about his true identity, but we can be fairly sure that the man who wrote, perhaps, the greatest collection of plays the world has ever seen really was the actor and writer working for the Chamberlain's Men (as the Globe company became known).

Born in Stratford-upon-Avon in 1564, Shakespeare was the son of a glover yeoman who was successful enough to become an alderman and bailiff of the town before falling on harder times. Marrying Ann Hathaway in 1582, who was almost certainly pregnant at the time, he had three children in Stratford before disappearing from the records in 1585. By 1592 he was living in London and officially recognised as an actor and writer for the Lord Chamberlain's Men.

Shakespeare's genius was to move beyond the simple presentation and embodiment of human characteristics that had been seen before in playwrighting, replacing it with psychologically complex characters able to express themselves in sublime and imaginative poetry. He wrote more than 37 plays. The most famous are the tragedies – *Hamlet*, *Macbeth*, *King Lear* and *Othello* – which over the centuries have become the supreme test of the English actor. In these he most fully realised the mixture of universal themes and poetic skill that has made his work so enduring.

Respect for his work has grown with every century, and the need for a permanent subsidised company committed to presenting and exploring his plays was finally realised with the formation of the Royal Shakespeare Company (RSC) in 1961. Since 1982, the RSC has had a permanent residence at the Barbican Theatre in the City of London. The Globe itself was pulled down in 1644, when the arrival of civil war resulted in the closure of all the London theatres. In 1948, the American actor Sam Wanamaker, searching for a memorial for this most famous of theatres, found only a small plaque on a block of flats. Outraged, Wanamaker made it his life's work to build a more lasting memorial.

In 1997 a new Globe was opened. Matching the original in every sense, the new theatre aims to examine and celebrate Shakespeare's plays by producing them in as authentic a way as possible. Led by the renowned Shakespearean actor Mark Rylance,

OPPOSITE American actor Sam Wanamaker working on a model reconstruction of Shakespeare's Globe. The new Globe eventually opened in 1997.

ABOVE Alex Jennings as Hamlet. Shakespeare's plays have been interpreted and performed in myriad styles over the centuries.

LEFT An early edition of Shakespeare's plays. The Bard wrote over 37 plays, for which he is widely considered the greatest playwright of all time.

the company seeks to prove the words of Shakespeare's obituary, penned by his friend and rival playwright Ben Jonson: 'He was not of an age, but for all time.'

THE WEST END

When, in 1660, Charles II was restored to the throne and the theatres were allowed to reopen, London's theatrical climate changed. Charles wished to see many of the innovations he had enjoyed on the continent, including painted scenery, proscenium arches and, for the first time on English stages, actresses. The most famous of these new performers was Nell Gwynne, a former orange-seller who became Charles II's mistress, and whose fame and notoriety has been immortalised on hundreds of pub signs throughout the city.

The social climate of Restoration London was boisterous and decadent and the plays of the time reflected this. Written in prose, free from the grand rhetoric and monumental themes of Shakespeare's day, the new plays were witty comedies of manners, using plots and characters taken straight from aristocratic life. The greatest exponent of Restoration comedy was William Congreve (1670–1729). His plays, *The Way of the World* and *Love for Love*, used witty word play and intricate plotting to reveal a world of sexual intrigue and obsession with appearance. It was around this time that many of the most distinguished theatres in London today were built. In 1663, the first Theatre Royal, Drury Lane, was opened. The Haymarket arrived in 1705 and Covent Garden appeared in 1732. Increasingly these theatres became less dependent on royal patronage and more

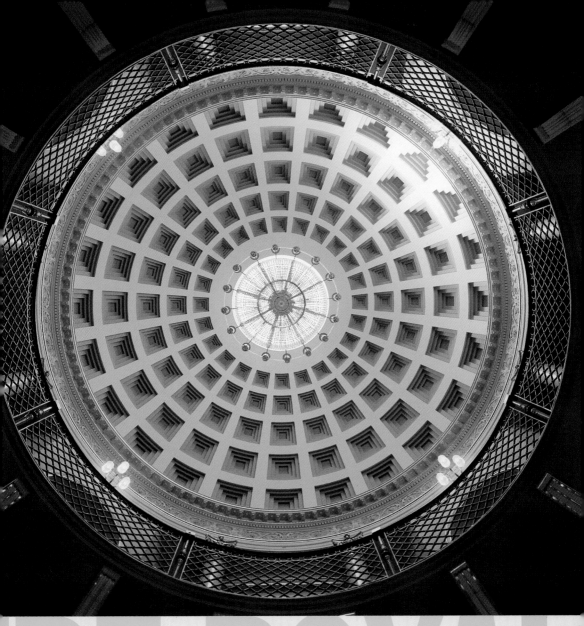

OPPOSITE Dustin Hoffman as Shylock in *The Merchant of Venice* at the Haymarket Theatre in 1989.

ABOVE The dome in the Theatre Royal, as it was rebuilt in Drury Lane in 1811–12, was inspired by the Pantheon in Rome.

RIGHT The Theatre Royal in Drury Lane pictured in 1810. In its rich history such well-known figures as Nell Gwynne have trod the boards here.

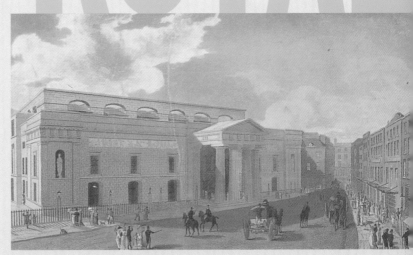

reliant on the hard cash of the middle-class merchants of the City. These new playgoers, who would travel from their homes in the square mile of the City to the theatres to the west, gave the emerging theatre district a new name – the 'West End'.

This new audience, however, didn't care for the hedonism reflected in Restoration plays and demanded morality and respectability. A mixture of high governmental control and middle-class sensibility is not a recipe for good writing, and many of England's writers turned their attention to the emerging art of the novel. However, at the same time, London's theatres became home to some of the greatest acting talents in the world, perfecting their skills not on the countless plays that were written in their day, but on the great plays of Shakespeare and his contemporaries.

This tradition of the star actor who played the leading parts and also managed the company and administered the theatre had its roots in Shakespeare's day and continued well into the 1950s, when specialist directors took over much of the burden of management. These actor-managers, among them David Garrick (1717–79) and Henry Irving (1838–1905), not only gave their names to many of London's theatres, but also gave English acting a worldwide reputation.

With the massive growth of the urban population and the prohibitive price of tickets, new forms of theatrical entertainments arose in the capital in the Victorian era. The rise in popularity of the melodrama reflected the population's taste for spectacle and sentimentality, while the music halls offered evenings of vulgar comedy and popular song. The spirit of the 'Halls', as they became known, was best exemplified by the comic singer Marie Lloyd (1870–1922). With songs like 'Oh Mr Porter', 'My Old Man Said Follow the Van' and 'The Boy I Love Is Up in the Gallery', she combined suggestive material with glamorous good looks and sentimental lyrics. So popular were these evenings that bigger and grander venues needed to be built and greater control exerted over the acts. These new theatres were known as 'Palaces of Variety', the most famous being the London Palladium in Argyll Street. Just as music hall gave way to variety, so variety gave way to the French-style

MARIE LLOYD.

Christmas Arrangements:
Palace Cambridge, and Metropolitan.
GRAND BURLESQUE TOUR
MARCH 16th, 1898.
SPECIALLY ENGAGED TO PLAY TITLE RÔLE.
AGENT, G. WARE.

DAVID GAR

ABOVE LEFT Burlesque performer Marie Lloyd became a popular music hall entertainer with songs such as 'Oh Mr Porter'.

ABOVE Actor-manager David Garrick, who helped to establish English acting's worldwide reputation. The Garrick Theatre and the Garrick Club both bear his name.

FAR LEFT The great Shakespearean actor Henry Irving as Richard III.

LEFT Interior of the Garrick Club, still a male-only enclave.

RICK & HENRY IRVING

entertainment, revue. Revue, which combined songs with written sketches, proved popular right up until the 1960s, when alternative comedy made the genre seem tame and dated. Revue's heyday, however, was in the 1920s and 30s, when its chief exponent was undoubtedly Noel Coward (1899–1973).

NOEL COWARD

So precocious and varied were Noel Coward's talents that he became known in theatre circles as simply 'the master'. Actor, playwright, librettist, director and raconteur, Coward united all the varied tastes of London's audiences and dragged them into the 20th century.

Starting as a child actor, Coward became an overnight star when his play *The Vortex* was staged in 1923. Dealing openly with drug addiction and extra-marital affairs, it presented a starkly modern picture of the 'Bright Young Things' of 20s society. However, it was the comedies that followed – *Private Lives*, *Hay Fever* and *Blithe Spirit* among them – for which he is best known.

His acting style, in which he used elaborate diction and witty asides to parry difficult emotions, suited an era that prided itself on its sophistication and discretion. At the height of his fame in the 30s and 40s, Coward seemed the embodiment of the West End stage; glamorous, popular and commercially successful.

By the 1950s, however, the West End of Noel Coward, celebrating the well-made play, seemed increasingly trivial. The vibrant energy of America's new realism, or the political sophistication of Berthold Brecht's plays in Germany, had not made an impact on London's stages. Even the popular playwright Terence Rattigan admitted that he wrote plays for his imaginary 'Aunt Edna' – the typical, unsophisticated playgoer suspicious of progressive plays who must never be offended.

THE ROYAL COURT REVOLUTION

In this climate of tired classical revivals and what one critic described as 'box-set, small cast plays about the minor emotional crises of the middle and upper classes', the English Stage Company was born. Based in the small Royal Court Theatre in Sloane Square, the

ABOVE Gertrude Lawrence and Noel Coward hamming it up at the piano in a scene from Coward's play *Private Lives* in 1931.

RIGHT Ballet stars Margot Fonteyn and Rudolf Nureyev in 1963 rehearsing Sir Frederick Ashton's ballet *Marguerite and Armand*.

English Stage Company wanted to build a body of work that would invigorate the theatrical scene. Under the guidance of its inspirational artistic director, George Devine, the company was dedicated to presenting the work of young and experimental playwrights.

The result of this policy led to perhaps the most famous first night in the history of the London stage. On 8 May 1956, the Royal Court presented a new play by a young actor who had never had a play produced in London before. The play was to cause a sensation and trigger a revolution in the British theatre. The writer was John Osborne and the play was *Look Back in Anger*.

With great verbal energy and venomous wit, the play attacked the pompous, hypocritical nature of British society. With his central character, Jimmy Porter, Osborne created a new kind of hero. Articulate and rude, and disillusioned both with society and himself, he became known as 'the angry young man'.

Most critics were united in their dismissal of the play. Only Kenneth Tynan in the *Observer* recognised its importance and called it 'the best young play of the decade'. Not only did Tynan realise that here was a play that dealt directly with social and political ideas of the day, but that in Jimmy Porter, Osborne expressed the mood of the time.

The theatrical establishment continued to be suspicious of the Royal Court, and it wasn't until Sir Laurence Olivier appeared there to universal acclaim in Osborne's second play, *The Entertainer*, that the West End bowed to the inevitable. Here were modern plays that the public wanted to see. The drawing room comedy gave way to the kitchen sink drama.

With its reputation established, the Royal Court went on to produce some of the most important plays of the next 30 years and acted as midwife to many of Britain's finest writing talents, including Arnold Wesker, John Arden, David Storey, David Hare,

ABOVE Kenneth Haigh as Jimmy Porter in the first Royal Court production of *Look Back In Anger* in 1956, which also included Mary Ure, Alan Bates and Helena Hughes in the cast.

RIGHT A photo portrait of playwrite John Osborne taken in 1959.

BELOW The Royal Court Theatre in Chelsea's Sloane Square, the scene of many historic milestones in the development of British theatre over the past five decades.

Edward Bond and Howard Barker. Its thinking had a profound influence on the formation and style of the National Theatre.

Out of the tidal wave of new writing that followed *Look Back in Anger*, one writer stood out for his unique sense of stagecraft and innovative style: Harold Pinter (b. 1930). With a background in the working-class Jewish community of London's East End, Pinter, like Osborne, had been an actor before turning to writing. His style, however, owed more to the absurd and surreal influences of modern continental European theatre than the bold rhetoric of Osborne's plays. Pinter aimed to present plays where the plots and characterisation were more ambiguous and difficult to explain.

His first play, *The Birthday Party*, produced in London in 1958, was misunderstood by the critics and went largely unnoticed, and it wasn't until the Royal Court presented *The Caretaker* in 1960 that his reputation was secured. Labelled 'the Comedy of Menace', these early plays combined a comic use of repetitive and trivial dialogue with an underlying sense of confusion and danger. Later he developed a more focused exploration of character, most notably in his 1975 play *No Man's Land*. His most recent plays have revealed an increasingly sparse use of language and more overt political themes, but all his works have possessed the sense of danger and human isolation that is his trademark.

A 1965 production of Pinter's *The Homecoming* by the Royal Shakespeare Company proved so successful that it transferred to the West End. This marked the arrival of a second wave of the revolution begun at the Royal Court in 1956. Something new, experimental and stylistically adventurous was now in the mainstream. Across the city a culture of new and challenging plays, many of them matching the fervent political mood of the time, were bubbling up from pubs and clubs.

With the abolition of stage censorship in 1968 – ending a conflict between the London stage and the city's politicians that had begun before Shakespeare's day – this culture of new and alternative theatre was free to take off. Basing themselves in converted church halls, or rooms above pubs (where rents were low and costs were cheap), these new 'fringe'

BELOW The controversial playwright Joe Orton, whose bizarre black comedies included *Entertaining Mr Sloane* (1964), *Loot* (1965) and *What The Butler Saw* (1969), the latter produced two years after the writer's death.

BOTTOM A 1994 National Theatre production of Pinter's *The Birthday Party* starring Dora Bryan and Anton Lesser.

BELOW RIGHT In rehearsal for Harold Pinter's *The Collection* with the Royal Shakespeare Company in 1962; (l to r) John Ronane, Pinter and Peter Hall.

LYRIC THEATRE
Shaftesbury Avenue, London W1

CLOSER

Tue 4 August 1998 7:30PM
(NOT SUITABLE FOR CHILDREN)
STALLS BB 2 £ 17.50

7SCCXS-QXS7Z7
6699257

CA REG 160 Aug 4 1998 6:44PM
Tickets are sold subject to the terms and conditions overleaf

ROYAL

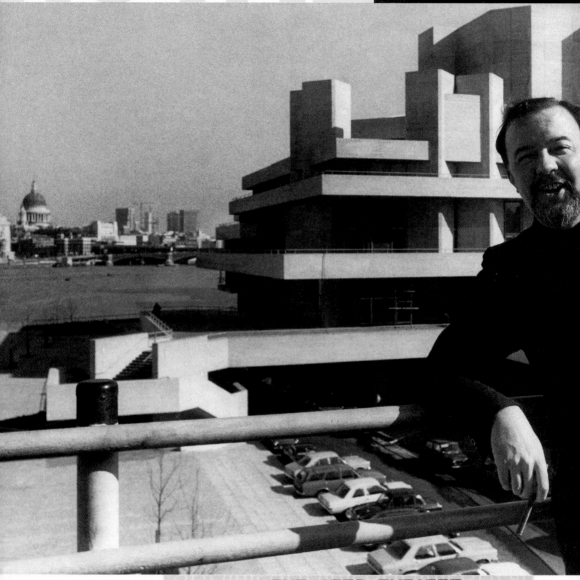

THE ARTS THEATRE

6/7 Gt Newport St. Tel. 071-836 2132

NO WAY TO TREAT A LADY

Thu 20-Aug-1998 8pm

£20.00 seats) SHIELD

STALLS

ROW : E SEAT : 10

NATIONAL

theatres could take on work that, because of its controversial or experimental subject matter, could not be seen in London's more conventional theatres.

Over the last 30 years, the fringe has become the filter through which many of the country's leading writers, directors and actors have emerged. Chief among these are the Bush Theatre in Shepherd's Bush, whose output of new plays has matched that of the Royal Court in the 80s and 90s; the Gate in Notting Hill, which former director Stephen Daldry established as the main forum for lost and neglected European classics; and the Almeida in Islington, whose commitment to innovative design and direction has attracted some of the world's most famous performers.

THE ROYAL NATIONAL THEATRE

By the end of the Second World War, a belief in the importance and quality of British theatre had led to calls for the establishment of a national theatre. In 1961, recognising the need for a state-subsidised theatre, free to produce high-quality work away from the compromising demands of the commercial sector, the National Theatre Company was established. Its first artistic director was Laurence Olivier.

Making the company's temporary home the Old Vic Theatre in Waterloo, Olivier modelled his new company on his experiences with Lillian Baylis in the 1930s. Baylis, eccentric and single-minded, dedicated her life to producing high-standard opera and drama at a price most Londoners could afford. She established the Sadler's Wells theatre in Islington as the home of English ballet, and at the Old Vic she presented Shakespearean plays with the leading actors of the day. John Gielgud, Ralph Richardson, Peggy Ashcroft and Olivier all gave some of the best performances of their lives there.

By the time the National Theatre Company moved to its new purpose-built premises on the South Bank, Olivier had been succeeded by Peter Hall as the company's artistic director (who was in turn succeeded by Richard Eyre and Trevor Nunn). Since its opening in 1976, the three theatres that make up the Royal National Theatre complex have seen performances by the nation's leading actors in plays by the

TOP LEFT The Royal Coburg Theatre in 1819; its name was changed in 1833 to the Royal Victoria Theatre – the Old Vic.

TOP RIGHT A scene from David Hare's acclaimed *Absence Of War*.

ABOVE Peter Hall in front of the newly completed Royal National Theatre in 1976.

THEATRE

country's major playwrights. Perhaps most notably has been the emergence of Tom Stoppard's witty and philosophical plays and David Hare's 'State of the Nation' trilogy, *Racing Demon*, *Murmuring Judges* and *The Absence of War*.

THE BRITISH MUSICAL

Meanwhile, the early 1970s had seen the beginnings of a new force in London's commercial theatre, which had more in common with the popular entertainments of the music hall and revue than the high ideals of the big subsidised theatre companies. The

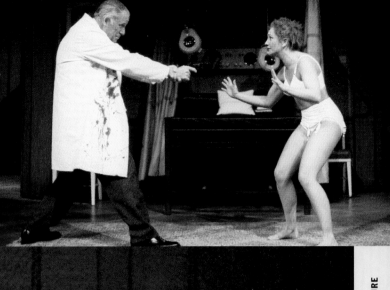

RIGHT Richard Wilson and Debra Gillet in a 1996 production of Joe Orton's *What The Butler Saw* at the National Theatre.

BELOW The actor, playwright and songwriter Ivor Novello in rehearsal with actress Joan Barry at the Globe Theatre in 1933.

British musical, for so long a pale imitation of its American cousin, was beginning to stir.

The tradition of the light musical comedy and popular revue had carried on throughout the middle part of the century, notably with the musicals of Ivor Novello. But compared to the sophisticated American shows, the identifiably British musical had practically ceased to exist.

It was not until Tim Rice and Andrew Lloyd Webber began to collaborate on a series of musicals in 1968, that the modern British musical began to emerge. *Joseph and His Amazing Technicolour Dreamcoat*, *Jesus Christ Superstar* and *Evita* were at the time called rock operas, because the songs, rather than spoken text, conveyed the narrative. In these shows they pioneered the style that would become Lloyd Webber's trademark – spectacular staging, strong but simple melodic lines and big ensemble casts.

In 1981 Lloyd Webber collaborated with the other wunderkind of British musicals, the producer Cameron Mackintosh, on the musical *Cats*. Based on a book of poems by T.S. Eliot, it proved to be the most successful show the West End has ever seen. Since then, by combining brilliant marketing strategies,

ABOVE Tim Rice and Andrew Lloyd Webber in front of a *Jesus Christ Superstar* poster in 1972.

BELOW The spectacular chorus in a 1996 London production of *Cats*.

ANDREW LLO

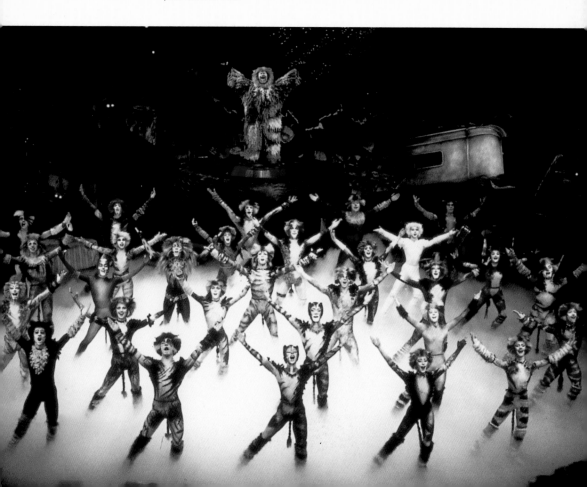

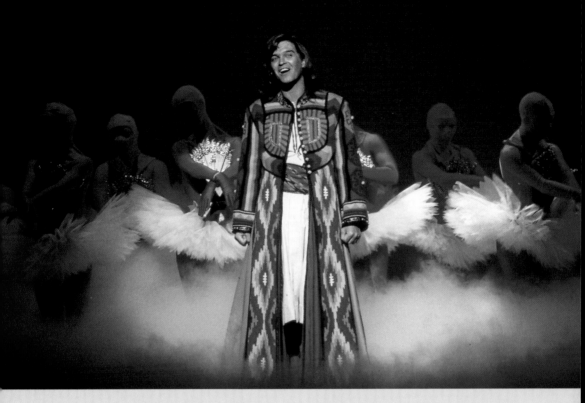

directors taken from the subsidised sector, and thrilling melodramatic themes, these two men have produced shows that have not only dominated the West End but also the world.

Shows like *Phantom of the Opera*, *Les Misérables*, *Miss Saigon* and *Starlight Express* have run for so long that they seem permanent fixtures of the London theatre scene. As their success has grown, and they have opened in cities throughout the world, they have acted as a calling card for London's theatrical reputation, ensuring a healthy future for the city with the greatest theatrical tradition of them all.

LEFT Whether it is *The Phantom of the Opera* at Her Majesty's or *Les Misérables* at the Palace, the musical has dominated the West End theatre over the past twenty years.

ABOVE Spectacle was always a hallmark of the Rice/Lloyd Webber musicals, right from the days of *Joseph and His Amazing Technicolour Dreamcoat*.

DIRECTORY

ARCHITECTURE

Albert Memorial
Kensington Gore, SW7

All Soul's Church
Langham Place, W1
(0171) 580 4357

**Arnos Grove
Underground Station**
Arnos Grove, N11

BBC Broadcasting House
Portland Place, W1
(0171) 580 4468

British Telecom Tower
Howland St, W1

Burlington House
Piccadilly, W1
(0171) 439 7438

Centre Point
New Oxford St, WC1

Hampton Court Palace
Hampton Court,
East Molesey, Surrey
(0181) 781 9500

Lloyds Building
Lime St, EC3
(0171) 327 3658

Royal Festival Hall
South Bank, SE1
(0171) 928 8800

St Pancras Station
Euston Rd, NW1
(0171) 387 7070

St Paul's Cathedral
Ludgate Hill, EC4
(0171) 248 4619/2705

Tower Bridge
Tower Bridge Approach, E1
Tower Bridge Rd, SE1
(0171) 407 0922

Tower of London
Tower Hill, EC3
(0171) 709 0765

Vauxhall Cross (MI5)
85 Albert Embankment, SE1

ART

198 Gallery
198 Railton Rd, SE24
(0171) 978 8309

Annely Juda Fine Art
23 Dering St, W1
(0171) 629 7578

Anthony d'Offay Gallery
20 Dering St, W1
(0171) 499 4100

Anthony Reynolds Galleries
5 Dering St, W1
(0171) 491 0621

British Museum
Great Russell St, WC1
(0171) 636 1555

Central St Martin's
107 Charing Cross Rd, WC2
27 Long Acre, WC2
(0171) 514 7000

Christie's
8 King St, SW1
(0171) 839 9060

Cubitt Gallery
2 Caledonia St, N1
(0171) 278 8226

Gasworks Studios & Gallery
155 Vauxhall St, SE11
(0171) 735 3445

Hayward Gallery
Belvedere Rd,
South Bank Centre, SE1
(0171) 928 3144

**Institute of
Contemporay Art (ICA)**
Nash House,
The Mall, SW1
(0171) 930 0493

National Gallery
Trafalgar Square, WC2
(0171) 747 3321

National Portrait Gallery
2 St Martin's Place, WC2
(0171) 306 0055

Royal Academy
Burlington House,
Piccadilly, W1
(0171) 439 7438

Royal College of Art
Kensington Gore, SW7
(0171) 590 4444

Saatchi Gallery
98a Boundary Lane, NW8
(0171) 624 8299

Serpentine Gallery
Kensington Gardens, W2
(0171) 402 6075

Tate Gallery
Millbank, SW1
(0171) 887 8000

Victoria & Albert Museum
Cromwell Rd, SW7
(0171) 938 8500

Wallace Collection
Hertford House,
Manchester Square, W1
(0171) 935 0687

White Cube Gallery
44 Duke St, SW1
(0171) 930 5373

Whitechapel Art Gallery
80 Whitechapel High St, E1
(0171) 522 7878

FASHION

Agent Provocateur
6 Broadwick St, W1
(0171) 439 0229

Aquascutum
100 Regent St, W1
(0171) 734 6090

Burberrys
18 Haymarket, SW1
(0171) 930 3343

The Cross
141 Portland Rd, W11
(0171) 727 6760

Harrods
Knightsbridge, SW1
(0171) 730 1234

Harvey Nichols
Knightsbridge, SW1
(0171) 235 5000

Issy Myake
270 Brompton Rd, SW3
(0171) 581 3760

Joseph
130 Draycott Ave, SW3
(0171) 584 1252

Liberty
210–220 Regent St, W1
(0171) 734 1234

Manolo Blanhik
49 Old Church St, SW3
(0171) 352 3863

Mimi
309 King's Rd, SW3
(0171) 349 9699

Richard James
31 Savile Row, W1
(0171) 434 0605

Tokio
309 Brompton Rd, SW3
(0171) 823 7310

Vivienne Westwood
430 King's Rd, SW10
(0171) 352 6551

Voyage
115c Fulham Rd, SW3
(0171) 823 9581

FESTIVALS & RELIGION

Bevis Marks Synagogue
Heneage Lane, EC3
(0171) 626 1274

Buckingham Palace
St James's Park, SW1
(0171) 930 4832

Highgate Cemetery
Swains Lane, N6
(0181) 340 1834

Horse Guards Parade
Tilt Yard, Whitehall, SW1

Houses of Parliament
St Margaret St, SW1
(0171) 219 3000

London Central Mosque
Hanover Gate, NW1
(0171) 724 3363

Speaker's Corner
Hyde Park,
Park Lane at Marble Arch

West End Great Synagogue
32 Great Cumberland
Place, W1
(0171) 724 8121

Westminster Abbey
Broad Sanctuary, SW1
(0171) 222 5152

Westminster Cathedral
Ashley Place, SW1
(0171) 834 7452

FOOD & DRINK

Anglesea Arms
35 Wingate Rd, W6
(0181) 749 1291

Atlantic Bar and Grill
20 Glasshouse St, W1
(0171) 734 4888

Bar Italia
22 Frith St, W1
(0171) 437 4520

Billingsgate Fish Market
Trafalgar Way, E14
(0171) 987 1118

Berry Bros & Rudd
3 St James St, SW1
(0171) 396 9600

Bibendum
81 Fulham Rd, SW3
(0171) 581 5817

The Blackfriar
174 Queen Victoria St, EC4
(0171) 236 5650

Brick Lane Beigel Bake
159 Brick Lane, E1
(0171) 729 0616

Carluccio's Food Shop
28a Neal St, WC2
(0171) 240 1487

Caviar House
161 Piccadilly, W1
(0171) 409 0445

Chutney Mary
535 King's Rd, SW10
(0171) 351 3113

The Eagle
159 Farringdon Rd, EC1
(0171) 837 1353

Fifth Floor Café
Harvey Nichols,
Knightsbridge, SW1
(0171) 235 5000

Fortnum and Mason
181 Piccadilly, W1
(0171) 734 8040

The French House
49 Dean St, W1
(0171) 437 2799

Fuller's Brewery
The Griffin Brewery, W4
(0181) 996 2000

Gordon's
47 Villiers St, WC2
(0171) 930 1408

Harrods Food Hall
Knightsbridge, SW1
(0171) 730 1234

The Ivy
1 West St, WC2
(0171) 836 4751

Manze's
87 Tower Bridge Rd, SE1
(0171) 407 2985

Mezzo
100 Wardour St, W1
(0171) 314 4000

Nobu
19 Old Park Lane, W1
(0171) 447 4747

Oxo Tower Restaurant
Barge House St, SE1
(0171) 803 3888

Paxton & Whitfield
93 Jermyn St, SW1
(0171) 930 0259

Quaglino's
16 Bury St, SW1
(0171) 930 6767

The Ritz
Piccadilly, W1
(0171)493 8181

The Savoy
Strand, WC2
(0171) 836 4343

Smithfield Meat Market
Smithfield, EC1
(0171) 248 3151

R Twining & Co
216 Strand, WC2
(0171) 353 3511

Vong
Berkeley Hotel,
Wilton Place, SW1
(0171) 235 1010

The Windsor Castle
114 Campden Hill Rd, W8
(0171) 727 8491

Yo! Sushi
52 Poland St, W1
(0171) 287 0443

Young's Brewery
The Ram Brewery,
Wandsworth High St, SW18
(0181) 875 7000

MUSIC

100 Club
100 Oxford St, W1
(0171) 636 0933

Abbey Road Studios
3 Abbey Rd, NW8
(0171) 266 7000

Academy Brixton
211 Stockwell Rd, SW9
(0171) 924 9999

Apollo, Hammersmith
Queen Caroline St, W6
(0171) 741 4868

Astoria
157 Charing Cross Rd, WC2
(0171) 434 0403

Barbican Hall
Barbican Centre,
Silk St, EC2
(0171) 638 8891

Coliseum
St Martin's Lane, WC2
(0171) 836 3161

**Earl's Court
Exhibition Centre**
Warwick Rd, SW5
(0171) 385 1200

Heaven
The Arches,
Villiers St, WC2
(0171) 930 2020